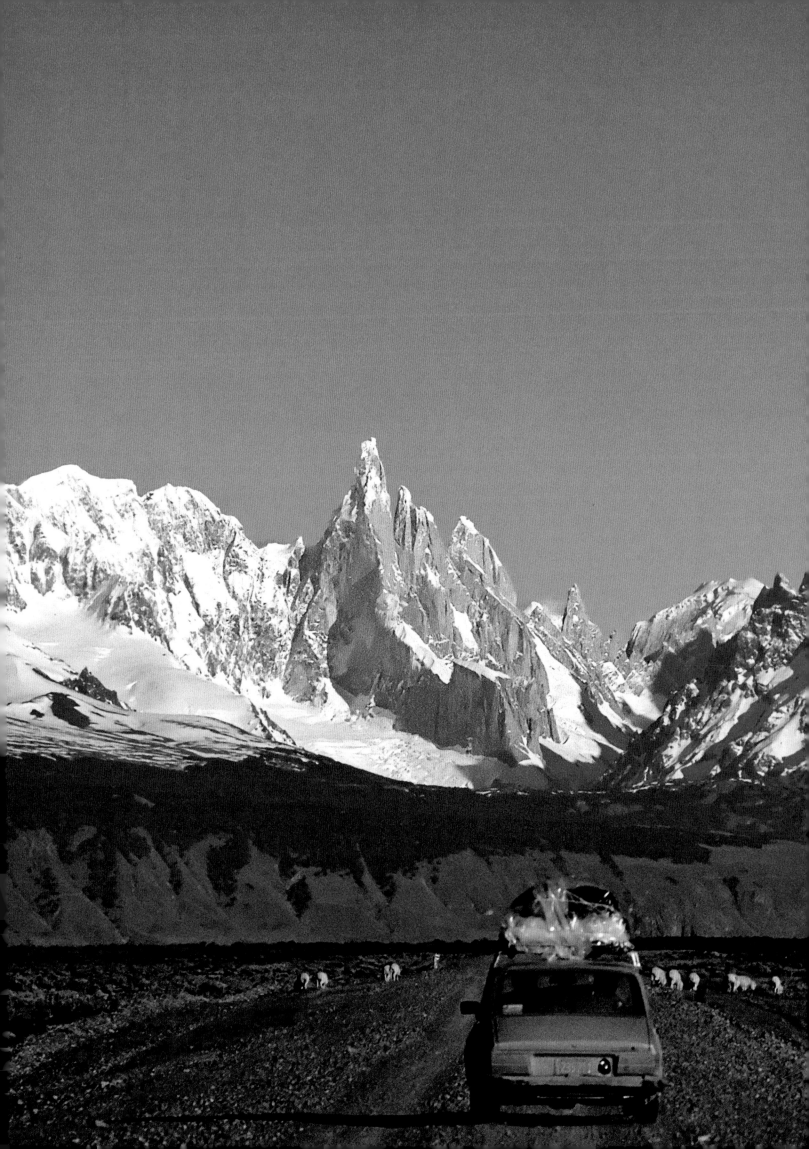

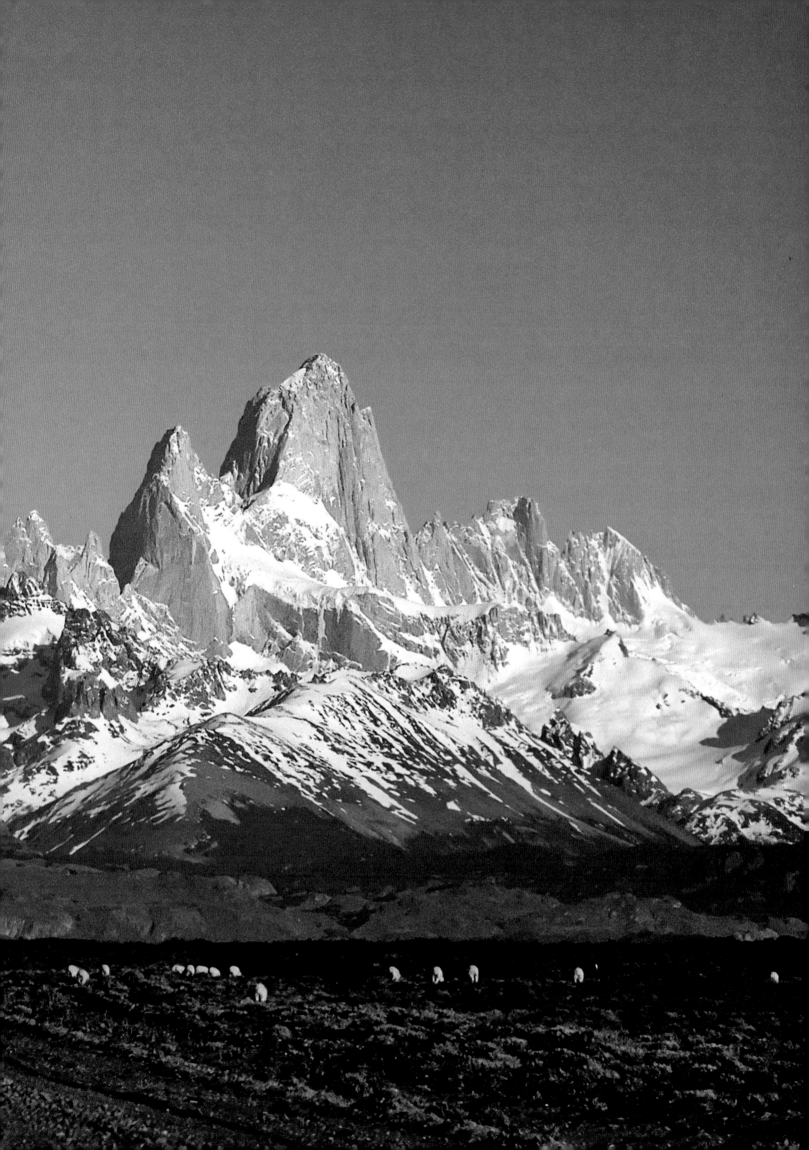

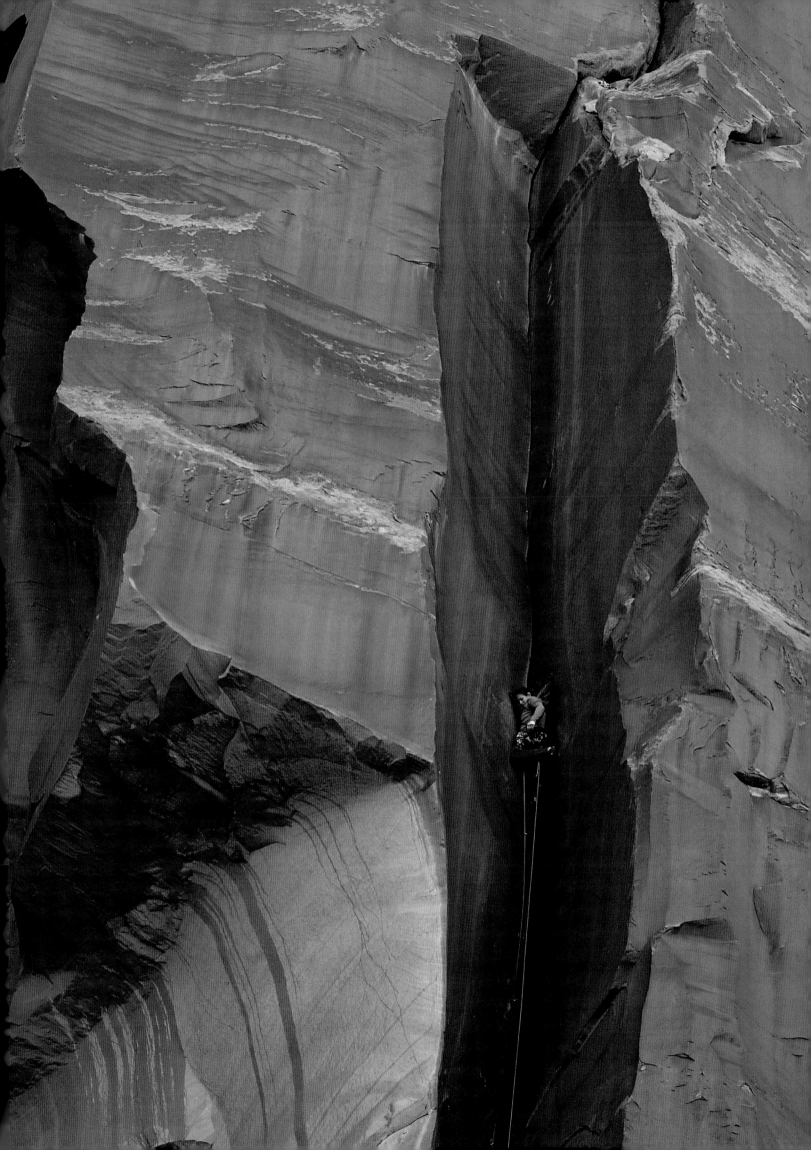

UNEXPECTED

30 Years of Patagonia Catalog Photography

Edited by JANE SIEVERT & JENNIFER RIDGEWAY

Foreword by RICK RIDGEWAY

BOOKS

Kitty Calhoun saddles up to the knee bar on Slot Machine. Indian Creek, Utah. ANNA PIUNOVA. *Spring 2009*

Overleaf: Heading toward Fitz Roy. Patagonia. BARBARA ROWELL. *Fall 1988*

UNEXPECTED:
30 Years of Patagonia Catalog Photography

This book is dedicated to the many photographers who over the past three decades have submitted approximately three million photographs to Patagonia.

First edition Printed in Hong Kong

Patagonia Books, an imprint of Patagonia Inc., publishes a select number of titles on wilderness, wildlife, and outdoor sports that inspire and restore a connection to the natural world.

Editors - Jane Sievert & Jennifer Ridgeway
Designer - Annette Scheid
Production - Tracy Smith, Brett Piatt & Rafael Dunn
Project Management - Jennifer Sullivan
Special thanks to Karen Bednorz, Sus Corez, Jenning Steger and Kelsey Curry-Williams.

Printed on 100% recycled paper with soy-based inks.

Front Cover: Lynn Hill on a bomber jug after leading Insomnia, 5.11, Suicide Rock, California. RICK RIDGEWAY. *Spring 1983*

Back Cover: Sculpture Geante de Detritus. Made by painter Andy Parkin and sculptor Phillipe Vouillamoz with community help. The litter was left on the mountain near Mer de Glace, Chamonix. GARY BIGHAM. *Fall 1990*

ISBN 978-0-9790659-9-6 (regular edition)
ISBN 978-0-9790659-6-5 (boxed edition)

Doug McPherson on the inner rim of Mount Bromo, East Java. DOUG McPHERSON. *Spring 1985*

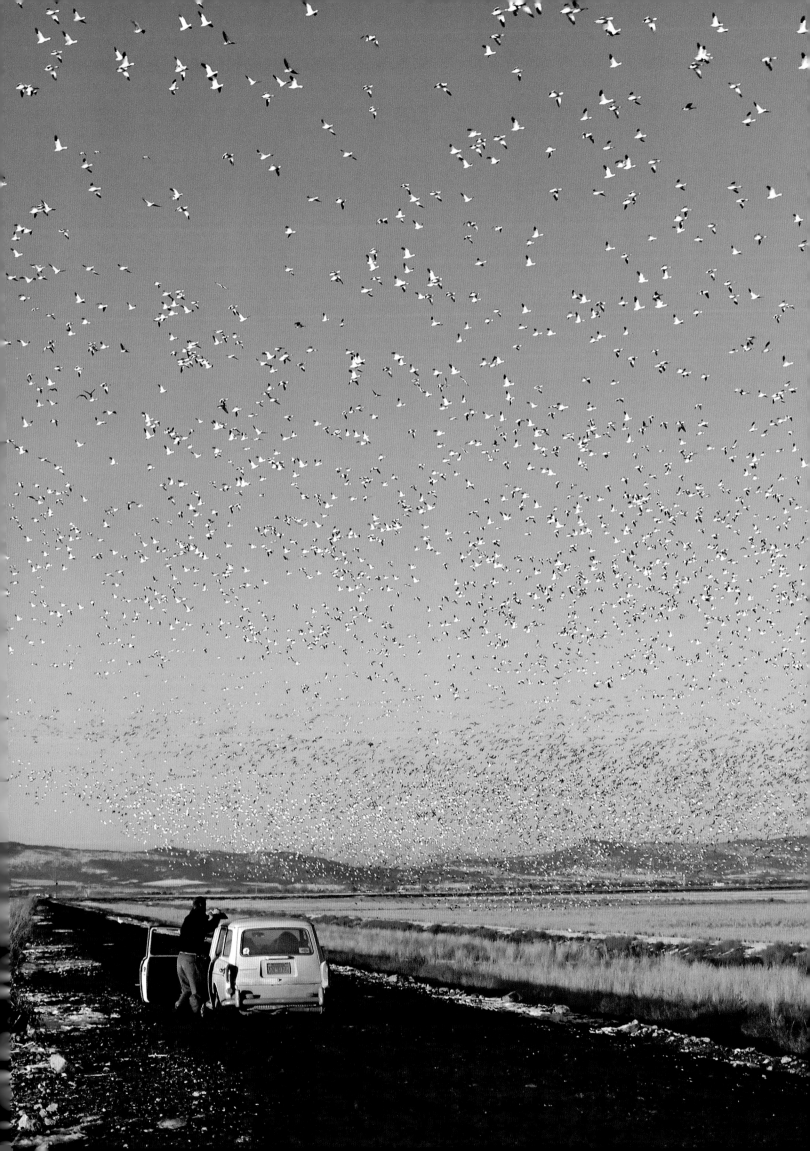

ESSAYS

Just off the highway to Tule Lake, an exaltation of snow geese. Klamath Basin Wildlife Refuge, California. LARRY MINDEN. *Fall 1984*

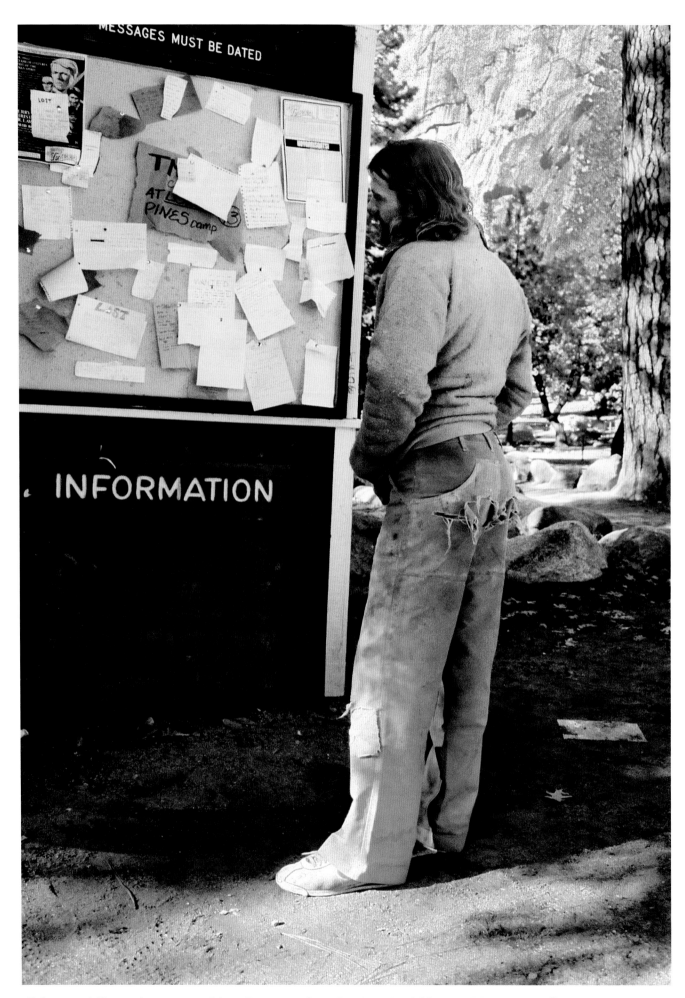

"Tailor wanted. No experience necessary." Steve Grossman at Camp Four. Yosemite, California. KATHY RYAN. *Fall 1984*

ORIGINS

Rick Ridgeway

YVON CHOUINARD, founder of the Patagonia clothing company, got his start in 1957 as an 18-year-old blacksmith and rock climber forging pitons in his parents' backyard, in Burbank, California. Word soon spread through the climbing community that although Chouinard sold his hard-iron pitons for an outrageous $1.50 apiece, they could be reused a number of times: A climber could now do a multiple-pitch ascent carrying far less gear. From the start, he never lacked business – and never wanted to make business his whole life. Summers, he would load his anvil into the back of his Model-A Ford and drive to Yosemite for the climbing season. Mail-order customers were advised, on the single mimeographed sheet that served as a catalog, not to expect quick delivery from June through September.

In 1972, the blacksmith operation, then called the Great Pacific Iron Works, produced its first real catalog. The cover was a 16th-century Chinese scroll painting called *Landscape in the Spirit of Verses* by Tu Fu. Inside were quotes from Einstein, St. Exupéry, and the Rolling Stones, and the now-famous article by Doug Robinson that ushered in the era of clean climbing. That catalog captured perfectly the essence of the company.

Through the rest of the 1970s, new catalogs came out every two or three years. These included in the back a few items of clothing made with the same design principles used for the climbing hardware, where form followed function: rugby shirts of heavy-duty jersey knit cotton with hard rubber buttons that held up on rock climbs; climbing pants and shorts from canvas so tough and stiff that when the first prototype came off the sewing machine, the seamstress stood them up on the table ("Stand Up Shorts" are still in the line).

The clothing line grew to the point that it needed its own name. A few years earlier, Yvon and some buddies had made a six-month road trip from California to Patagonia to climb a granite spire called Fitz Roy, and the landscape – the jagged rock spires, remote glaciers, high winds, condors, and gauchos – left an imprint on Yvon strong enough that he called the line Patagonia: For him it was a name that spoke for all wild places – and the ruggedness he wanted in the clothes.

Yvon and Kris McDivitt, his general manager, hired me to write the copy and take the photographs for the 1980

catalog. I realized the climbing equipment pages would be easy to produce: Take photos of the tools in a studio, add a few climbing shots, and do your best to imitate the inimitable editorial style for the copy. The other half – the clothing line – was more of a challenge. While I had developed some skill taking photographs of climbing and surfing, I had never worked with models.

But calling the people I used in that 1980 catalog "models" was also a stretch: I conscripted whomever I could find around the machine shop and sewing room, put some clothing samples on them, walked them down to the riverbed behind the shop, and had them stand stiffly staring at the camera with their hands on their hips. The *arundo* thickets served as a backdrop as we checked off the list of the photos we needed one by one. When the catalog came out and I showed it to Yvon, I could tell what his reaction was by the way he stared at his shoes and shuffled his feet. I could also divine Kris's opinion when she said, "The photographs really suck, pal."

A week later, Yvon and I were in the lineup, sitting on our surfboards between sets.

"Hey Rick, you know those photographs in the last catalog?"

"Yeah?"

"I think I've got it figured out. We'll run photos of real people doing real things. We'll take shots of the clothes in the studio, just like we do with the hardware, but the other shots will be of people out in their regular lives doing the stuff they do. You don't need to focus on the products' features. In fact, the more worn in and used they are, the better."

Shortly after that, my new bride Jennifer took on the job of producing the 1981 Patagonia catalog. When we met, she had been living on Manhattan's Upper East Side, which belied the rumor that Patagonia employees had to be recruited from climbing camps or taco stands. Yvon, Kris, and Jennifer worked closely on that seminal catalog – separated for the first time from the climbing hardware catalog – that was the first to use what we started calling image photographs: photographs that captured the mood, the spirit, and the adrenaline of the moment.

Catalog companies that use ad agencies and location photographs normally hire professional photographers to

go out and get the shots, but at Patagonia, if you were a professional, you had to agree to work on spec. You also had to unlearn what most pros considered to be the de rigueur ingredients of a quality photograph: good light, balanced composition, and stunning models. They learned quickly when their images were rejected because they were too perfect.

Some of the most memorable images came from friends, friends of friends, loyal customers – whom we lovingly called Patagoniacs – sending in their shots from travels, expeditions, even their backyards: a guy in shredded Stand Up Pants checking out the message board at Camp 4 in Yosemite, a mechanic under his road-worn truck grease-balling a pile jacket, a climber rappelling off El Cap in a snowstorm, a radiant Lynn Hill finishing the final crux on a 5.11 climb at Tahquitz.

We published an invitation to "Capture a Patagoniac" in the catalog. Soon there were hundreds, then thousands, then tens of thousands of photographs a year coming in. It was a lot of work for Jennifer – and later Jane Sievert – to edit them; no other company would have made that kind of commitment to keep it real. But we considered it worth our time.

The clothing catalog, like the early Chouinard Equipment Catalog, began to capture the essence of the company. A business magazine, reviewing the catalog in a 1988 article titled "The Anti-Marketers," said, "The catalog, it turns out, is also the perfect expression of the company – it is the guidebook to Patagonia's soul."

It's amazing that in the 30-year history of the Patagonia catalogs, there have been only two photo editors, Jennifer Ridgeway and Jane Sievert, both of whom describe their journeys in their own essays. In "Capture a Patagoniac," Jennifer describes her arrival in what in 1981 was to her a foreign land – the Patagonia clothing company; her successor Jane Sievert describes her own journey in "Personal Work." We also have essays by long-time Patagonia photographic contributors John Sherman and Beth Wald, as well as relative newcomers Cory Richards and Jeff Johnson and an interview with one of our earliest contributors, the Patagoniacally prolific John Russell. They tell us how they came to be photographers and showed up at Patagonia's door, and a bit about their favorite shots.

The photos tell the full story.

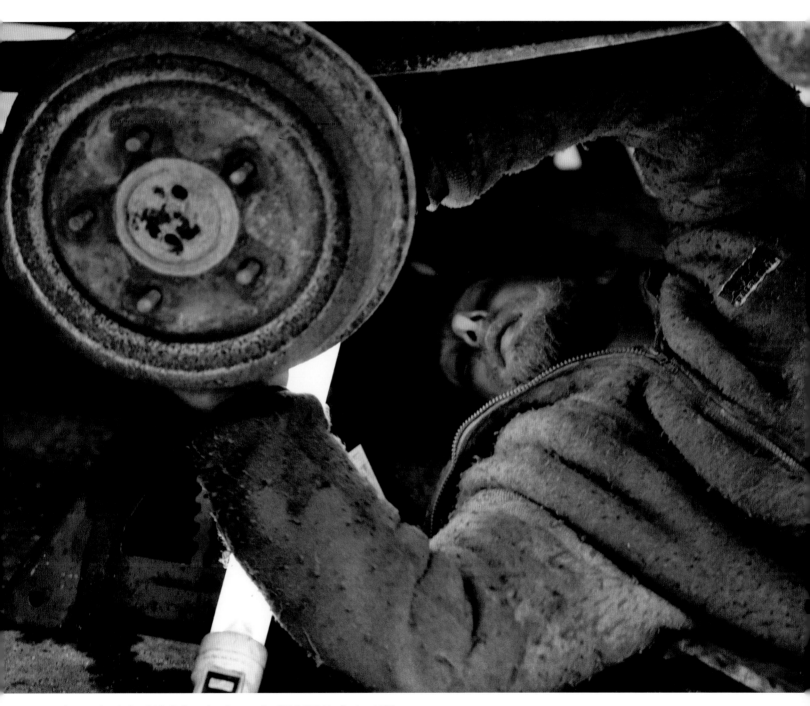

Ace mechanic Brad McCalister hard at work. CIRO PENA. *Spring 1989*

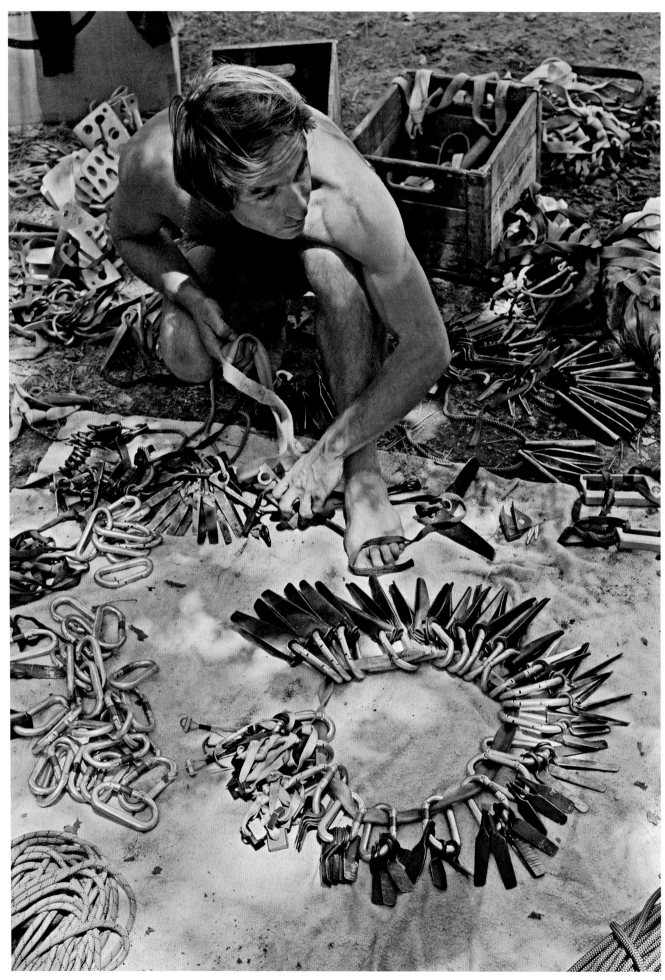

Circle of pins. Yvon Chouinard, 1969. Yosemite, California. GLEN DENNY. *Spring 2007*

Chuck Pratt juggling at the brink of Vernal Fall, 1969. Yosemite, California. GLEN DENNY. *Spring 2007*

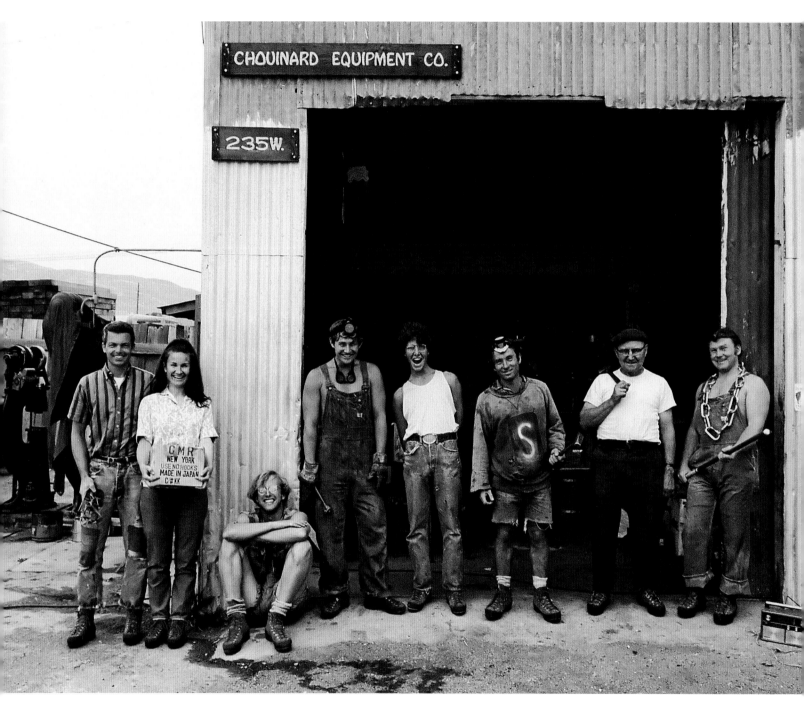

The Chouinard Equipment crew in front of the Tin Shed. Ventura. PATAGONIA HISTORICAL ARCHIVES. *c. 1968*

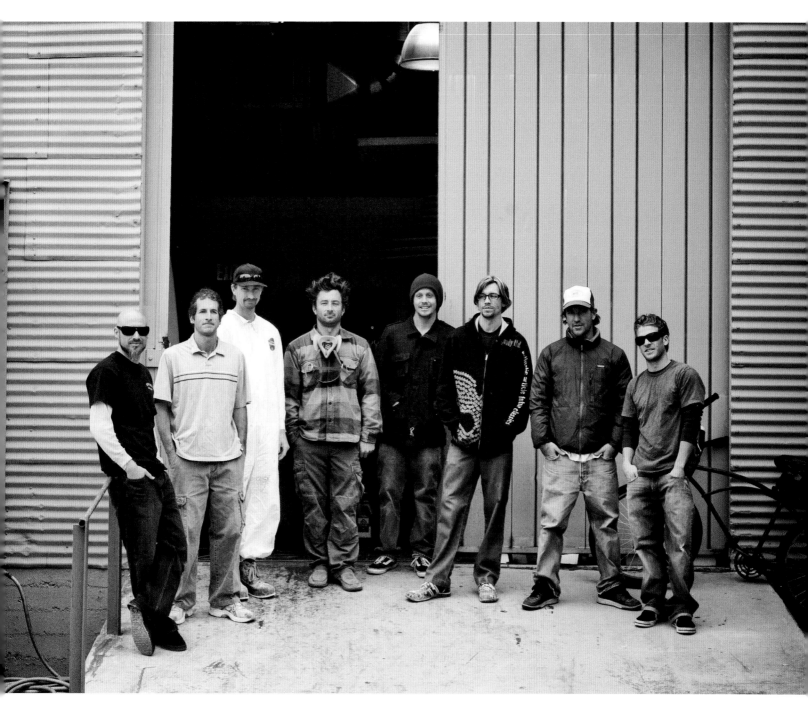

The FCD crew, give or take a few. Ventura, California. TIM DAVIS. *Spring 2009*

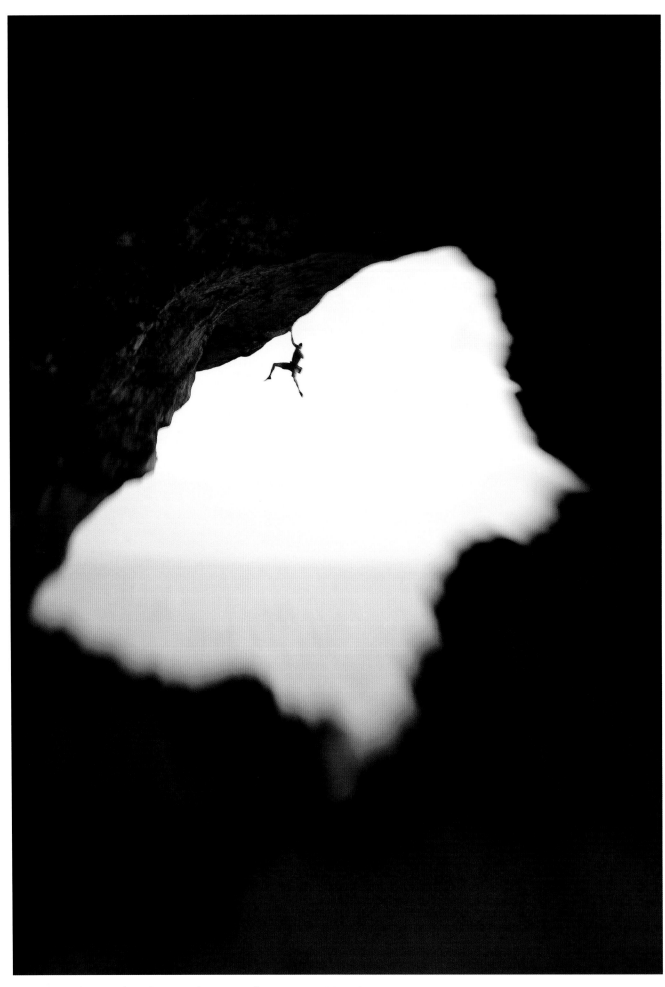

Deep-water soloing on the Cala Sa Nau buttress. Mallorca, Spain. BOONE SPEED. *Summer 2005*

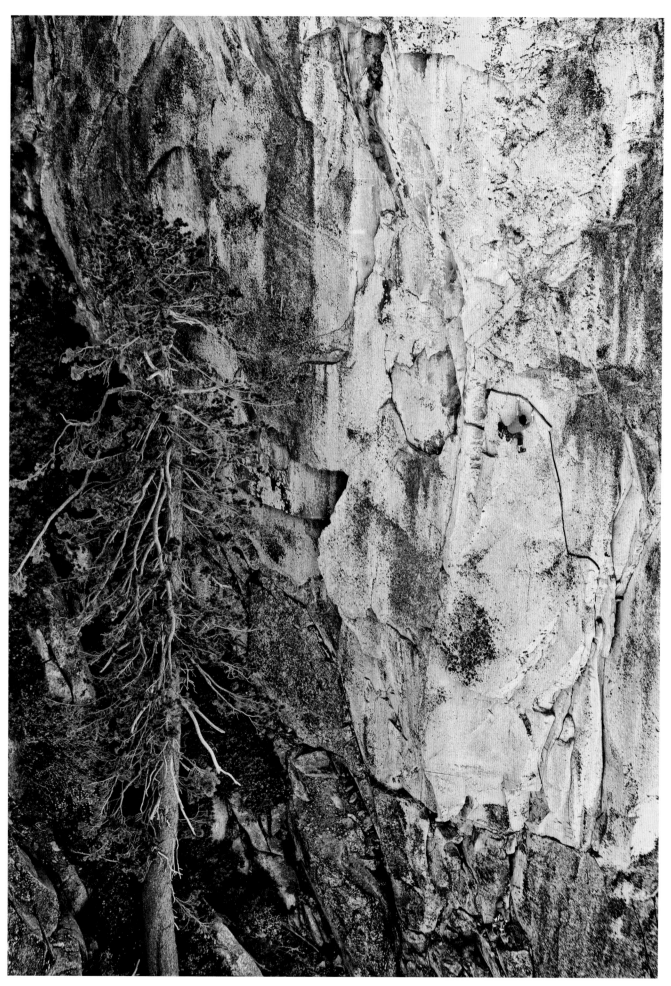

Townsend Brown jams through the lichen with Kay Okamoto on belay. The northeast face of Chimney Rock Spire's unforgettable hand-and-fist crack, Freaky Deaky. Giant Sequoia National Monument, California. GREG EPPERSON. *Spring 2010*

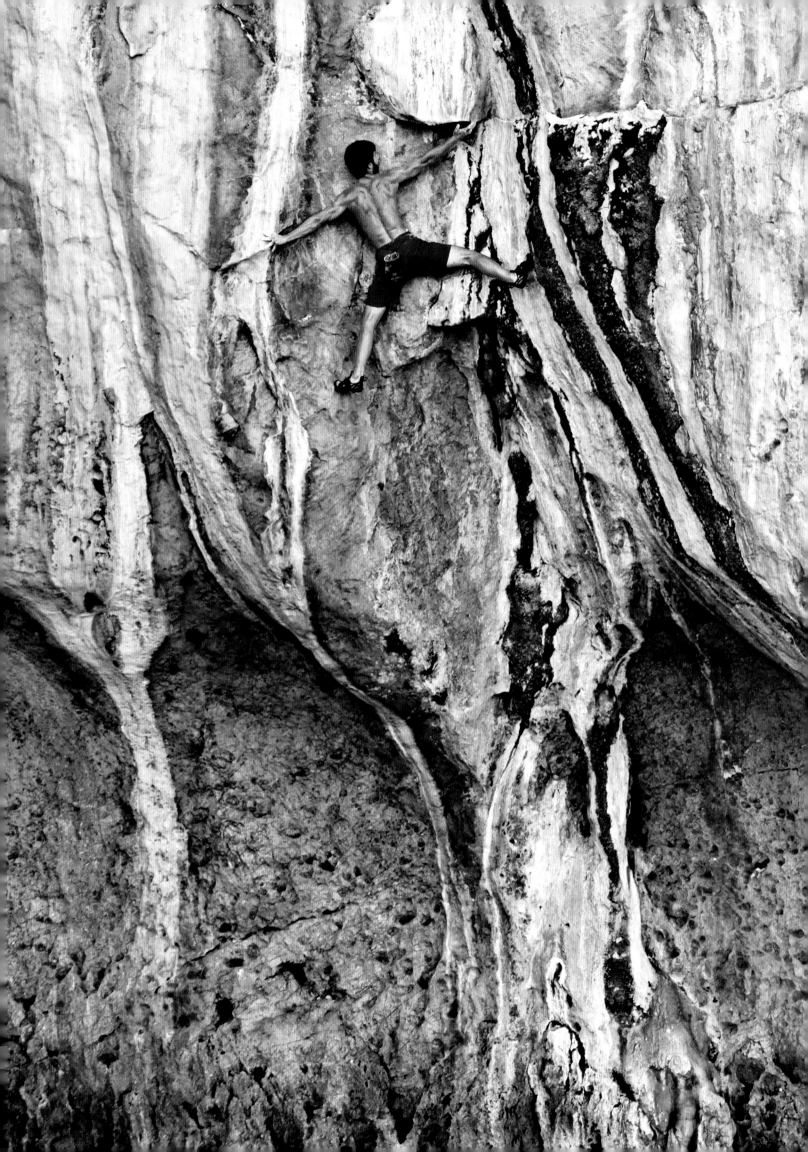

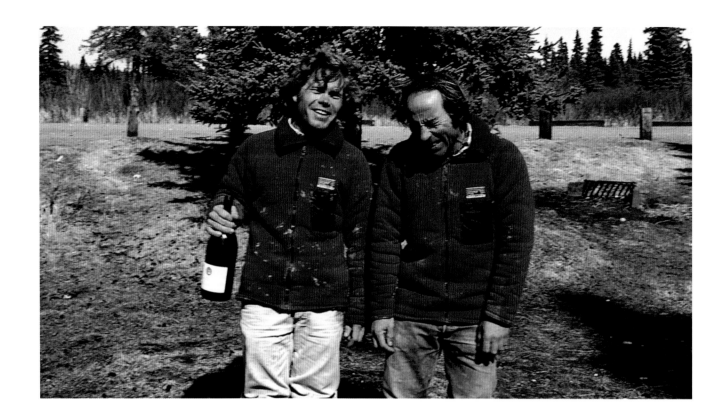

CAPTURE A PATAGONIAC

Jennifer Ridgeway

The original version of Jennifer Ridgeway's classic essay "Capture a Patagoniac" appeared in the Patagonia Catalog in 1986. We have published it here essentially unchanged, but with a few modifications suggested by Jennifer. She was our founding photo editor.

THE BEST PLACE TO BEGIN, I guess, is at the beginning of this chapter of my life. In the spring of 1981, I had been in Bangkok looking at silks for Calvin Klein. En route back to New York, I missed my flight out of Delhi. Knowing that I did not want to hang out in Delhi for three days alone waiting for the next available flight, inspired by the Cat Stevens song, I decided to pop up to Katmandu and check it out. It was April Fool's Day, and I was in the lobby of the Yak and Yeti Hotel quite pleased with my escape and sipping a gin and tonic, when this guy sits down next to me, hands me another gin and tonic, and introduces himself.

"My name is Rick Ridgeway, and I'm here doing a story on Mount Everest National Park for National Geographic."

I told him I was in Katmandu on a three-day lark, and to my surprise, he immediately invited me to join him on his three-week "trek."

"I've got wads of rupees in my expense account, and I'll hire you an army of Sherpas. We'll sip Remy Martin in Namche Bazaar and dine on yak steak on the Khumbu Glacier."

"But the farthest I've ever walked," I protested, "is from

a cab on Fifth Avenue into the front entrance of Bergdorf-Goodman."

Since the flattest shoes I had with me were three-inch kid-skin boots, I'm certain that had I accepted, Carissa (age 3) and Cameron (age 3 months) Ridgeway would not at this moment be with us in this world. In fact, looking back on it, it still amazes me that events unfolded as they did. After all, Rick had climbed K-2, which is considered the most techni-cally difficult mountain to climb in the world.

"Well, if you don't want to trek up to Everest National Park with me," Rick persisted, "why don't you come and visit me when we're back in the States."

"Where do you live?"

"I've got a quaint little beach cottage just south of Montecito."

Clever way to describe Ventura, I discovered when I showed up three months later. I had been doing a show at the Neiman-Marcus in Beverly Hills, and my plane from Santa Monica was two hours late into the Ventura/Oxnard airport. By the time I arrived, it was the tail end of Happy Hour at

Lucidly searching for clams. Yvon Chouinard and Rick Ridgeway on the Kenai Peninsula, Alaska. PETER HACKETT. *Spring 1986*

Overleaf: Matt Maddaloni opts for big moves over a big fall during the first ascent of the Line of the Rose. Deep-water soloing on Ko Kha, Gulf of Thailand. DIANA SABREEN. *Spring 2011*

the "Red Baron" airport bar, and my welcoming committee – Yvon Chouinard, Naoe Sakashita, and Rick – each had four jumbo margaritas under their belts.

I hadn't had time to change out of my Calvin Klein ballerina-length silk dress, pearls, and five-inch heels, and my first thought as they greeted me was, "Great, I'm being hosted by three drunk dwarfs."

My second thought, as I got into the hole-laden, rusting 1969 Datsun Chouinard Equipment "gofermobile" with a greasy interior and only one working door, was a shallow one: "My dress is probably worth at least four times as much as this car."

Despite it all, Rick won my heart (didn't I say he is persistent?), and five months later we announced our engagement. We married on Valentine's Day 1982. Part of the plan was that I move from my Upper Eastside Manhattan apartment to that quaint cottage – read "shack" – on the outskirts of Montecito. That was okay, but I wanted to work – not just stick around the "cottage" watering houseplants. I wanted a job, and there didn't seem to be anything obvious for me to do in Ventura.

"We'll have my buddy Yvon set you up," Rick said.

"Doing what, making pitons or whatever you call those metal things you climb with?"

"No, no. We'll get you in at Patagonia."

An interview was arranged for me with Kris McDivitt, Patagonia's general manager, who had worked at the company since she was a teenager taking wholesale orders over the phone. If too many orders came in in one day, she'd throw them in the trash.

"I started modeling at age 12," I said, "and modeled through high school and college. I moved to New York City after college and got a job with Calvin Klein designing preview line shows at Saks, Bergdorf-Goodman, Barneys, Neiman Marcus. Shows in New York, Paris, Milan, and Tokyo."

"Perfect. We'll put you in advertising."

"Advertising?"

"Yeah, we need somebody to put together an advertising department."

"But I don't know anything about advertising."

"Neither does anyone else around here."

I started that year in what was referred to as "the box," the upstairs 10' × 5' torture chamber in the old building that I shared with four other people, one of whom was a cash-strapped climber who used a piton to spread Miracle Whip on his Wonder Bread sandwiches to keep his calorie count up, perhaps 10 times a day. A curiosity for someone accustomed to living on celery and tomato juice. That summer it topped out in the room at 113 degrees, and with each degree rise on the thermometer, it seemed Montecito receded that much further north. That fall, Rick started working on *Seven Summits* – you can guess how much time away from home that entailed.

Despite the fact I couldn't figure out just what to wear to work, the job was great. Those first few months, I was in charge of advertising, art, and PR. They even had me writing catalog copy. As soon as I could spell *polypropylene*, I began scheduling ad campaigns for long underwear (not exactly high fashion), working with the media, running the pro-purchase program, managing catalog production, and creating a photography department. That fall, we came out with the second Patagonia catalog to feature "image" photographs – and the first catalog ever that was on schedule.

Over the next three years, as the company grew tenfold and the Ridgeway family grew fourfold – with the arrival first of Carissa, then of Cameron – I cut back on my duties, and now I handle the part I've always enjoyed the most: working with photographers and editing and collecting photos for the catalogs, ads, and posters. We do not send photographers out on paid assignments to do shoots for us. We work completely on spec with photographers, many of whom are friends or friends of friends. We find out what expeditions they are going on or what surf trips or what exotic parts of the world they are going to be in, and we give them Patagonia clothes to take along. This is how we get such diverse photographs. It isn't just the vision of one photographer or a few photographers. Hundreds, maybe thousands, of photographers are involved. The goal of the photos is to sweep people away, to inspire them – to let them visualize what its like to be "out there," not stuck sitting at a desk or in front of a TV. The message is to get off your bum and get out there and do stuff.

I put together a team of handsome and dashing world-class climbers, surfers, skiers, kayakers, fisherman, mountain bikers, and sailors to help me edit and solicit their sport-specific shots. Rick, since he did all the sports above but fishing helped edit and solicit too. Yvon reviewed all final edits. None of the team wore shoes. I stopped wearing five-inch heels and pearls and slowly gave away the silk dresses.

I work with both amateur and professional photographers, and since we started placing a notice in the catalog soliciting shots from the general public to "Capture a Patagoniac," I've been in charge of reviewing all the photographs that come in. And believe me, there are some weird ones.

The most common shots we get are successful conquests of this or that mountain – set-jawed, one hand on the hip, the other hand shading eyes that gaze across their conquered domains. But we also get a good "gonzo" selection (a term I didn't know before working for Patagonia), too. Last week I got one of a cow dressed in bunting and another of a deer wearing a pile balaclava. The dog we published several years ago (the one wearing a bunting jacket and goggles) started some kind of craze, and now I get at least one Patagonia-clad dog a week.

But we're still waiting for someone to send in our dream shot. We'll pay triple, maybe even quadruple. What we really want (well, what Yvon really wants) is Dr. Hunter S. Thompson dressed in a Pataloha Fish and Tits shirt, cigarette holder in mouth, and visor down over his eyes, shooting pool with Ted Kennedy.

Now that's an image shot.

Brian Stork sorting gear after climbing the South Face of Washington's Column in Yosemite. California.
MARTIN HOLTMEYER. *Spring 1992*

Overleaf: Ulrika Hedlund and Goran Tammert in front of a 1957 Beaver. Northern Lappland. FELIX OPPENHEIM. *Fall 1989*

Frederique Pino in Kongsfjorden during a sea-kayak expedition in the Spitsbergen islands. 12 degrees E, 79 degrees N.
JEAN-BERNARD COLLAS. *Winter 1991*

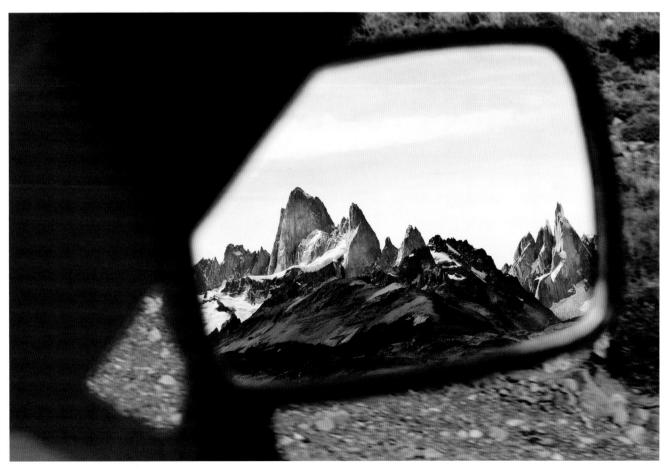

Until next year. Mikey's parting shot of Cerro Fitz Roy and the Cerro Torre massifs. Patagonia, Argentina. MIKEY SCHAEFER. *Fall 2009*

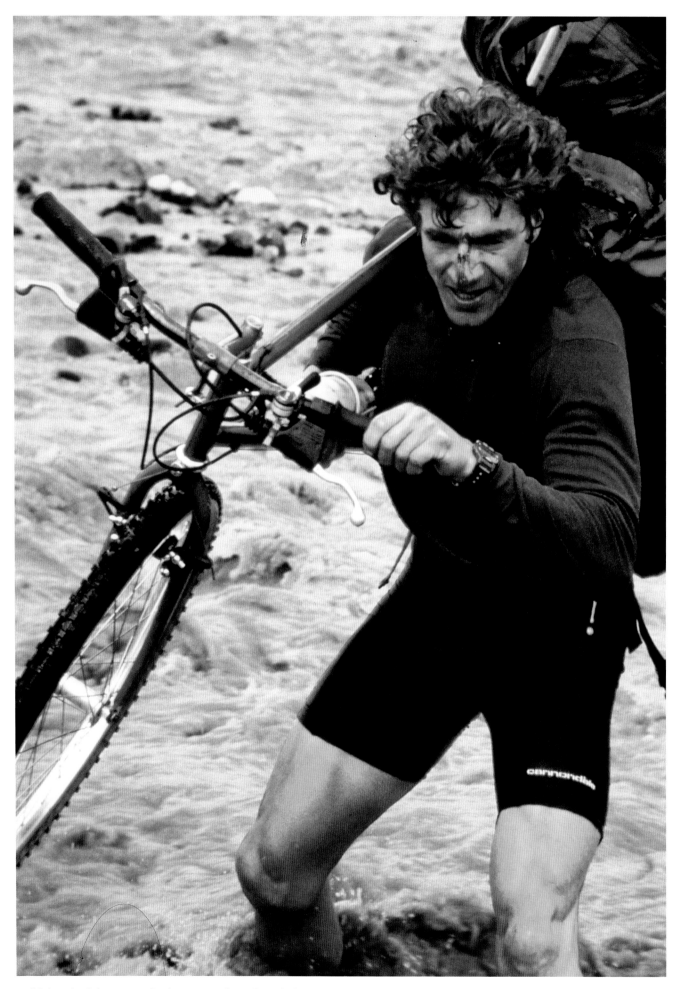

Hell biking by definition. Carl Tobin, Wrangell-St. Elias, Alaska. ROMAN DIAL. *Fall 1990*

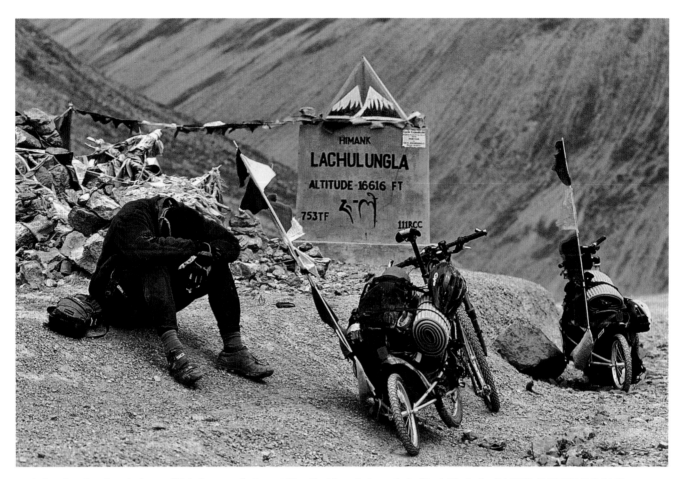

Lachulungla takes the wind out of Eric Parsons during a 300-mile ride to Leh, capital of Ladakh, India. DANIEL BAILEY. *Fall 2003*

Peggy Dial bushwhacking Class IV alders. Gates of the Arctic National Park, Brooks Range, Alaska. ROMAN DIAL. *Fall 1989*

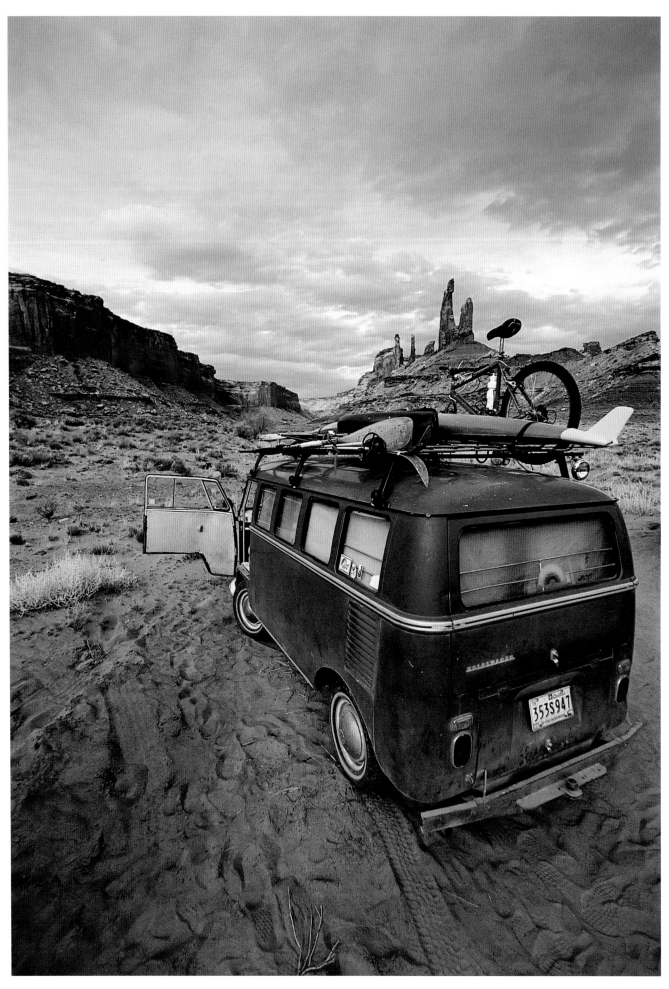

Mobile toy chest. Bryn Palmer's van awaits the next opportunity for play. Canyonlands National Park, Utah.
GREG EPPERSON. *Late Summer 2003*

WILEY / WALES. *Spring 1995*

King of the bongo, Scott Stoughton on the Colorado River. Cataract Canyon, Utah. DAWN KISH. *Late Summer 2007*

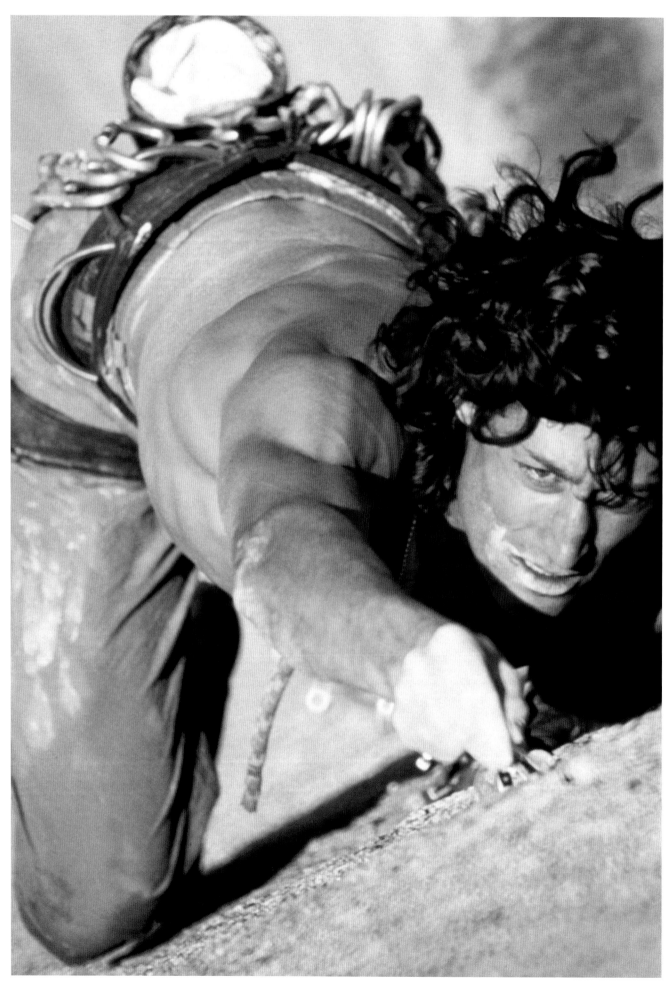

Jeff Schoen on "Ankles Away," the Witch Needle. The Needles, California. GREG EPPERSON. *Fall 1994*

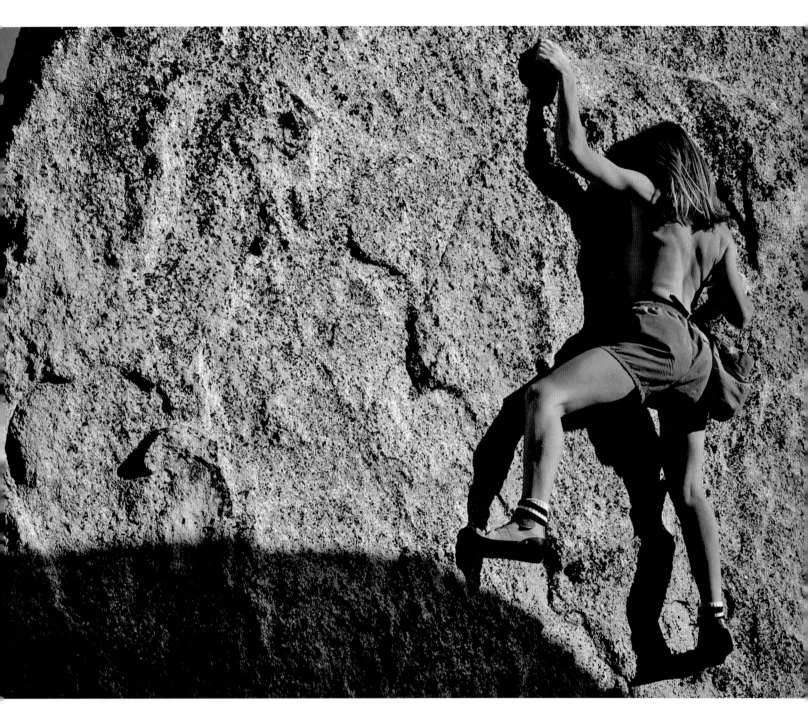

Marsha Collins in a secluded spot on a serene evening, edging to the top. Cañon Tajo, Mexico. GREG EPPERSON. *Spring 1988*

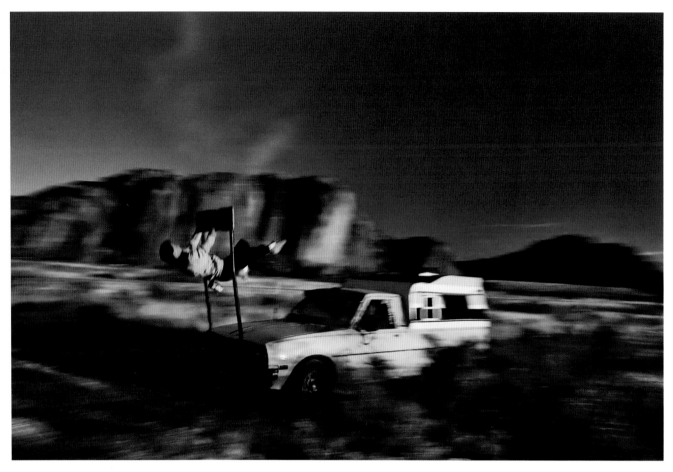

Fright simulator: Paul Piana undergoing aerodynamic training near Hueco Tanks, Texas. BETH WALD. *Fall 1991*

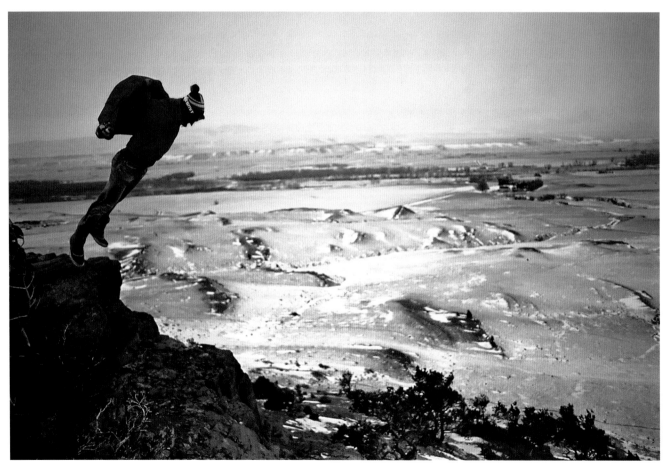

Barney Hallin body flying near Livingston, Montana, 50 knots. PAUL DIX. *Fall 1989*

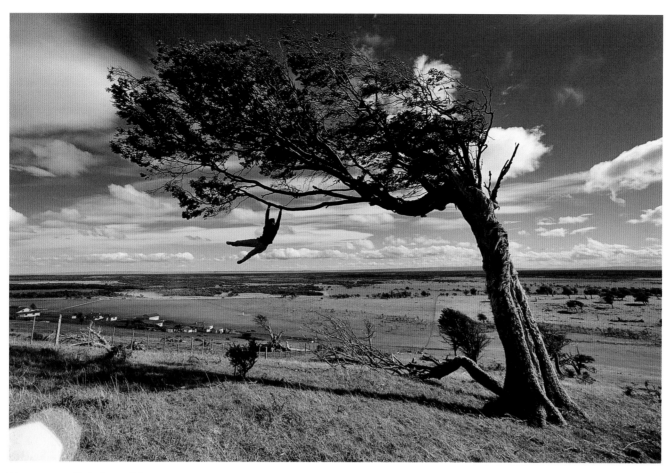

Way out on a limb, but still hanging on in Patagonia. WADE McKOY. *Fall 2002*

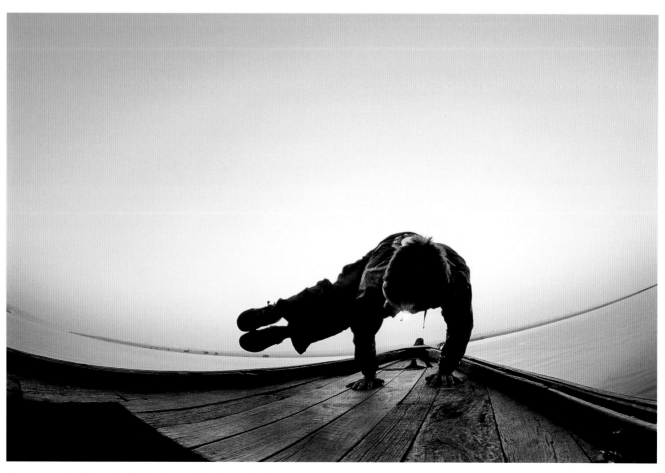

Not your typical figurehead. Jim Martinello adorns the bow. Ganges River, Varanasi, India. ALAIN DENIS. *Spring 2006*

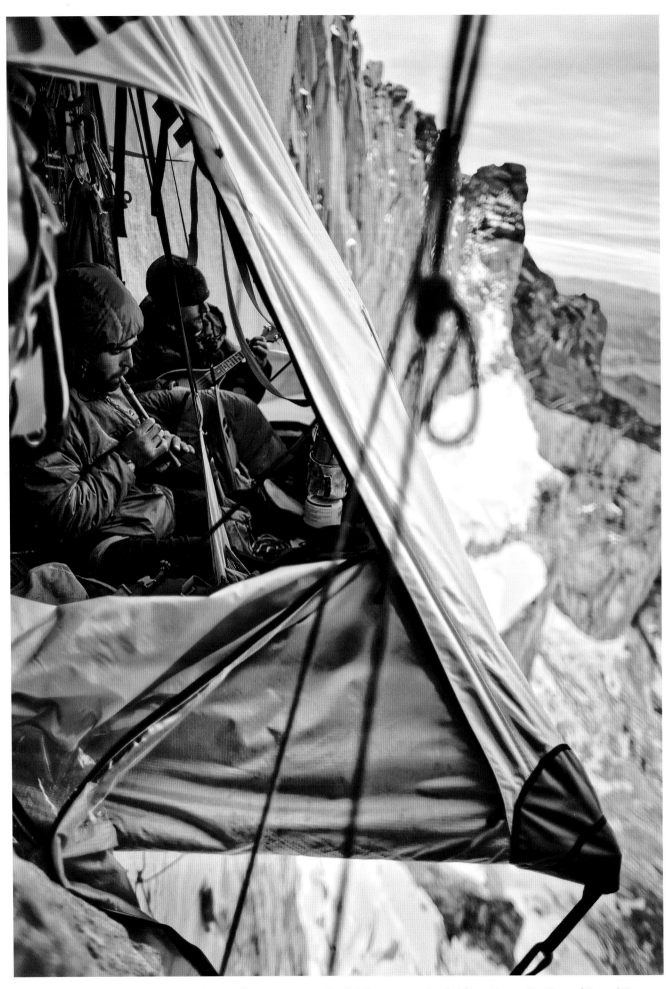

Climbing ambassadors Nico Favresse and Sean Villanueva warm up for their latest venue. South African Route, East Face of Central Tower, Torres del Paine, Chile. BENJAMIN DITTO. *Fall 2010*

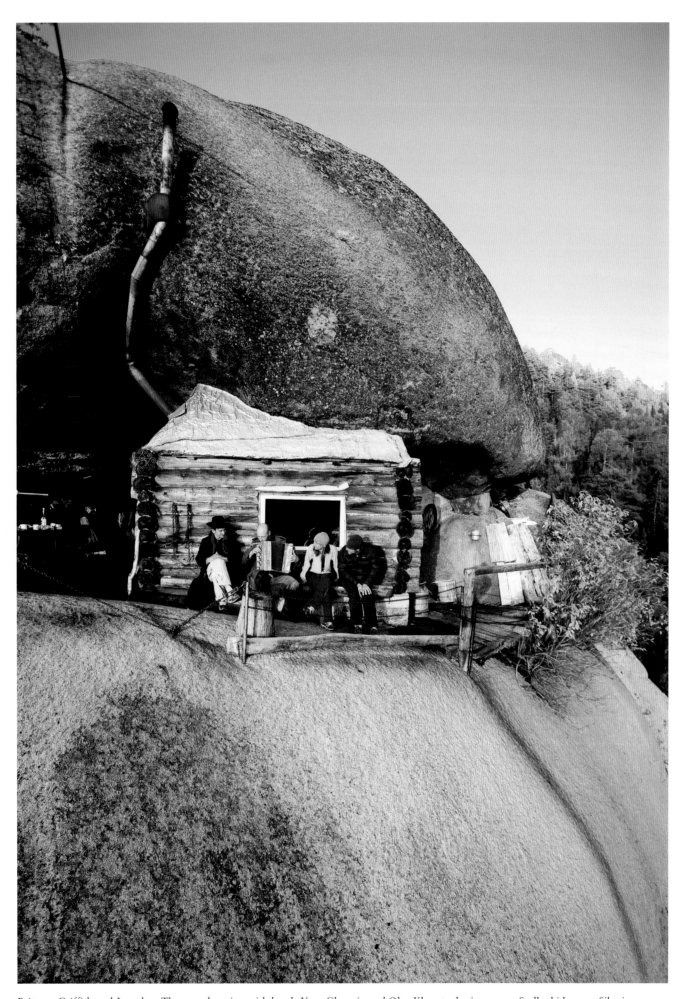

Brittany Griffith and Jonathan Thesenga hanging with locals Yury Glazyrin and Oleg Khvostenko in a secret Stolby hideaway. Siberia.
JOHN BURCHAM. *Early Fall 2009*

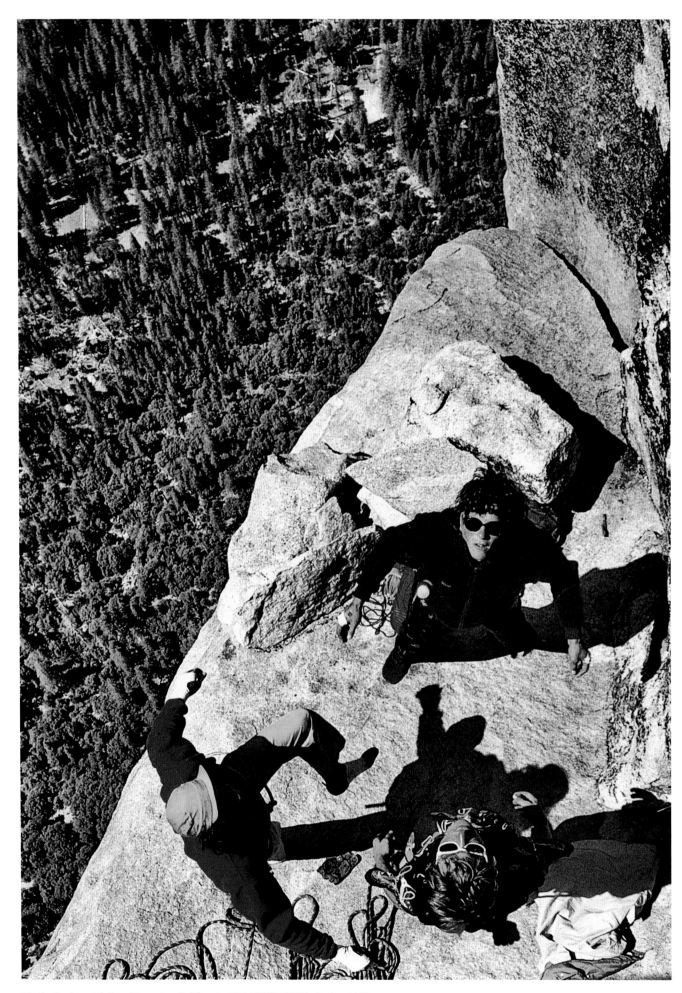

Hacky Sack on El Cap. Yosemite, California. ULI WIESMEIER. *Spring 1989*

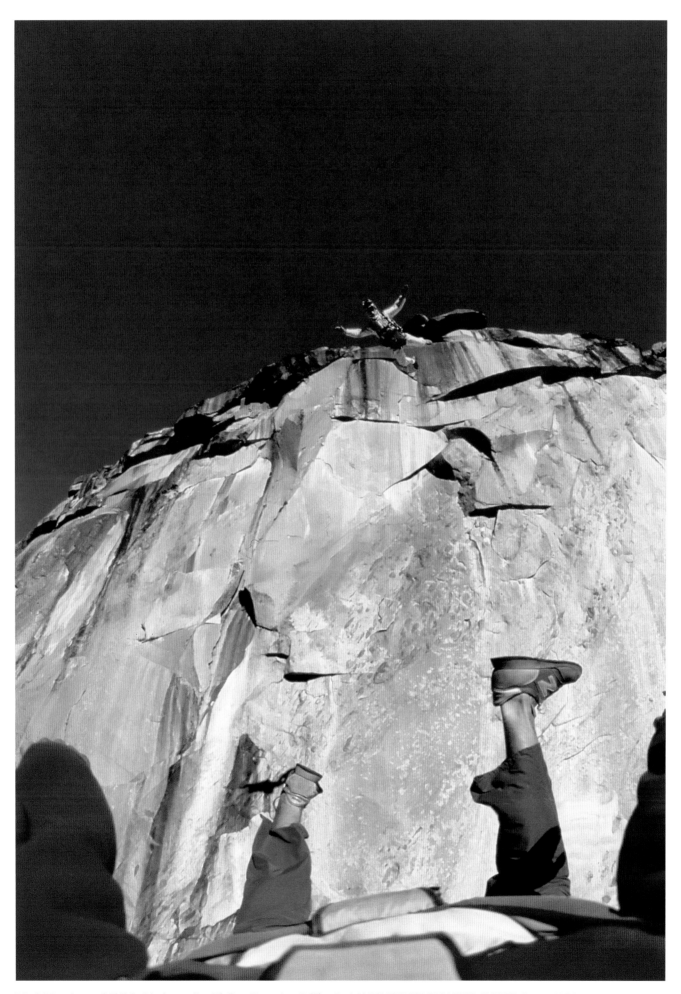

Mark Herndon and Phil Smith descending El Cap. Yosemite, California. MARK HERNDON / PHIL SMITH. *Spring 1988*

Meshing with pasta along the Bruneau River, Idaho. GLENN ALLISON. *Fall 1991*

"It's a mini-van, it's a toaster oven!" "Moonie" Myong Jae demonstrating in Joshua Tree, California. PAUL AMSTUTZ. *Fall 1993*

Choosing a hairstyle at the outdoor barber. Craig Smith in Nairobi, Kenya. JOHN SHERMAN. *Spring 1990*

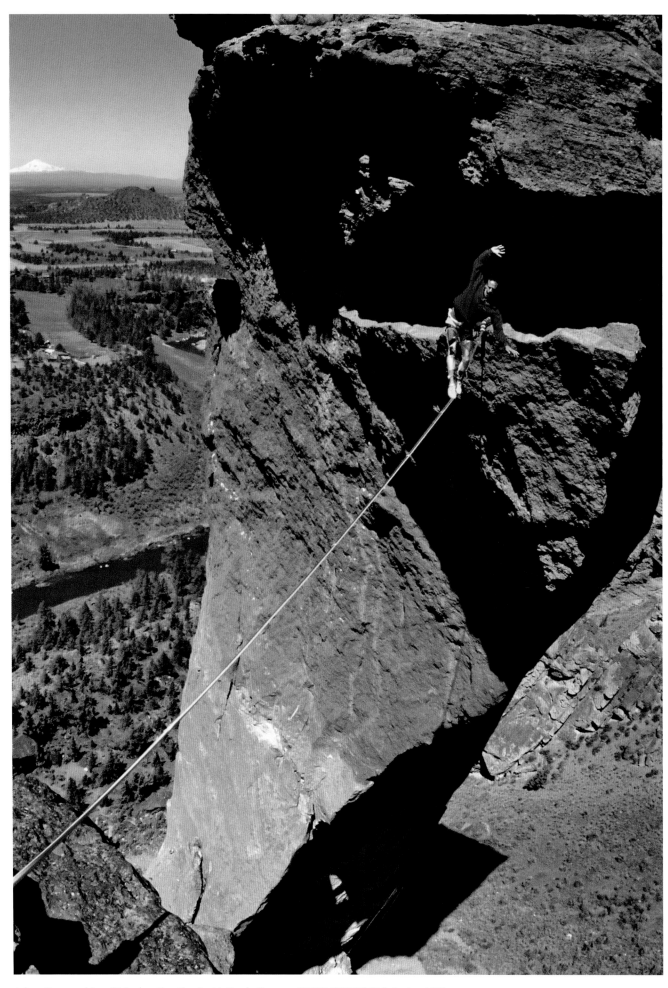

Adam Grosowski on "Monkey Face" at Smith Rock, Oregon. GREG EPPERSON. *Spring 1989*

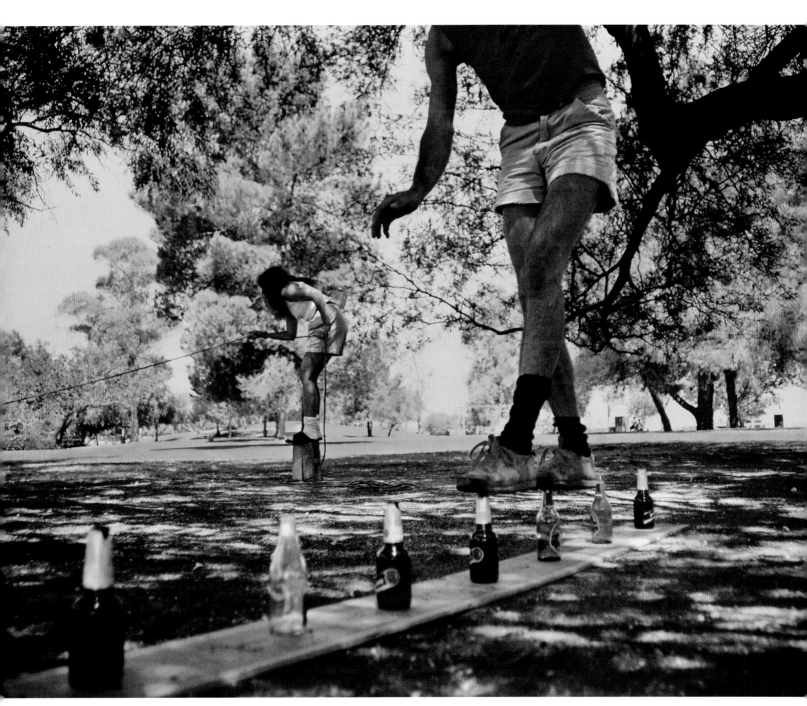

In some sports, expertise is its own reward. PETER NOEBELS. *Spring 1988*

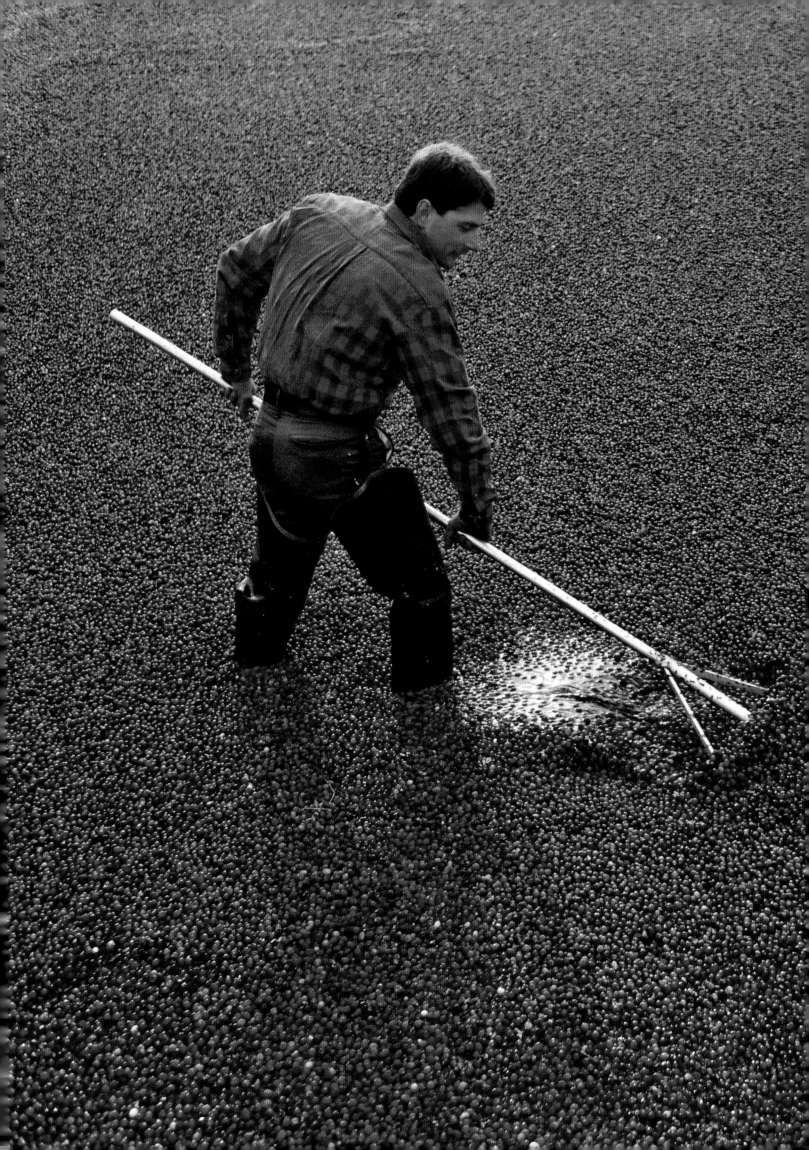

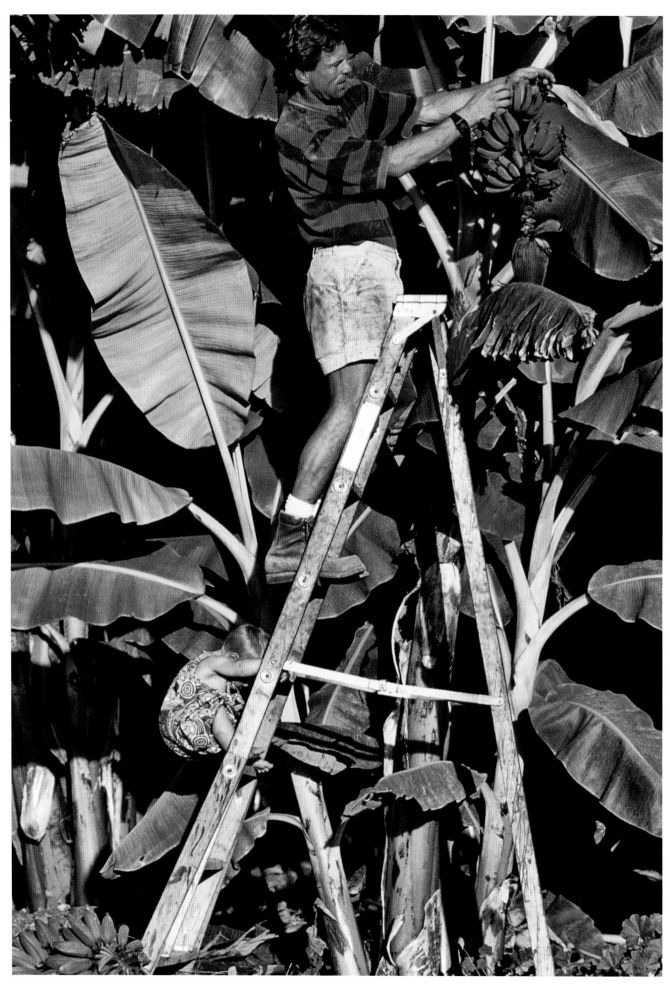

Doug Richardson harvesting with local help Connor Ridgeway, at the Seaside Banana Gardens. La Conchita, California.
RICK RIDGEWAY. *Spring 1990*

Overleaf: Harvesting cranberries in East Wareham, Massachusetts. DAVID BROWNELL. *Fall 1988*

Organic food advocate, Creek Wilson Tompkins. Telluride, Colorado. T. R. YOUNGSTROM. *Fall 1996*

Organic gardener Denise Ackert collects a feast at Jackson Hole, Wyoming. JAMES BURWICK. *Spring 1993*

Chris Clark, Cataract Canyon, Utah. JOHN KELLY. *Spring 1987*

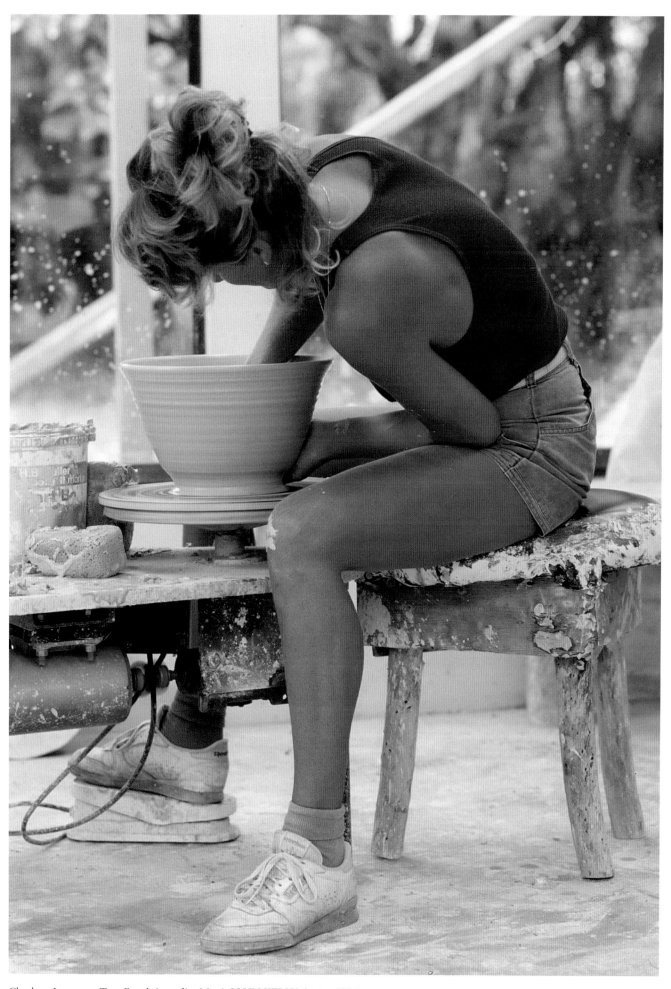

Charlene Larson at Tom Faught's studio. Maui. JOHN KELLY. *Spring 1988*

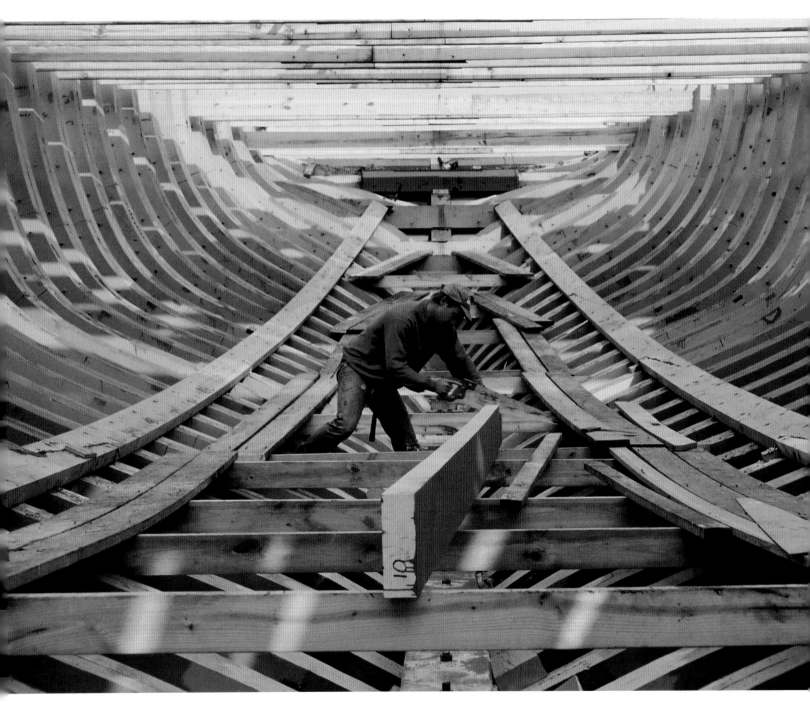

Building the *Pride of Baltimore II*. Shipwright Dan Thorman in Inner Harbor. BILL BAND. *Fall 1998*

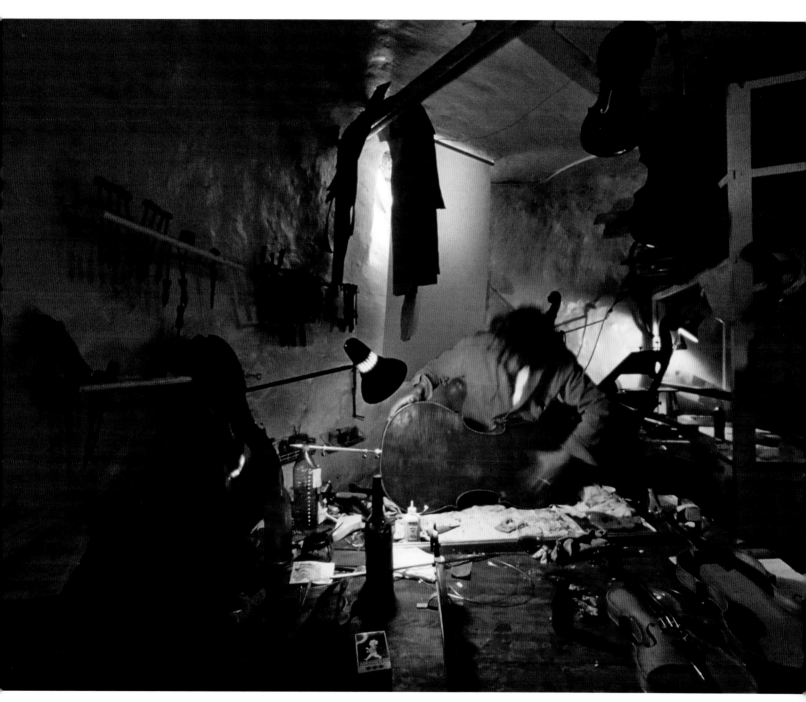

Sylvain Thieurmel repairing an 18th-century Stradivarius cello. FELIX OPPENHEIM. *Fall 1990*

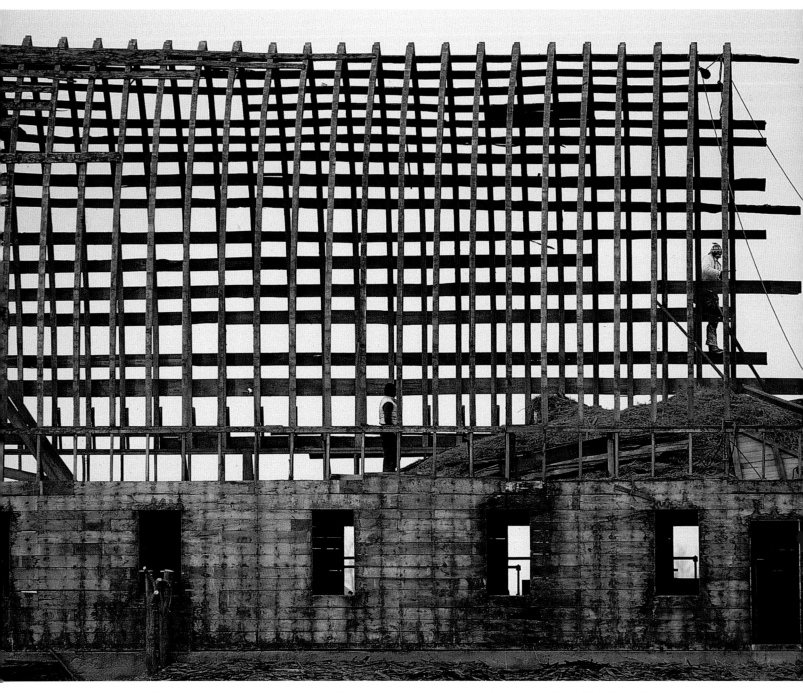

Howard and Pat Jostad recycling white oak from a 70-year-old barn in Belle Plaine, Minnesota. LAYNE KENNEDY. *Winter 1990*

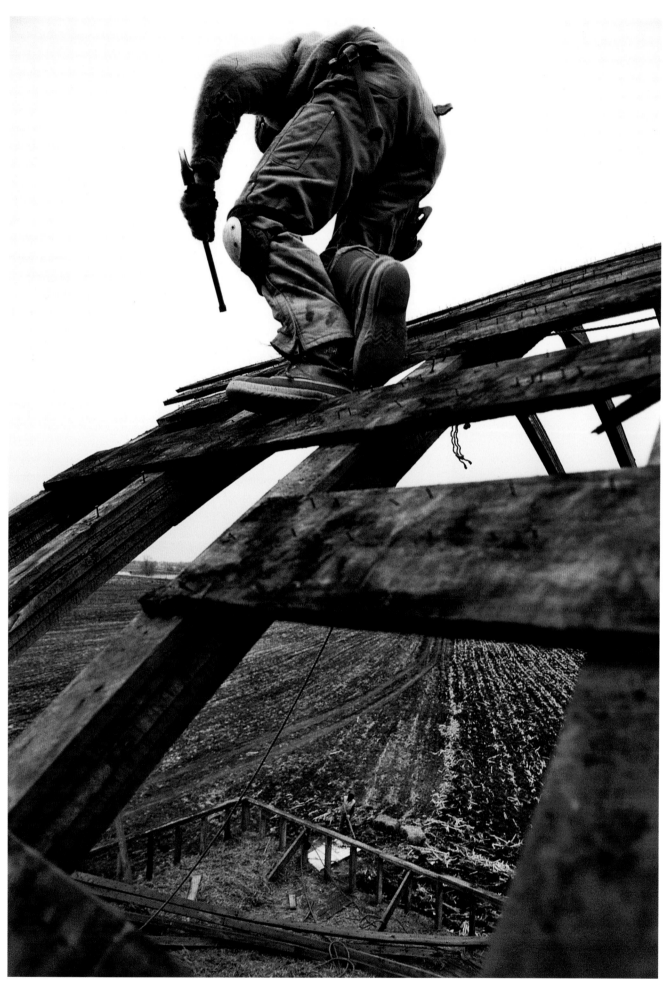

Howard Jostad (see left) salvaging white oak from the roof of a 70-year-old barn in Belle Plaine, Minnesota. LAYNE KENNEDY. *Fall 1994*

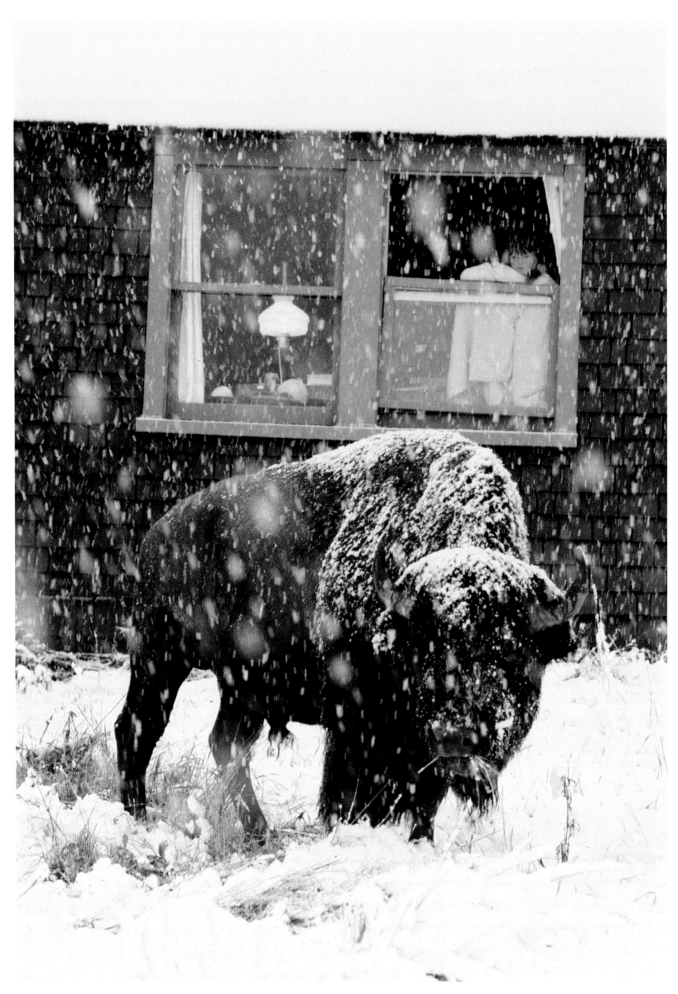

Skye Fuller and a morning visitor at the winter keeper's cabin overlooking the Grand Canyon of the Yellowstone River, Wyoming.
STEVEN FULLER. *Fall 1990*

David nails up the last pair at Dave's Boot Repair. Ketchum, Idaho. DAVID WHEELOCK. *Spring 1993*

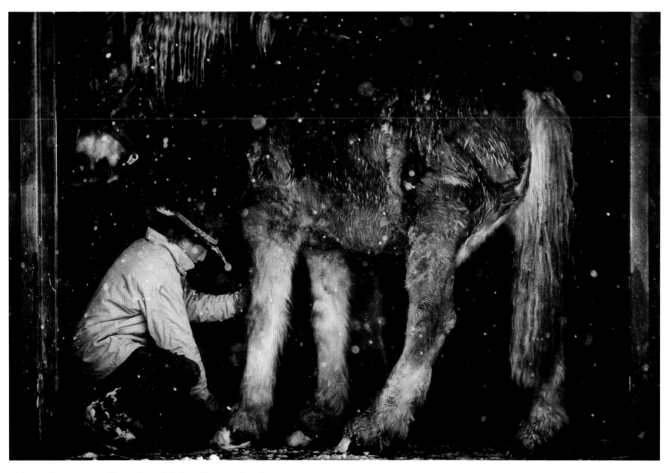

Mike and Amos prep for a day of sled pulling. Colorado. TONY DEMIN. *Winter 2002*

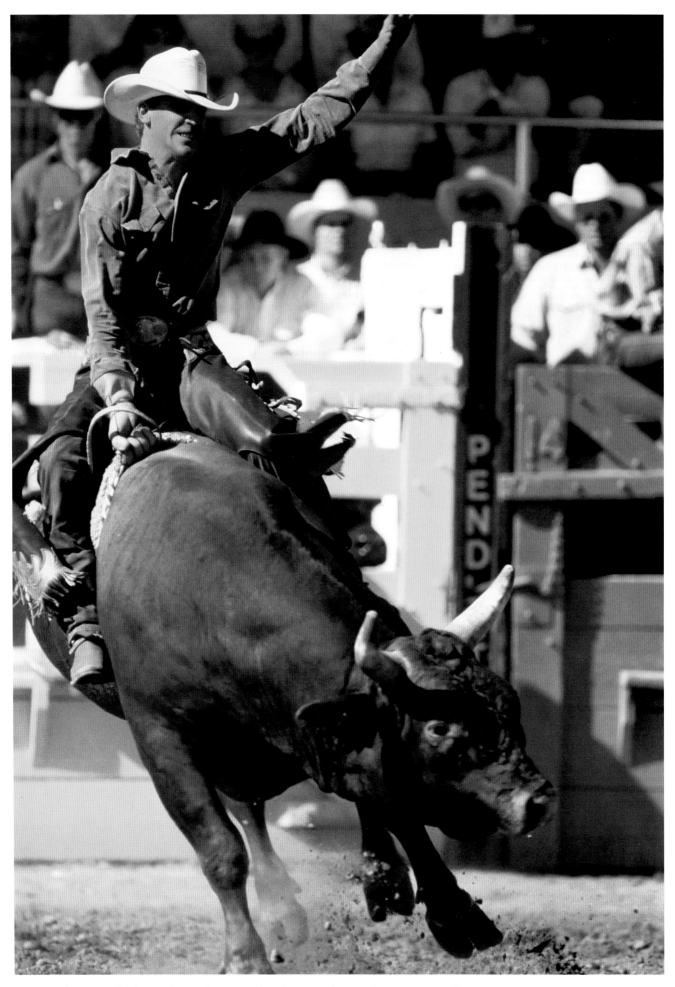

Five seconds to go. Bull riding at the Pendleton Roundup, Oregon. GARY BRETTNACHER. *Fall 1993*

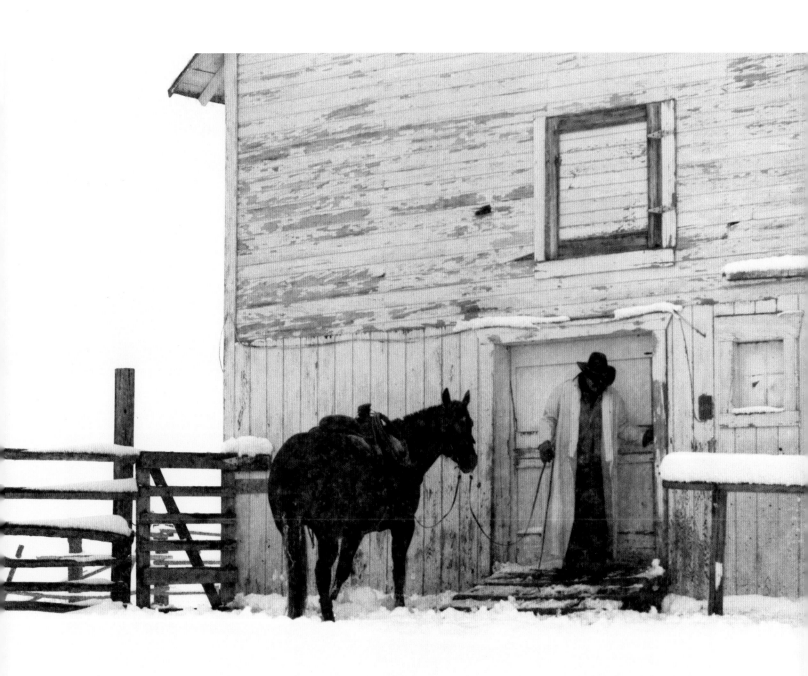

Setting out on the winter rounds at Triple Tree Ranch, 10 miles south of Bozeman, Montana. RICK HARRISON. *Fall 1991*

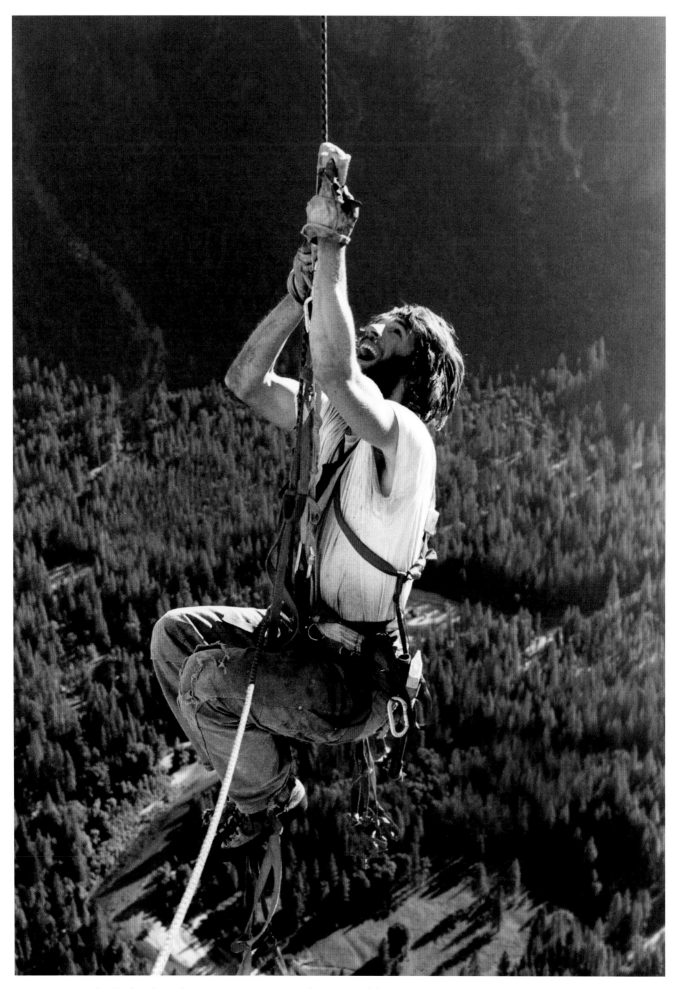

Rusty Reno jugs the 22nd pitch on the New Dawn, Yosemite's El Capitan. California. CHARLES COLE. *Spring 1984*

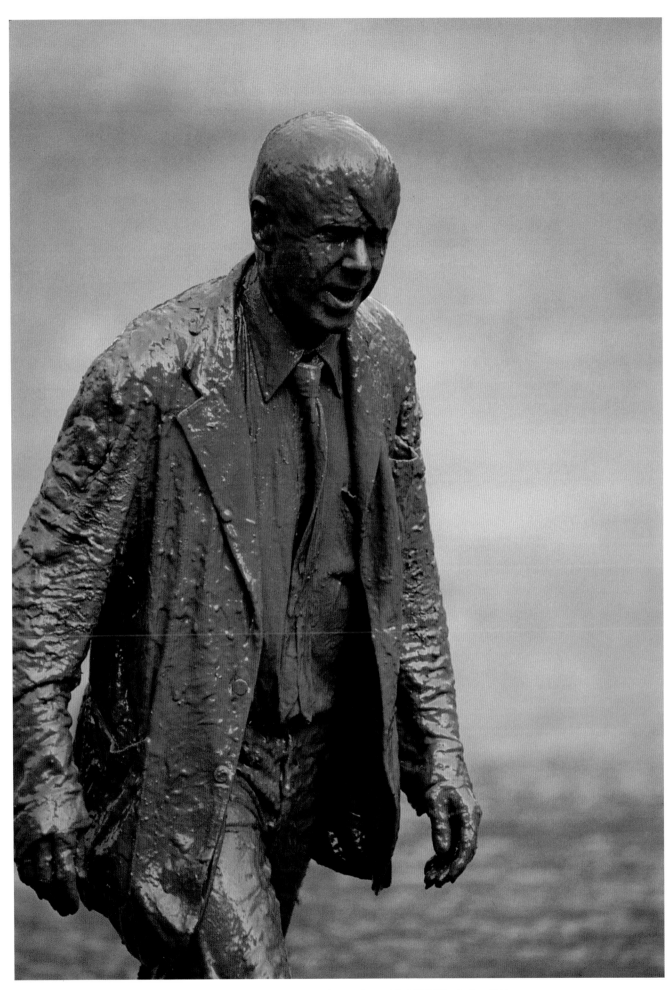

Participant in the Mud Bowl, halftime. North Conway, New Hampshire. DAVID BROWNELL. *Spring 1989*

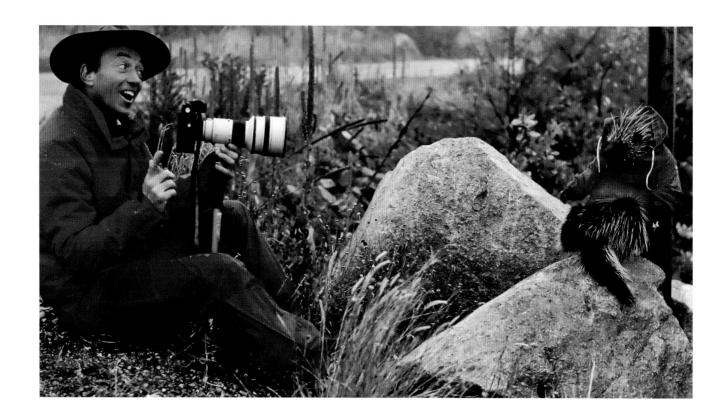

AN INTERVIEW
WITH JOHN RUSSELL

Patagonia has had a longer relationship with John Russell than with any other photographer. We don't add these things up, but it could be that we've run more John Russell photos than anyone else's. As John says in this interview, he was an unlikely choice to join our ensemble cast. A highly successful ski and tennis commercial photographer – as well as nonmountaineer, nonsurfer, nondirtbag – he had in common with his friends here only a love of natural light and a disdain for taking the self too seriously, though he does take his work seriously, unless he's shooting for Patagonia. John got his start as a photographer in Aspen and now lives in Hawai'i. He was gracious enough to consent to an interview while visiting friends in Georgia.

Doing anything interesting on the road?

Yes, I'm here to do a pro bono shoot with Andre Agassi and his wife Steffi Graf. My relationship with Andre goes back to when he was three or four years old and I first took a picture of him looking over his dad's shoulder at a professional tennis tournament in Las Vegas. For the next five years, I shot pictures of him and his family playing tennis and sent them to his dad for free as a favor. A picture of mine taken of Andre at age seven is on the back cover of his autobiography, *Open*. When Andre came blasting onto the tennis scene, I started doing a lot of work with him, hanging out with him at tournaments around the world.

My friendship with Andre is the most wonderful example of relationships being the most important, satisfying, heartening – and, I think, the only – thing I'll take from this world into the next one. It's a relationship that has blessed me

personally and professionally and continues to grow deeper and stronger 37 years after I took those first pictures of him on his dad's shoulder.

When did you first pick up a camera?

In 1966, when I was a student at Dartmouth, the film *Blow-Up* came out, and everybody all of a sudden had to have a camera. So I waited about three years, then picked one up myself. I had a job in the ski industry and shot as the occasion presented itself, slowly building up a little portfolio. When the ski company went bankrupt, I had my camera, some shots of great skiers, and no job. So why not do something new?

My first gig was shooting a pro ski race for $50 a day. I couldn't believe someone would pay me to do what I would do for nothing. My brother was working for Head

Wildlife Fashion Photographer, John Russell with Pete Porcupine. JOHN RUSSELL. *Spring 1986*

Overleaf: Ranch woman Kathy Jakabowski facing off a Scottish Highlander near the Cozy Point Ranch, Colorado.

Ski Company, which had Jean-Claude Killy as their ski ambassador and a new tennis division with Arthur Ashe. So I started out shooting Jean-Claude Killy and Arthur Ashe and worked my way down from there. Along the way down I met Chouinard.

I was at the ski show at Las Vegas – I did lots of covers for ski magazines in addition to work for commercial clients – and went out with a friend, Johnny Ruger, to Red Rocks, as everyone did, to get away from the soulless and sterile Vegas strip. Chouinard and Malinda were there that day, and Johnny introduced us. People go to Red Rocks to boulder or climb, and everyone was kind of reverential around Chouinard – he was a legend already for his gear and *Climbing Ice*. But because I wasn't a climber, I had no idea that he was so special. I had my camera out and asked him to climb this crack; he did that fine. Then in my own manic way I asked him to lay belly down on a flat rock, which he agreed to. Then I lay down, with my foot against his head and had Johnny shoot it from above, so it looks like I'm using Chouinard's head as a foothold on a vertical rock face. Why he allowed this I have no idea. I weighed about 240 then and was wearing red-and-white-striped nylon running shorts – not a Patagonia catalog shot. He must have thought I was crazy. When I found out more about Patagonia and saw the catalogs, I thought *they* were all crazy. I'm not a Patagoniac. If I couldn't get the shot out of the back of a Wagoneer, I wouldn't bother.

I'd run into him from time to time, and we would talk and got a chance to form our opinions about each other. I'm sure Chouinard considered me some kind of neo-Nazi right-wing Christian evangelist, and I thought of him as a high-alpine nihilist. But things have changed for both of us.

Over the years, I got to know him and the family better, as well as others at Patagonia. Early on, I was invited to an all-company meeting in Ventura and stayed with the Ridgeways – Rick and Jennifer, her mother, and the kids. A couple of years later, when I was staying with Killy in Geneva, I met up with Chouinard and Malinda in Chamonix – they were opening their first European store. Later, I traveled with him on the same flight to Bali, where I was headed on vacation with my family. He was there with Fletcher and Mickey Muñoz, staying in a shithole in Kuta – that's just like him, he's so cheap. He and his crew came up and stayed a couple of nights in this beautiful house we had in Ubud. We tried to give them a taste of the local culture.

The greatest gift Patagonia and the Chouinards have given me has been introductions to some amazing people who became good friends. Besides the old-timers at Patagonia, I got to know Rell Sunn through the Chouinards, and Andy Neumann, Patagonia's architect. Andy designed my house in Hawai'i, the one I live in now, that's cantilevered over a cliff and a waterfall. All these people have a wonderful thing in common: They're all the best at what they do but share an unselfconscious humility.

Do you remember your first photo for Patagonia?

No, I don't, though it may be have been the shot of Ruthie Hamilton running with Jenni aboard a baby jogger. Anyway, the first couple of submissions seemed easy to get published. Then they'd ask me to do shots and wouldn't use them. I'd get halfway indignant about it. I thought they were throwing me a curve ball. Everyone else I worked for on assignment with an agreed-upon fee. Patagonia, you sent in a shot, and they might use it or they might not.

And they had different standards. For me, photography is all about two things, light and relationships. And Patagonia didn't seem to care about beautiful light. What worked for others – covers for *Ski* and *World Tennis*, print ads for Salomon, Sport Obermeyer, or the Aspen Ski Company – front lit, bright, bold, was too pretty for Patagonia. They published some of my photos in classically beautiful light – Lynn Hill climbing in the Baths of Virgin Gorda or Mike Field diving off a Polynesian canoe, both catalog covers. But often Jennifer passed on what I thought were killer images. I was jealous of all those shots Ridgeway got in, but of course he was sleeping with the art director. And he had to work for those shots, go into the jungle and get covered with leeches.

I was a control freak working for other companies – you have to be, dealing with art directors, clients, helicopters, and models. I liked shooting for Patagonia because I could shoot when, what, and where I wanted. The best shots came when things weren't in control.

One of those shots made it onto a Patagonia hangtag. My daughter Kate was about 10 then. I had her on a dogsled, reins in hand, with the two front dogs snarling at each other. We told Kate to just jump off when they got going, just roll over in the snow – the handlers will take care of the rest. Well, it wasn't so easy for Kate, just jumping off and rolling in the snow. But good thing she did, because the dogs got away from the handlers – we watched the sled disappear like a ghost ship. But half an hour later, the dogs with the driverless sled circled back and lay down panting.

How'd you get the porcupine shot?

I had an old sheepdog who'd been nailed a few times too many by the same porcupine. So I borrowed a shotgun – I hadn't fired a gun for years and hardly knew what to do with it. I sat in my driveway in Aspen after dark with the headlights on, waiting; finally, he crossed the driveway, into the path of the lights. Now porcupines don't move fast, but neither do I. By the time I fired, he'd moved out of the light. I didn't even aim, just fired once from the hip – a shot in the dark – and went back in the house, not knowing if I'd hit it. I checked the next morning, and sure enough, I'd nailed the porcupine.

A photographer friend of mine from New Zealand, who was getting married later that day, was up at the house. I somehow got the porcupine dressed in a red Patagonia kid's rain suit, set it up on a rock, and took out a long lens – and my

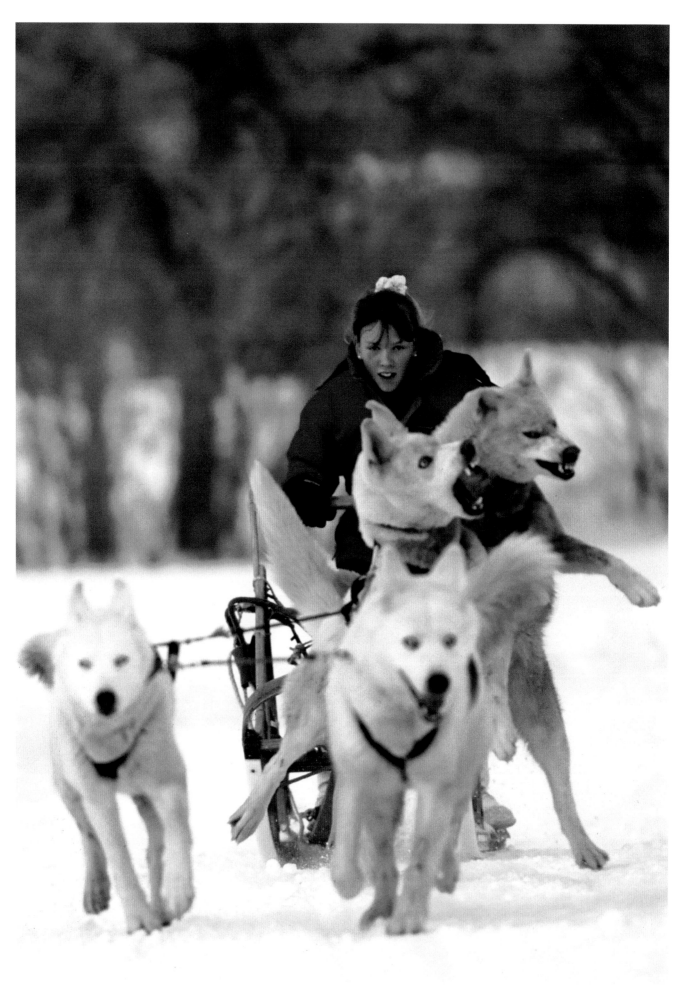

Some attitude adjustment may be necessary. Driver Kate Russell in the White River National Forest, Colorado.
JOHN RUSSELL. *Fall 1989*

friend snapped a few frames. I sent in the shot to Patagonia with a caption describing myself as a wildlife fashion photographer. It was a total goof. I was just pimping Jennifer and the crew. Then I got a call from Chouinard, growling, "Hey, Russell. I love that shot. Funny, I have friends in Wyoming who have a pet porcupine." So I had to confess. They still liked the shot, so it made it in.

Whom among photographers do you feel kinship?

The ones who come to mind are outside my field – I was influenced by classic photographers who really changed the way I see. Avedon, Cartier-Bresson, Ernst Haas. I love to keep things simple. I'd often do national ads shooting by myself with one skier – as opposed to hauling along a production crew.

The camera never blinks, but you can tilt it. People think what's printed from a camera is real. But as Malcolm Muggeridge – whom I was privileged to spend some wonderful days with – warned, the most dangerous invention of the 20th century might be celluloid. That's "film" for all the predigital dudes. A photograph can be altered and retouched and presented as reality, which it is not. Perspective changes everything. Tilt your camera, and a bunny slope at Buttermilk becomes Corbet's Couloir. An OC1 on a small wave becomes dramatically bigger when shot from a helicopter.

Why did you move from Aspen to Hawai'i?

There were a lot of photographers in Aspen – the National Geographic crowd and many commercial ski photographers. I was always comparing, competing, criticizing rather than simply being comfortable with who I was and the work I was doing. And I could do ski magazine covers with my eyes shut. Coming to Hawai'i for the first time opened my eyes to new colors – it was warm. Having grown up in Indiana as a competitive swimmer I'd always loved the water and fantasized about living near the ocean. So it was like coming home to my fantasy island.

Did you become a surfer?

Part of the deal with Andy Neumann when he designed my house was that he'd give me surf lessons. But no. I'd always been around the best skiers and tennis players in the world – and I loved capturing great images of them doing what few people can do. I was blessed to have access to those great athletes and to be able to do what I do well. What I do best is collaborate in the creative process, which is what I've enjoyed doing with my friends at Patagonia.

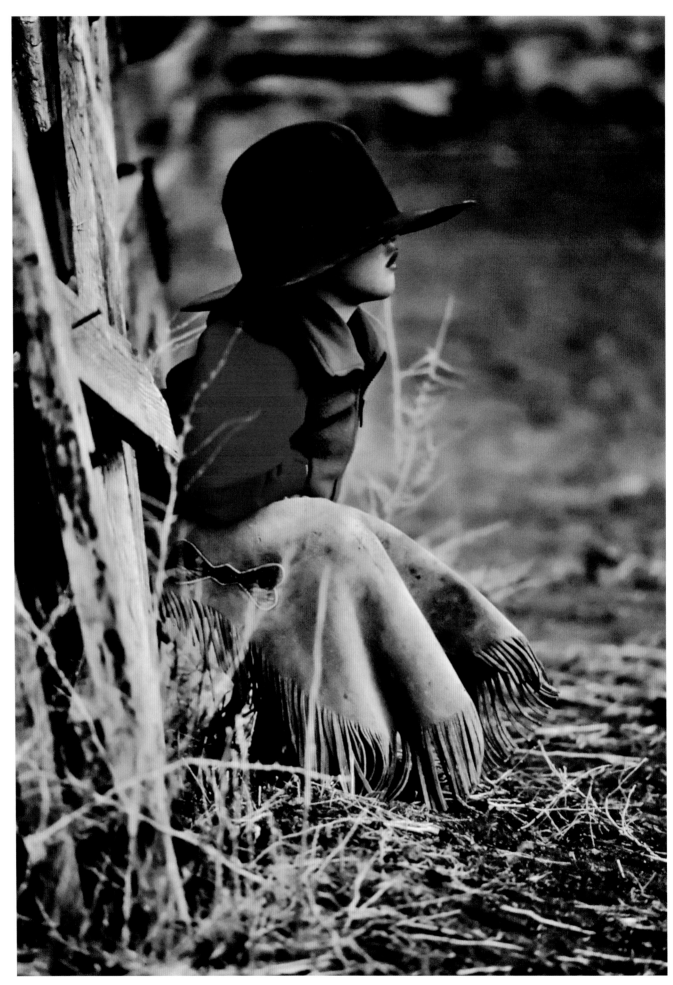

Branding season just before a rain. Zackary Dufurrena on the Paiute Meadows Ranch, Nevada. LINDA DUFURRENA. *Spring 1988*

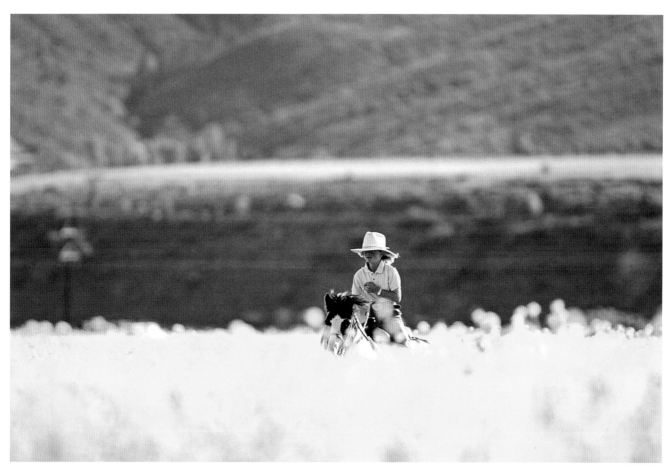

Jesse Lyle through the mustard. Cozy Point Ranch, Colorado. JOHN RUSSELL. *Spring 1991*

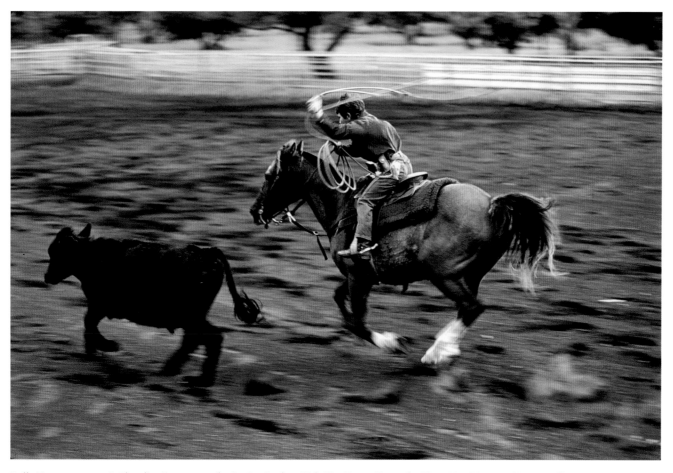

Bully Fergstrom, age 9, "heading" a steer at the Junior Rodeo, Hale Kea Farm. Kamuela, Hawai'i. JOHN RUSSELL. *Fall 1992*

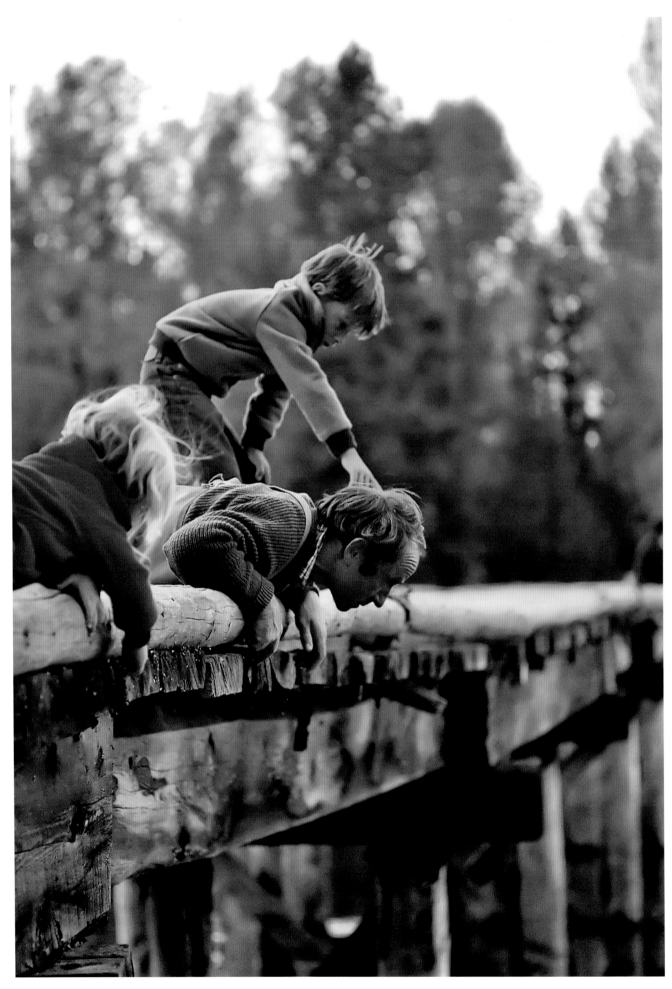

Yvon, Fletcher, and Claire Chouinard spying on trout. Snake River, Wyoming. MALINDA CHOUINARD. *Spring 1984*

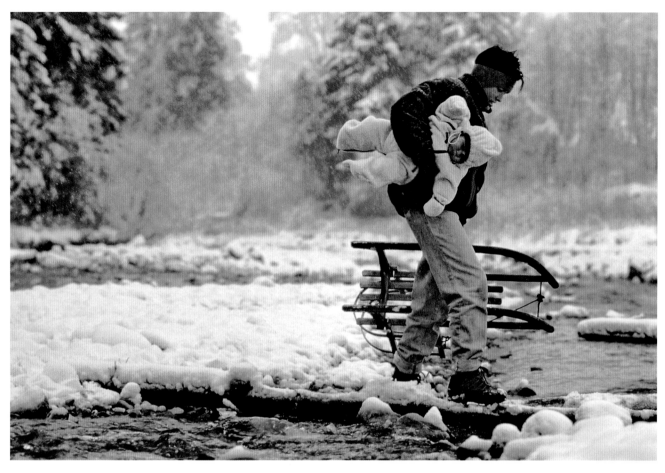

Baby Felix with his mom, Marion. Off to go sledding near Garmisch, Germany. ULI WIESMEIER. *Fall 1988*

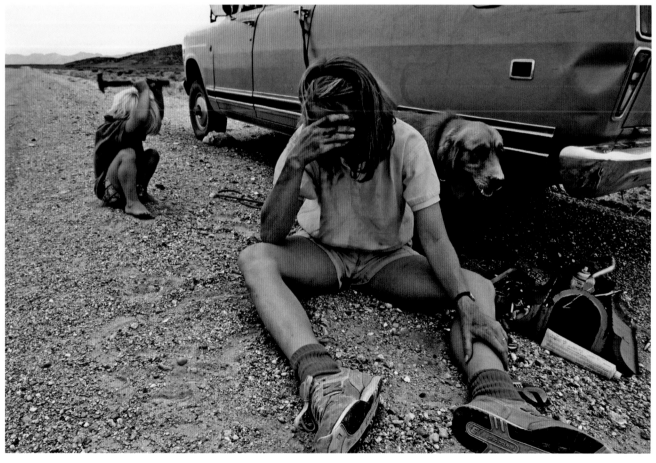

The last straw. Meredith Wiltsie wiring the damn muffler en route to the Ruby Mountains, Nevada. GORDON WILTSIE. *Spring 1993*

Kitchen cuts by Cara. Cara Bednar and Jeremiah in Andover, New Hampshire. DAVID BROWNELL. *Fall 1989*

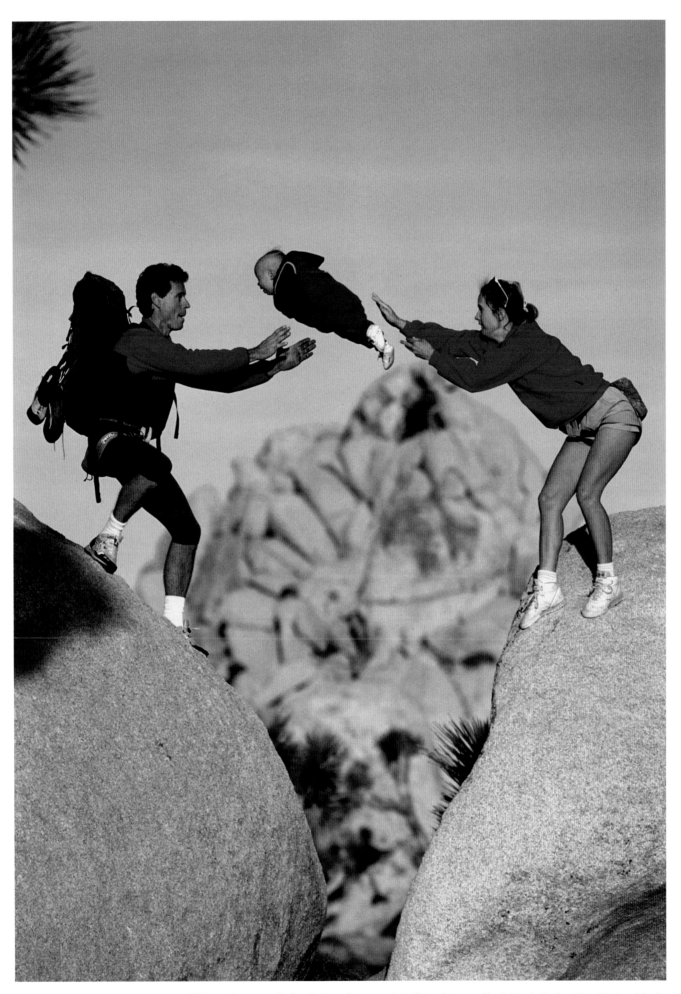

Come to Papa. Jordan Leads, lifting off from Sherry Leads, heads for safe reentry in Jeff Leads' arms. Turtle Rock, Joshua Tree National Park, California. GREG EPPERSON. *Spring 1995*

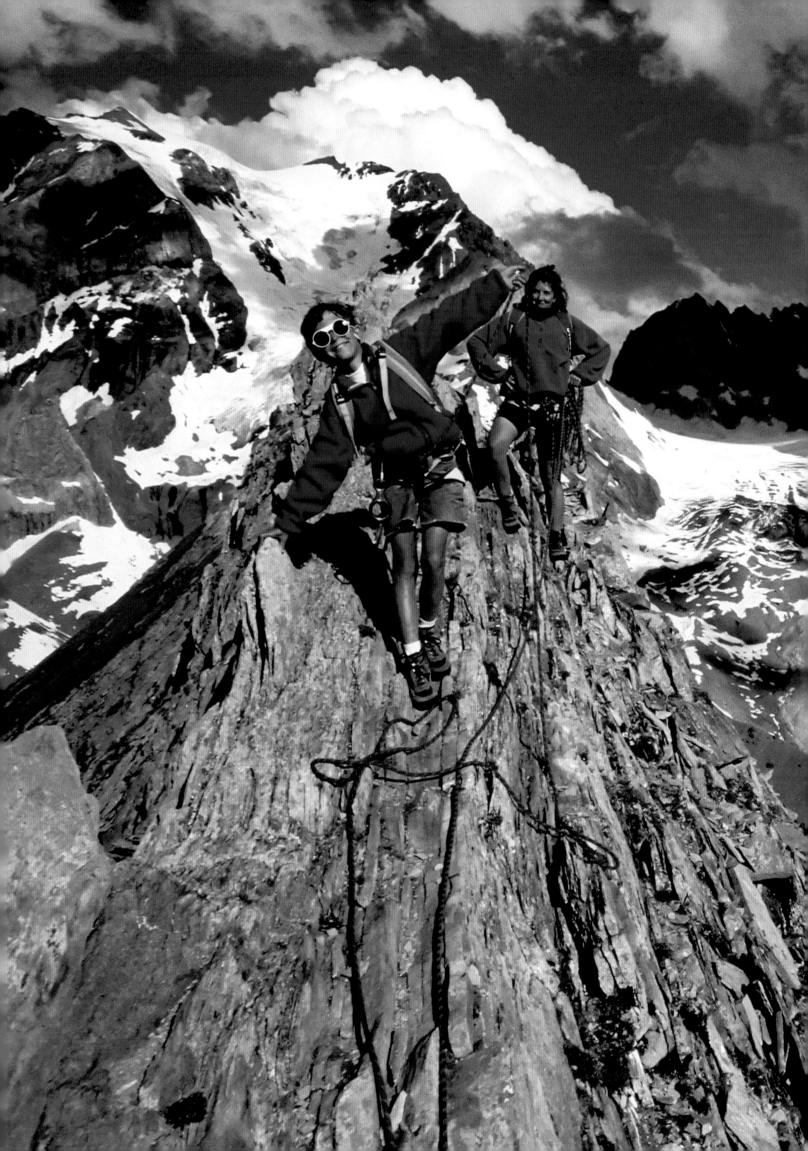

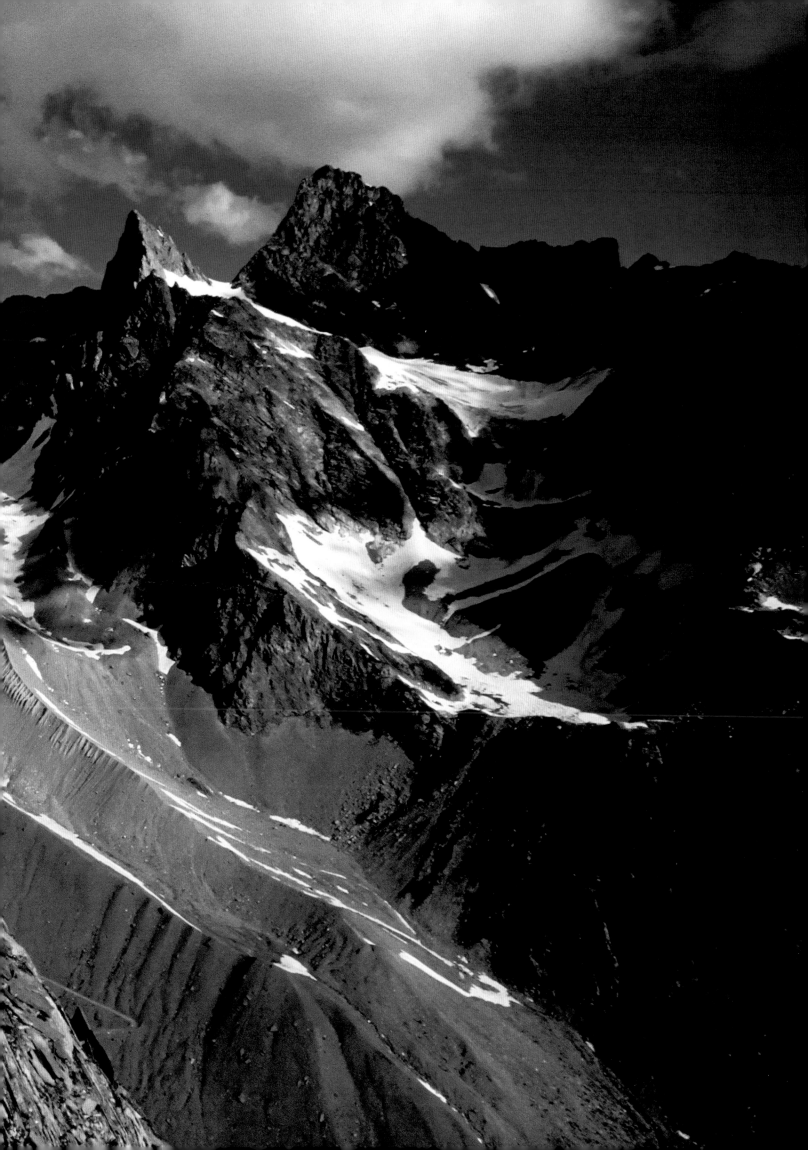

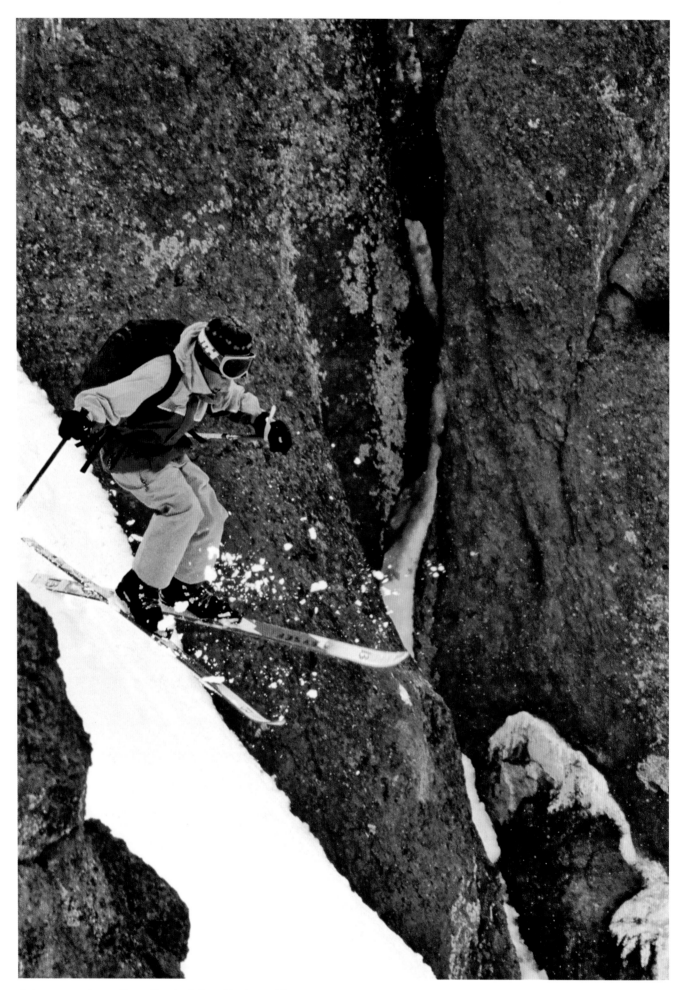

Only one way down. Chase Cleveland slotted in the Boulder Mountains, Idaho. DAVID WHEELOCK. *Fall 1997*

Overleaf: Givois kids Veronique, age 13, and Bertrand, age 10, on the summit of L'Aiguille de la Vanoise. Savoie, France. DIDIER GIVOIS. *Spring 1992*

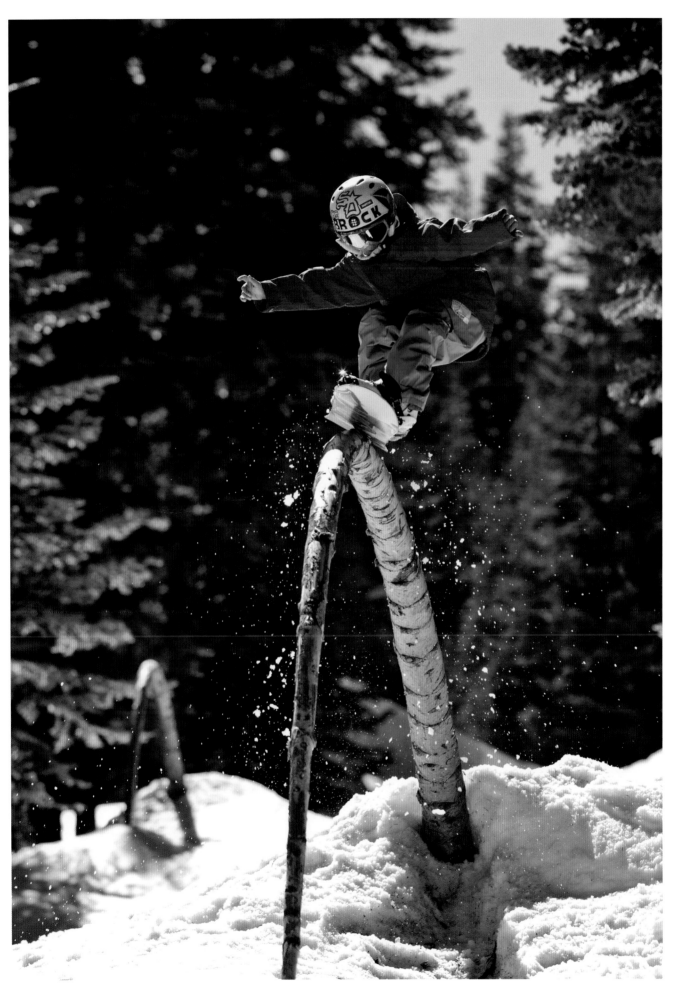

A tree falls in the woods and somebody shreds it. Northern California. JEFF CURTES. *Fall 2010*

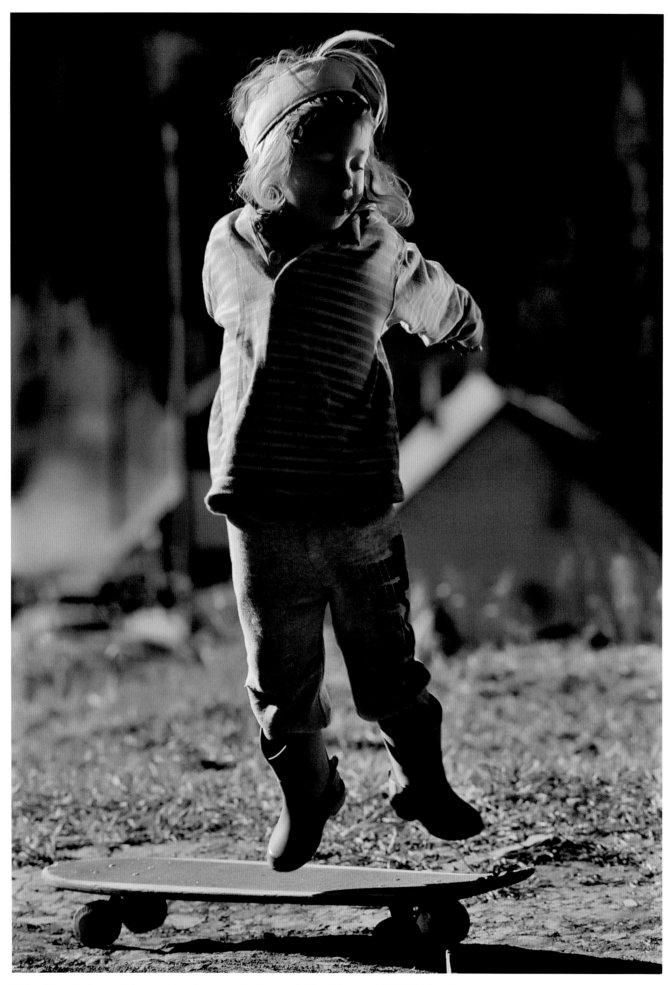

Walter Max Kvale, age 3½ , practicing skateboard levitation, Ophir, Colorado. ACE KVALE. *Fall 1992*

Free amusement: Guri Bigham, age 1. Telluride, Colorado. GARY BIGHAM. *Fall 1993*

Mud fishing near Cottonwood Creek, Wyoming. YVON CHOUINARD. *Fall 1990*

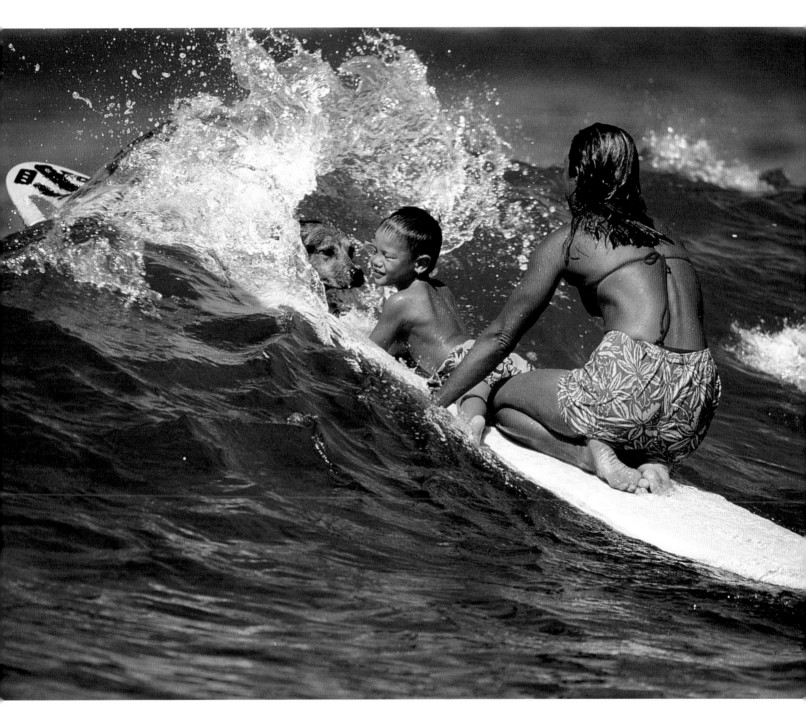

Interspecies with canine pro, Lokahi (Harmony), Pao Kalani (Bridge to Heaven), age 5, and Kapolioka'ehukai (Heart of the Sea, aka Rell Sunn).
Makaha Beach, Hawai'i. JOHN RUSSELL. *Spring 1995*

Andrew Jackson faces off Toby Turtle. JOHN RUSSELL. *Spring 1998*

"I wonder if I should eat it?" RICK RIDGEWAY. *Spring 1991*

Ian Nichols in Rwanda with a three-horned chameleon. MICHAEL NICHOLS. *Spring 1989*

Scott Swart, fresh out of the burn pile at the family's Christmas tree farm. Alpenglow Farm, New Hampshire.
PETE SWART. *Spring 1991*

Alison Blehert-Koehn, age 9, high-steps a boulder problem in Hidden Valley. Joshua Tree National Park, California. DEBBIE BLEHERT-KOEHN. *Fall 1995*

Felix Wiesmeier's first experience of "sour." ULI WIESMEIER. *Fall 1990*

Menehune, Jason Shibata, against the Makaha backwash. West Shore, Oʻahu. JIM RUSSI. *Spring 1996*

Letting go. Oliver Whitcomb at Havasu Falls. Grand Canyon, Arizona. DAVID BROWNELL. *Spring 1992*

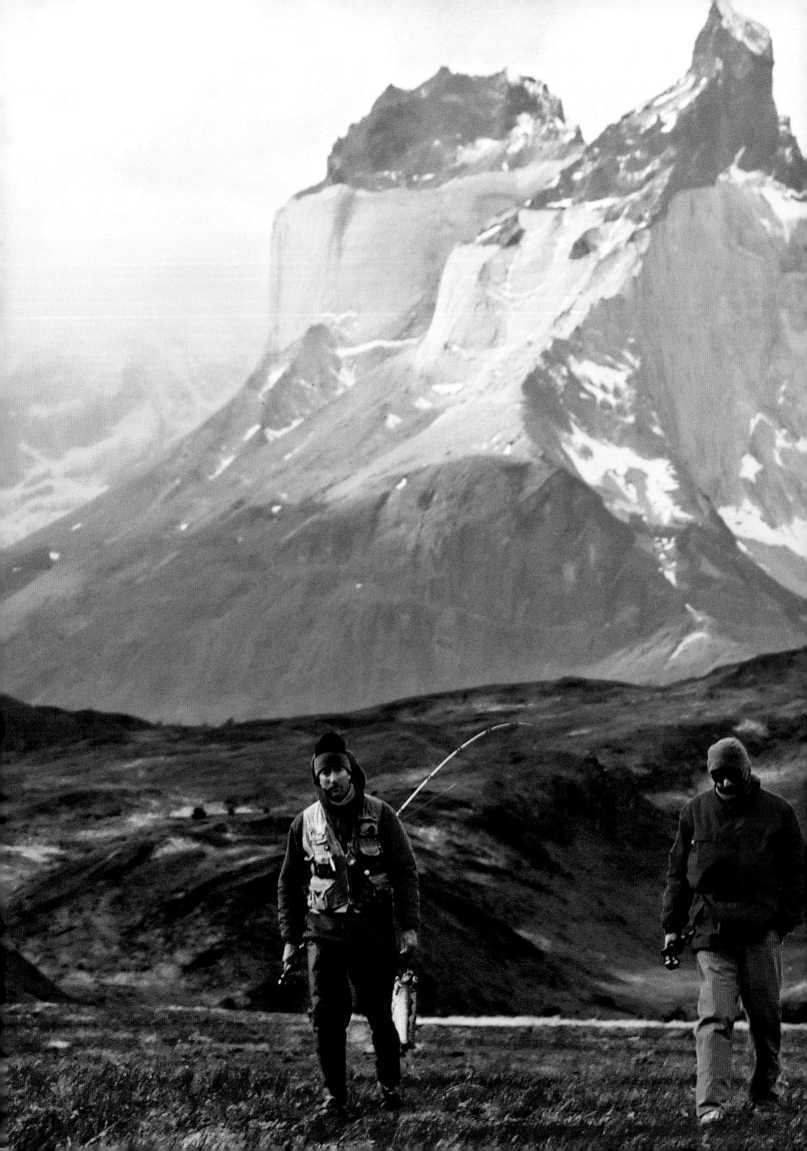

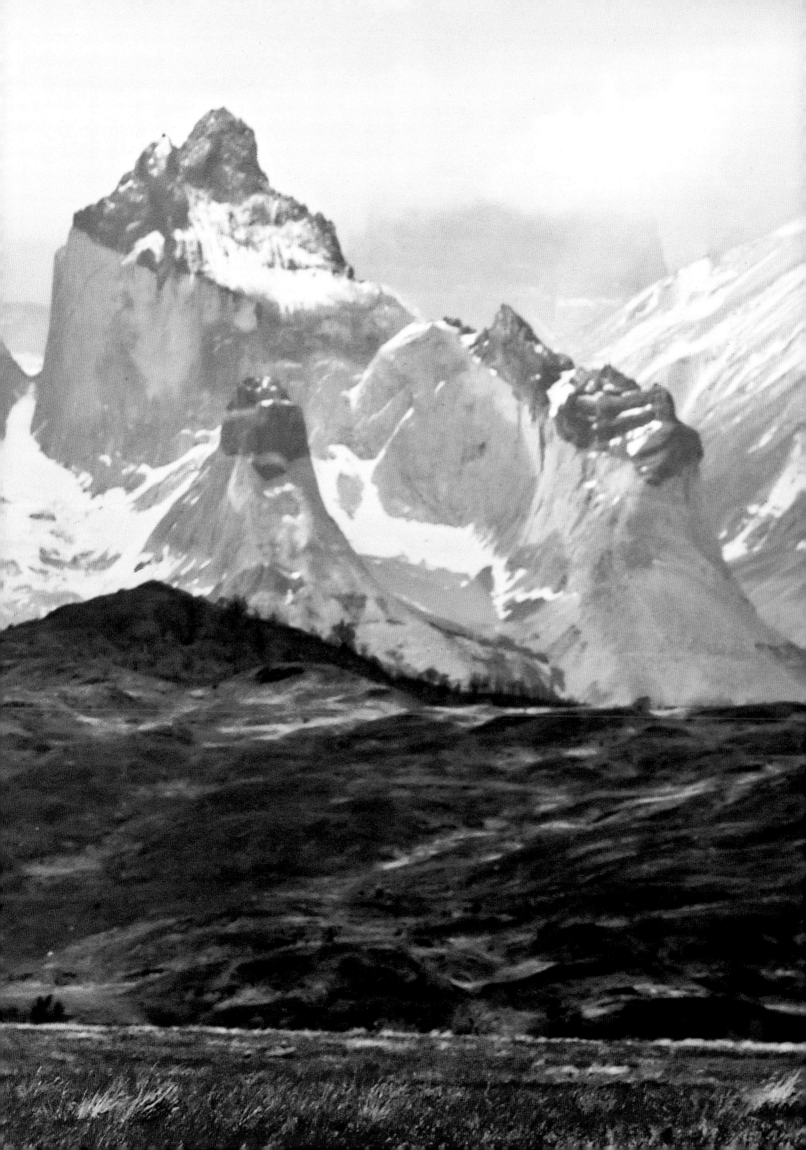

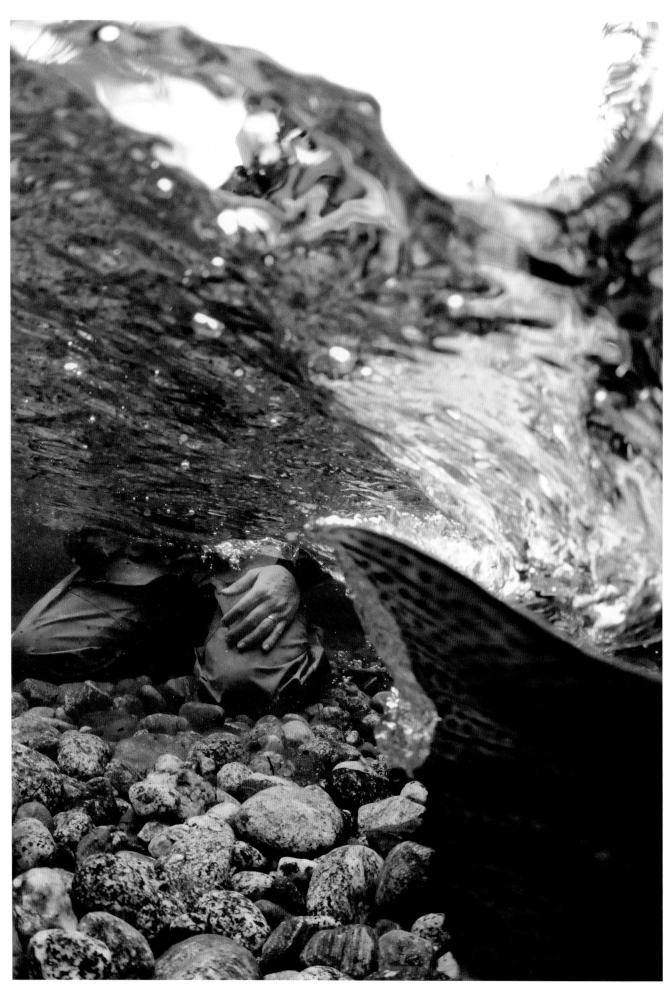

All those miles hiking through devil's club become a distant memory. Releasing a wild steelhead salmon hen in the Eagle River along Alaska's rugged coastline. TIM PASK. *Spring 2010*

Overleaf: Bringing home the trout. Allan Bard and Allan Pietrasanta in Torres del Paine, Chile. CASEY SHEAHAN. *Winter 1990*

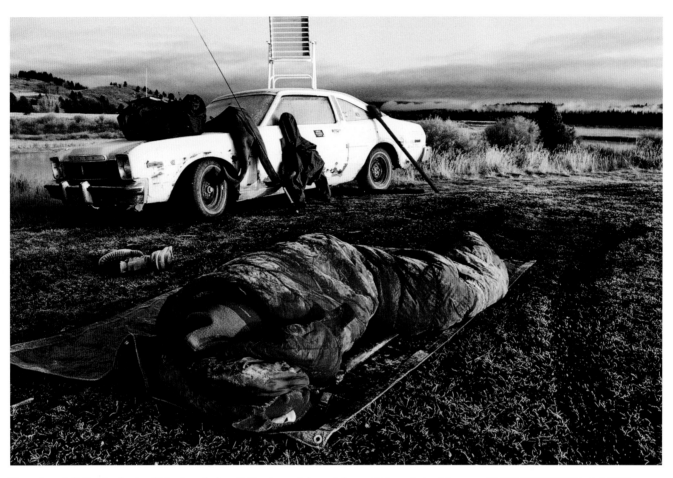

Trout bum Jeff Currier fends off the frost before fishing for gulping rainbows. Hebgen Lake, Montana. ANDY ANDERSON. *Fall 1995*

Dave and Tim Trevithick look no further than their car's bumper when choosing a fly for the Encampment River, Colorado.
RYAN BONNEAU. *Spring 2010*

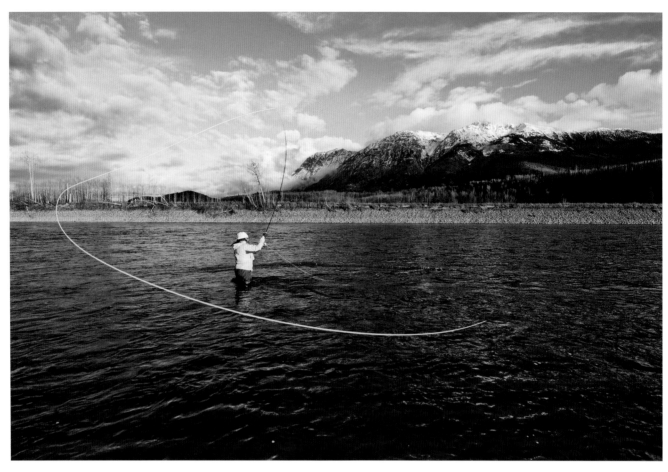

Sonya Pask builds D-loops and bombs casts with the faith that steelhead are not only in the river but will grab her fly.
Skeena River, British Columbia. TIM PASK. *Spring 2010*

Fred Mugler enjoying Rocky Mountain sushi and holding the fort in the cultural hub of the Teton. Driggs, Idaho.
BRIAN O'KEEFE. *Fall 1991*

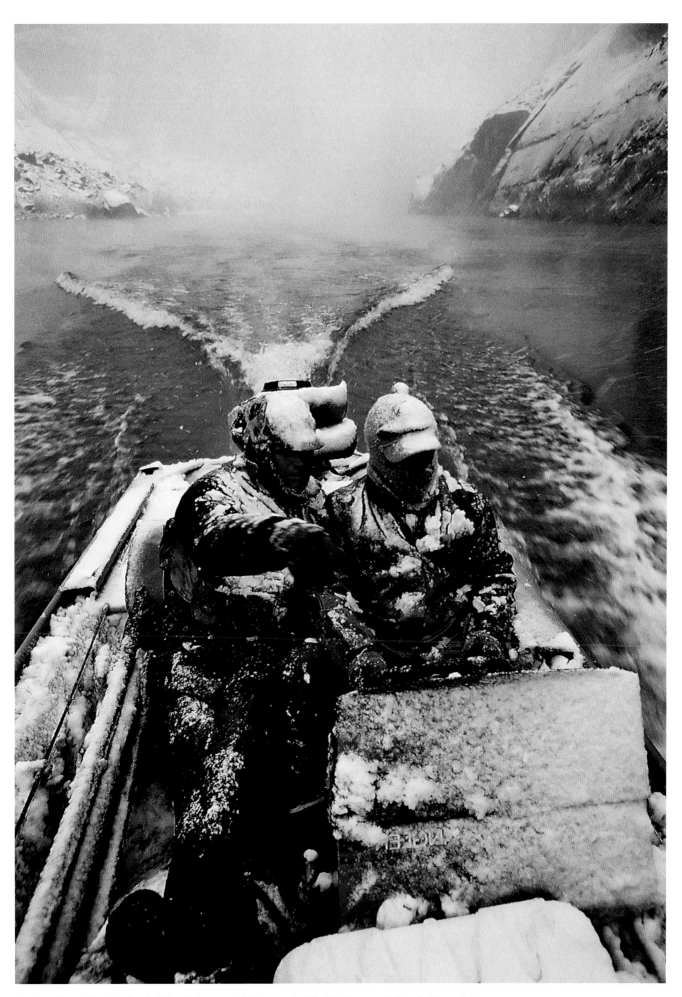

Joe Bressler and Bob Butler dodging icebergs, mid-February in Marble Canyon. Colorado River, Arizona.
TOM MONTGOMERY. *Spring 2001*

Ali Howard started her historic swim in these alpine meadows of British Columbia's Sacred Headwaters, where the Skeena River begins its 380-mile journey to the Pacific Ocean. BRIAN HUNTINGTON. *Spring 2010*

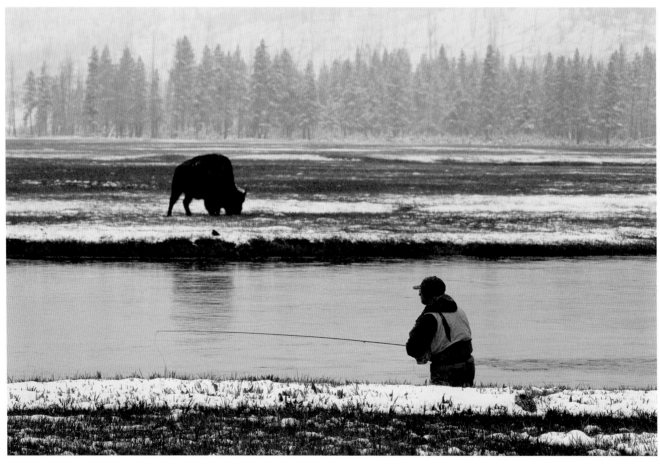

Doug Daufel starts to feel some fishing pressure during a late spring snowstorm on the Firehole River, Wyoming. JOHN JURACEK. *Late Fall 2005*

Tom Sawyer, aka Scott Cole, and Huck Finn, aka Nick Yvernault, cross the mighty Mississip', aka Secret Fishin' Spot. Wind River Range, Wyoming. ANGUS THUERMER. *Spring 2008*

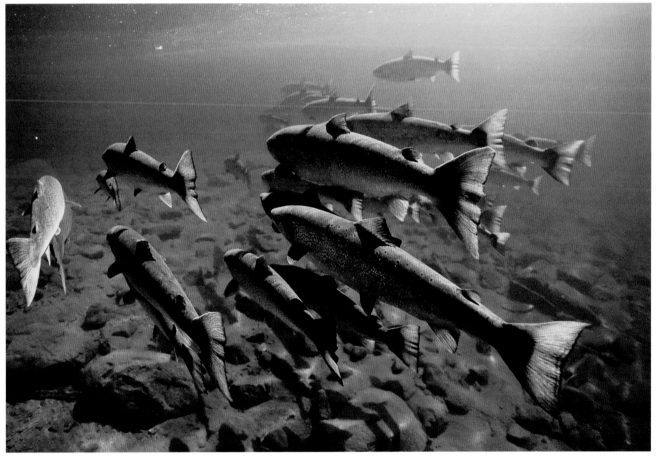

Atlantic salmon in the Dartmouth River, Gaspé, Quebec. GILBERT VAN RYCKEVORSEL. *Fall 1993*

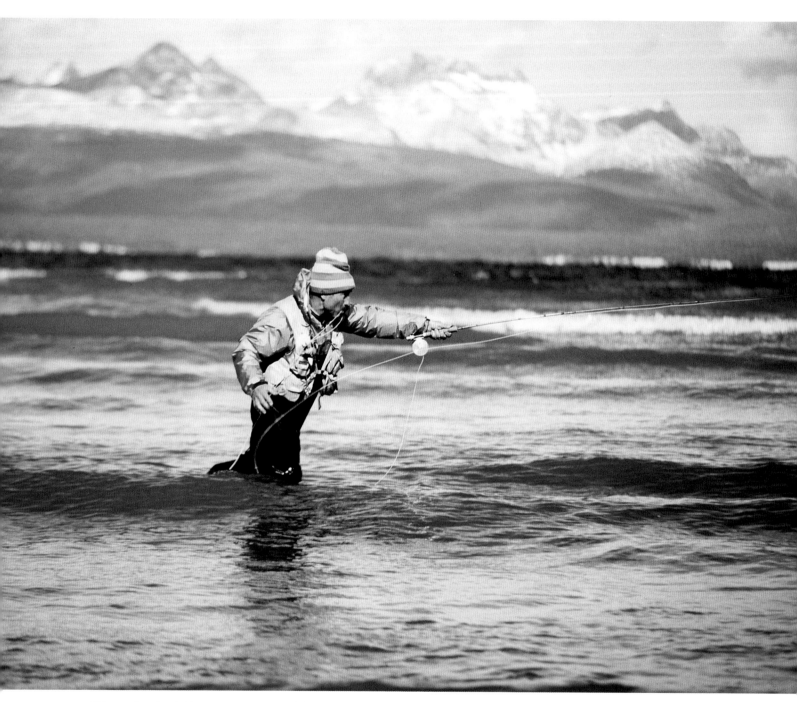

Who needs a dentist? Lago Fagnaro, Tierra del Fuego. DOUG TOMPKINS. *Fall 1987*

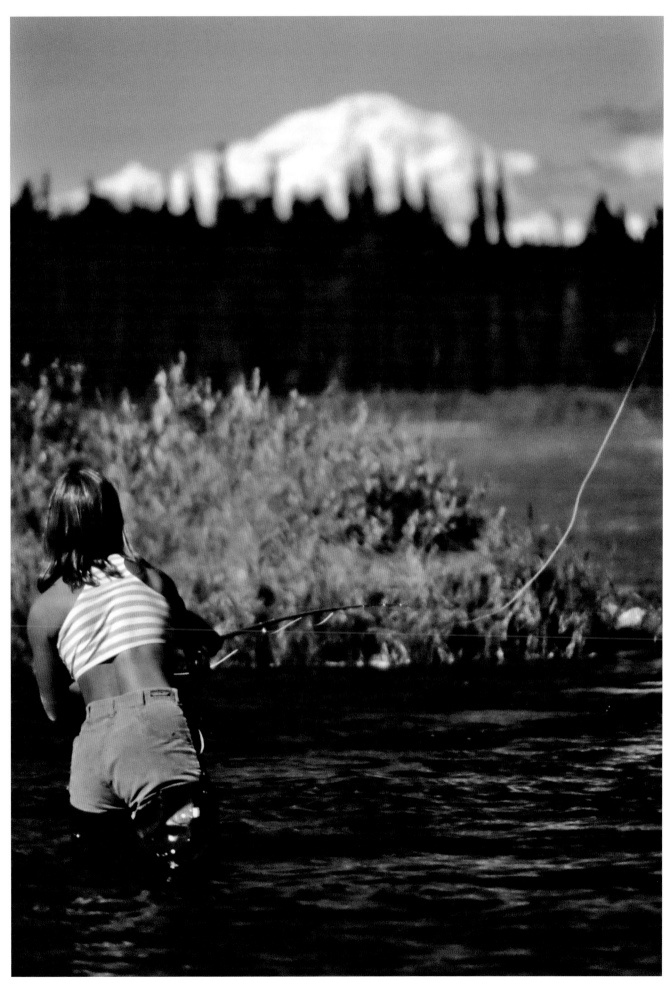

Laurie Mastrella casting for silver salmon. Lake Creek, Alaska. REX BRYNGELSON. *Spring 1988*

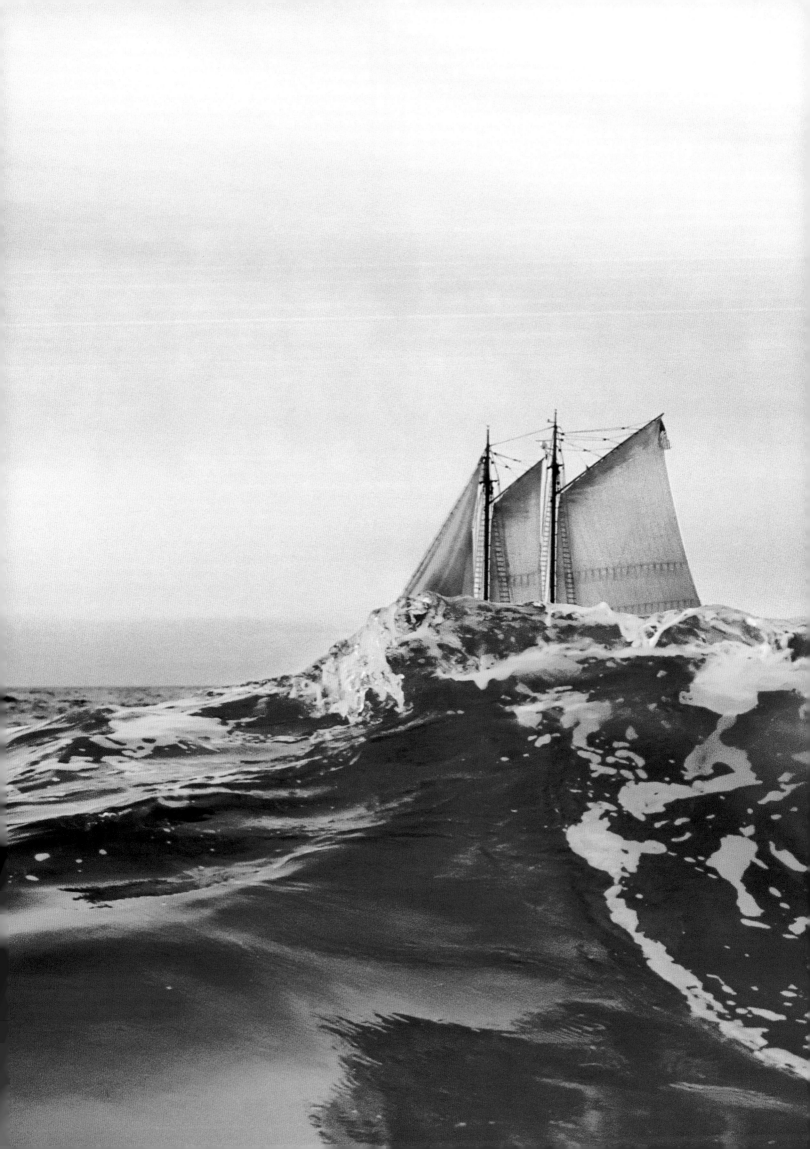

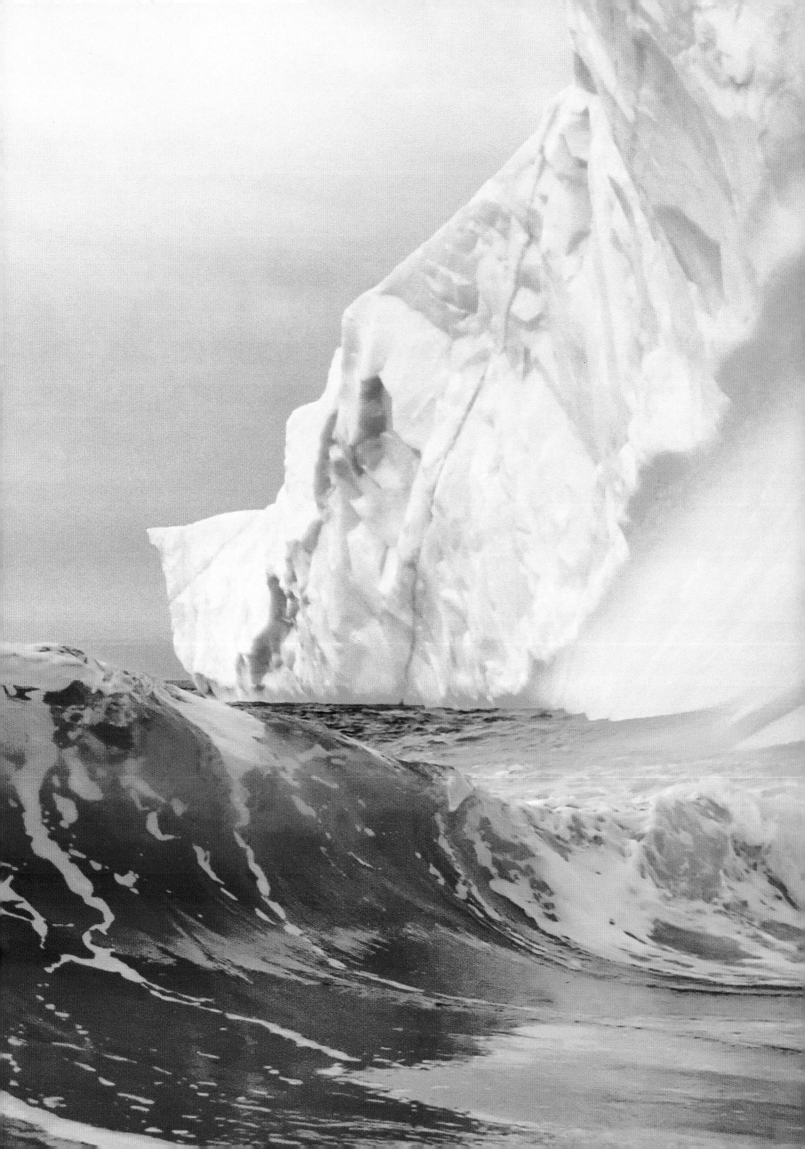

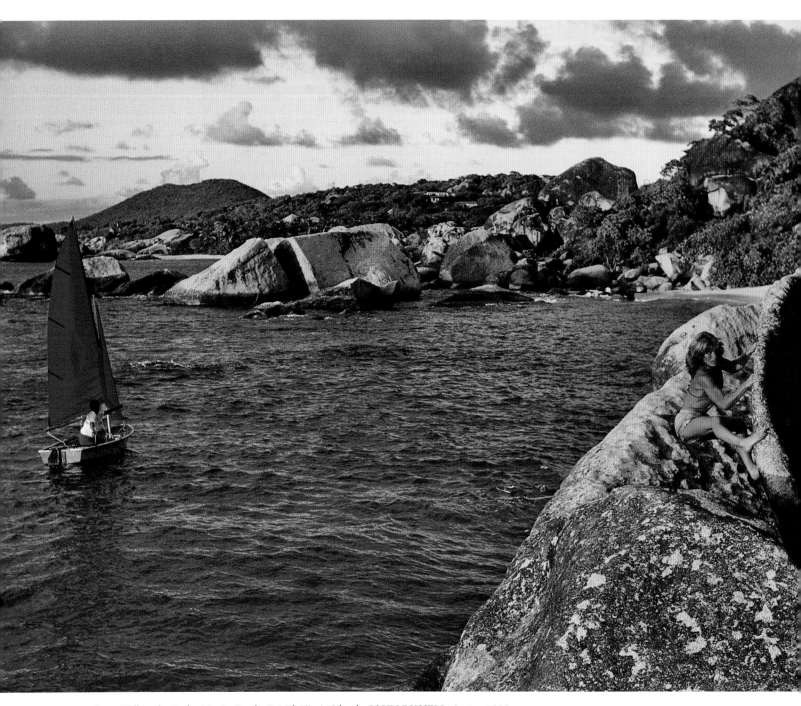

Lynn Hill at the Baths. Virgin Gorda, British Virgin Islands. JOHN RUSSELL. *Spring 1998*

Overleaf: Bowdoin northbound amidst southbound ice. Coast of Labrador. TOM STEWART. *Spring 1993*

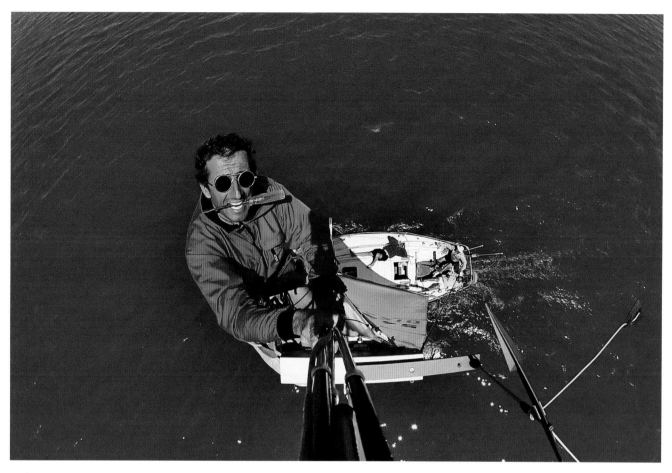

Early morning rig check on Lake Ontario, Canada. DIDIER GIVOIS. *Fall 1990*

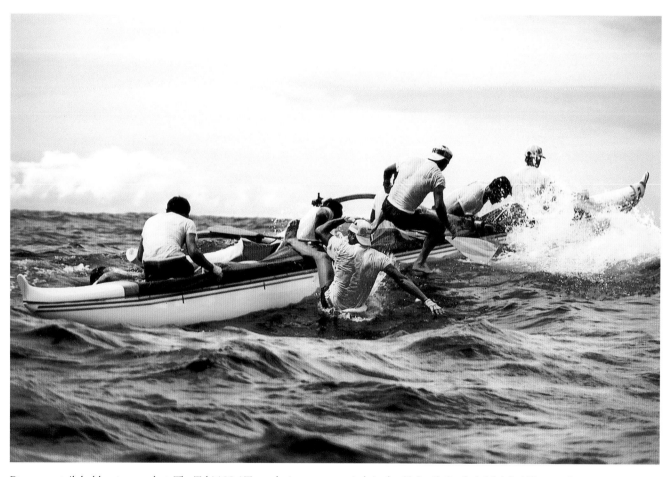

Drag your tail, hold onto your hat: The Tahiti Nui Team during a crew switch in the 40.8-mile Bankoh Molokai Hoe outrigger race across the Kaiwi Channel from Moloka'i to O'ahu. Hawaiian Islands. MARIA VEGHTE. *Fall 1991*

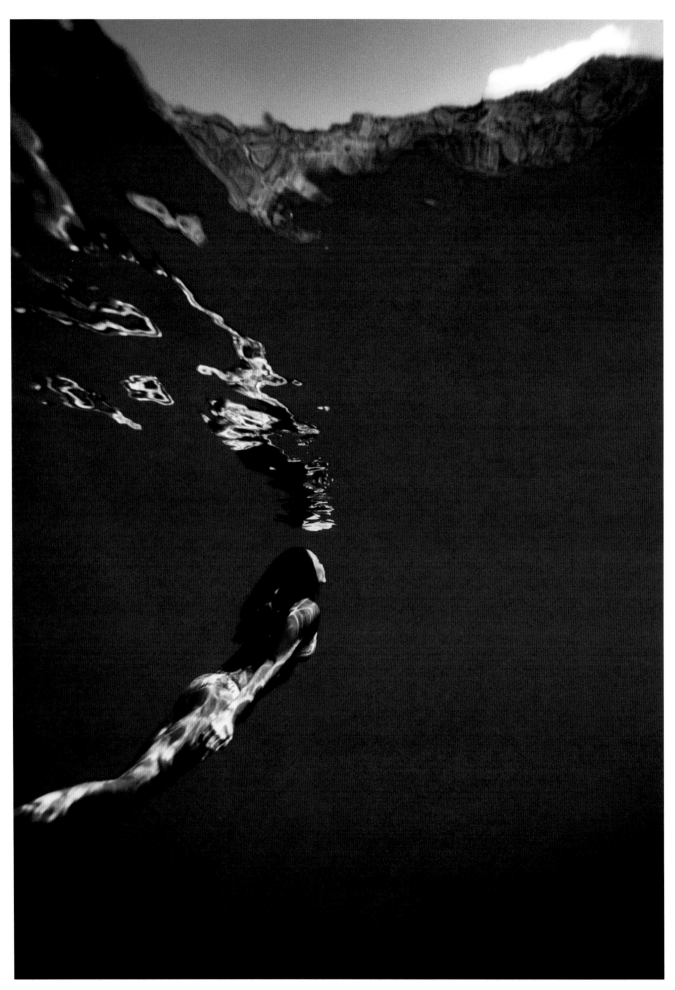

Tiare Friedman ascends to meet a fragmented image of herself in Kealakekua Bay. Hawai'i. DAVID PU'U. *Summer 2007*

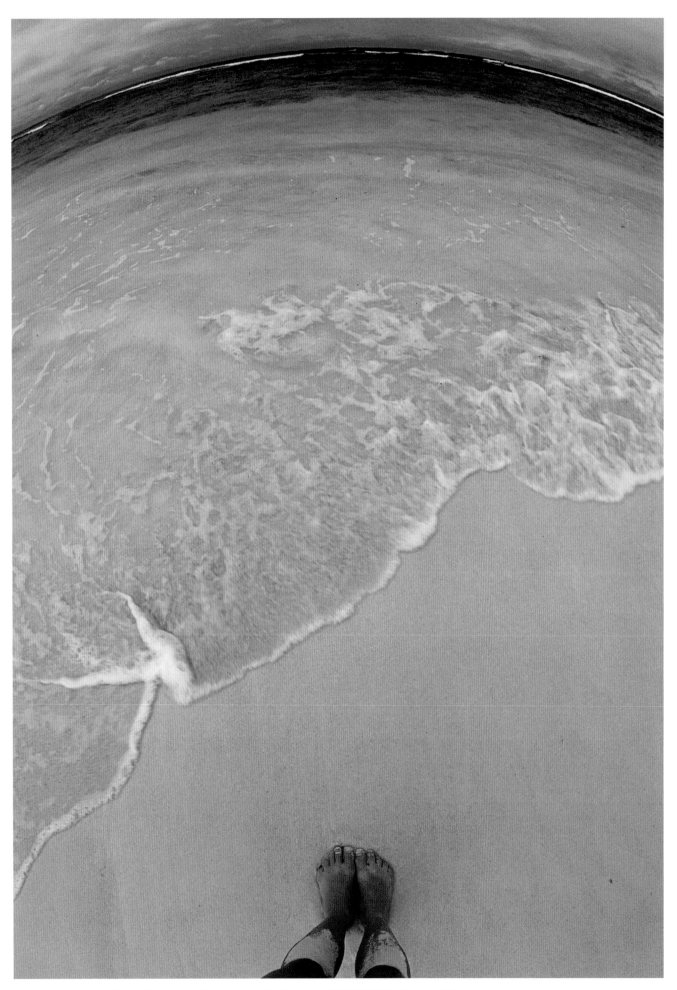

Amy Kumler's feet in the Indian Ocean. West Sumatra, Indonesia. AMY KUMLER. *Spring 2002*

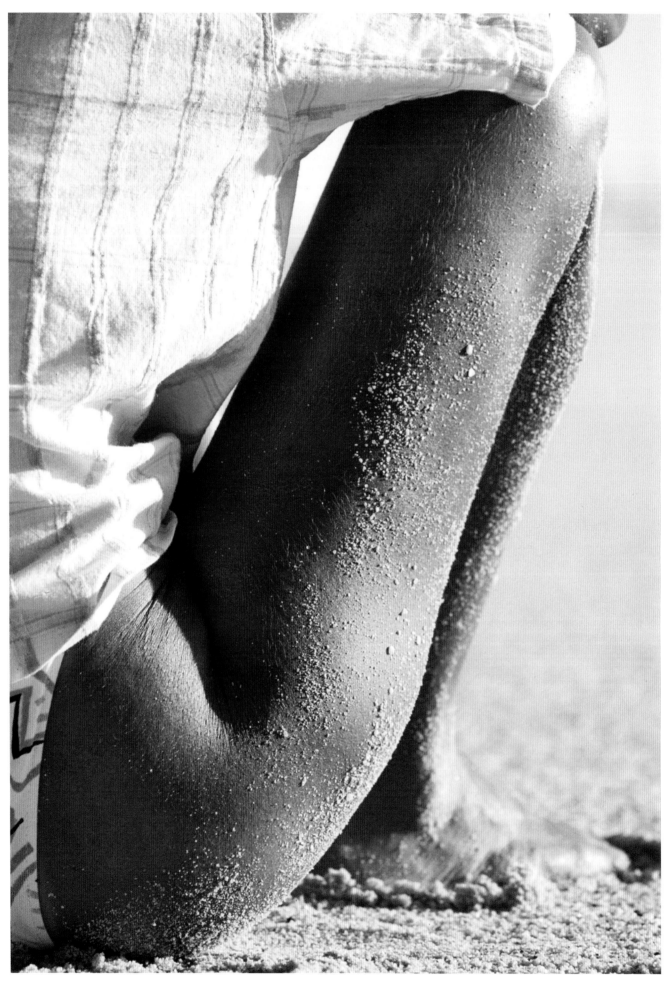

"The Leg." RICK RIDGEWAY. *Spring 1990*

Elisa Maturo off Carmen Island in Baja California Sur. JOHN GUSTAFSON. *Spring 1988*

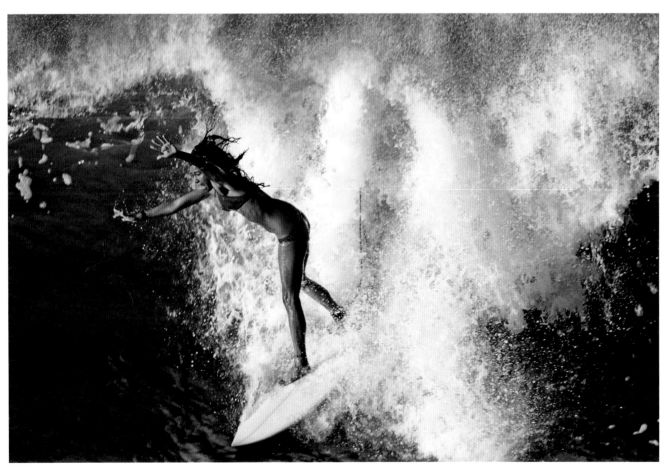

Mahealani Gambill getting it done. Hawaiʻi. JOHN RUSSELL. *Spring 2007, Surf*

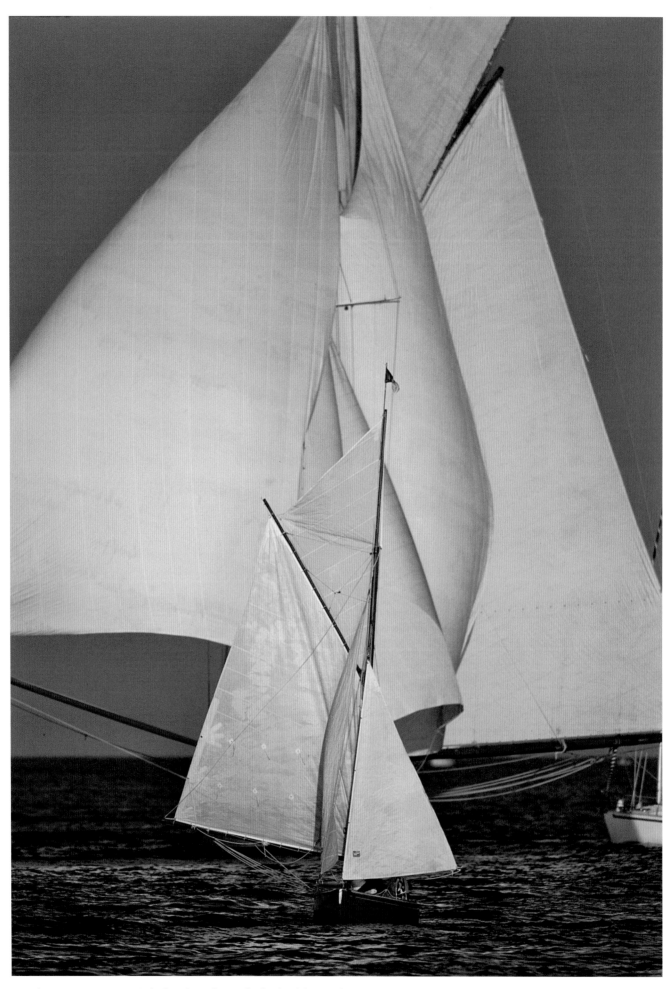

David (*Demeter IV*) meets Goliath (*Altair*) during the finish of the Nioulargue. St. Tropez, France. GILLES-MARTIN RAGET. *Summer 1995*

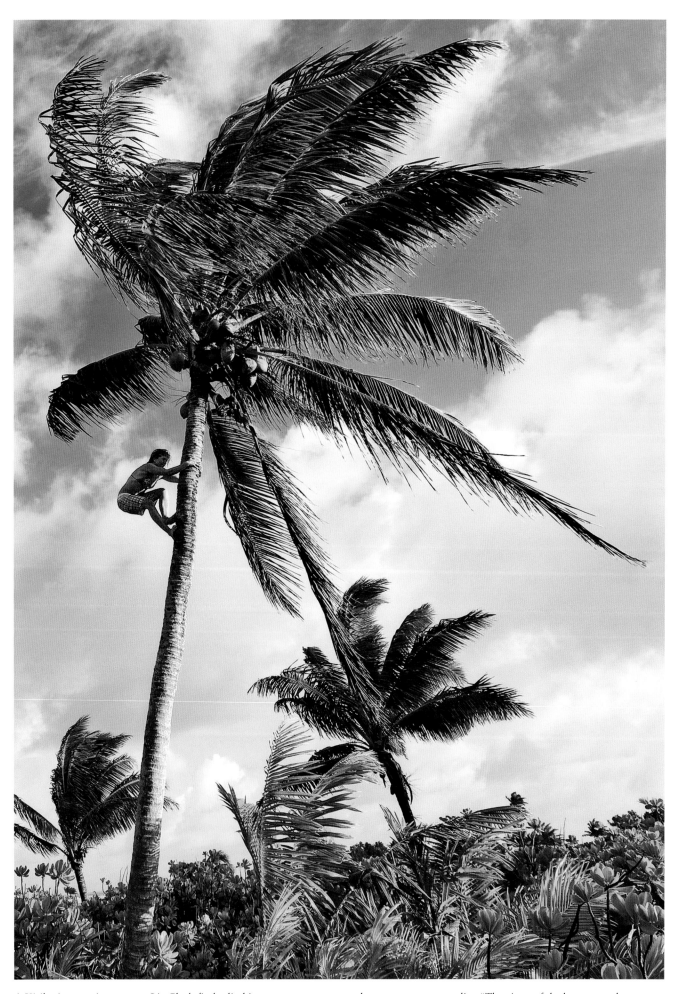

A Kiribati convenience store: Liz Clark finds climbing coconut trees more than a way to get supplies. "The views of the lagoon up there are spectacular!" CHRIS McGEOUGH. *Summer 2009*

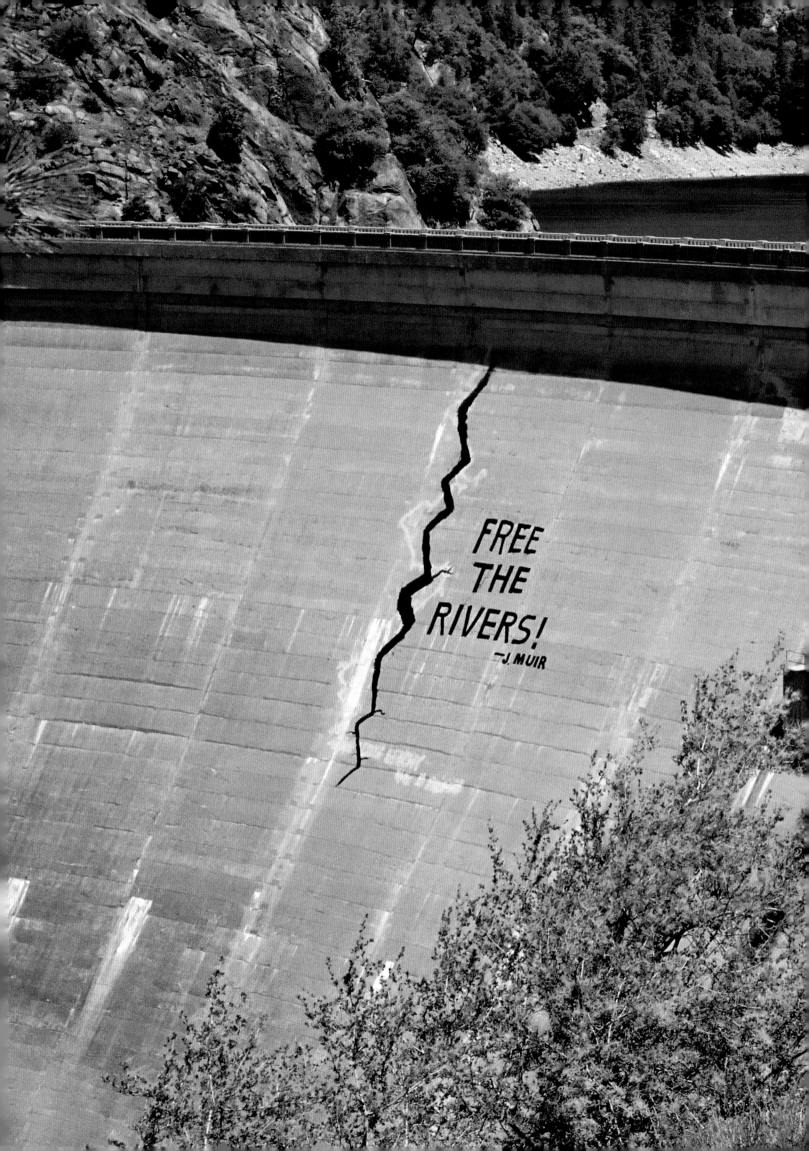

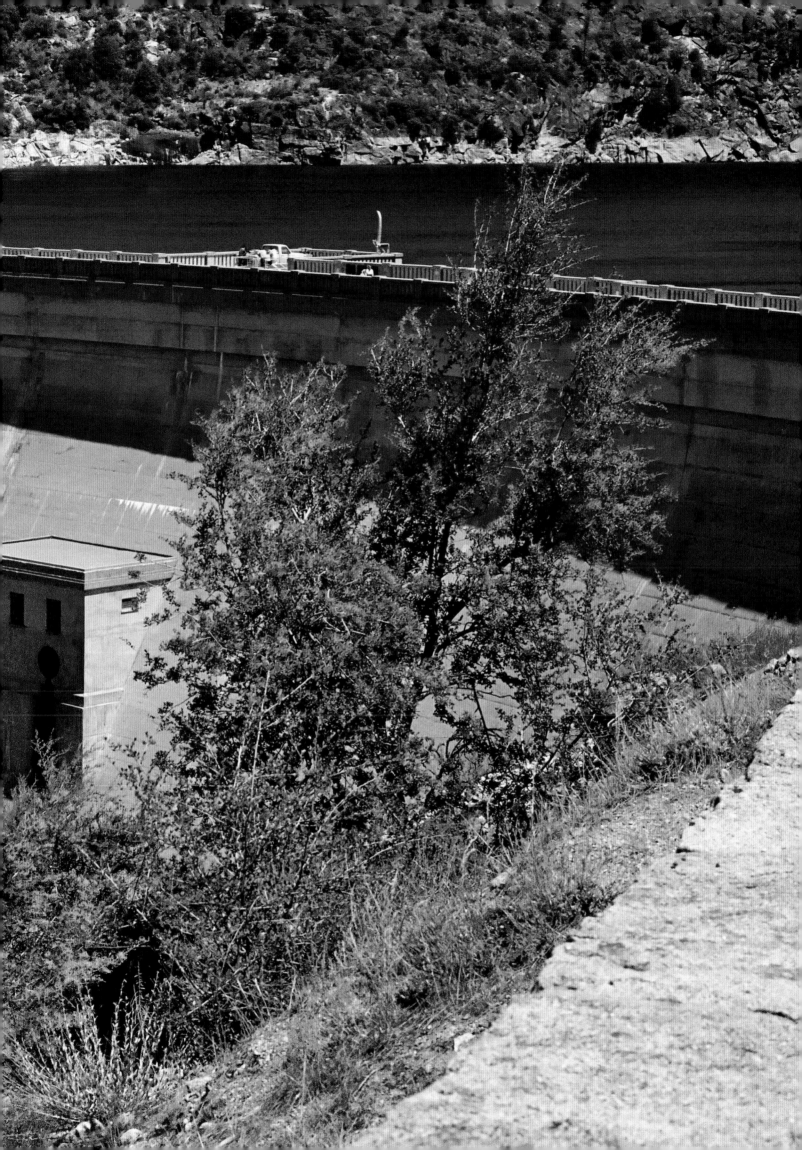

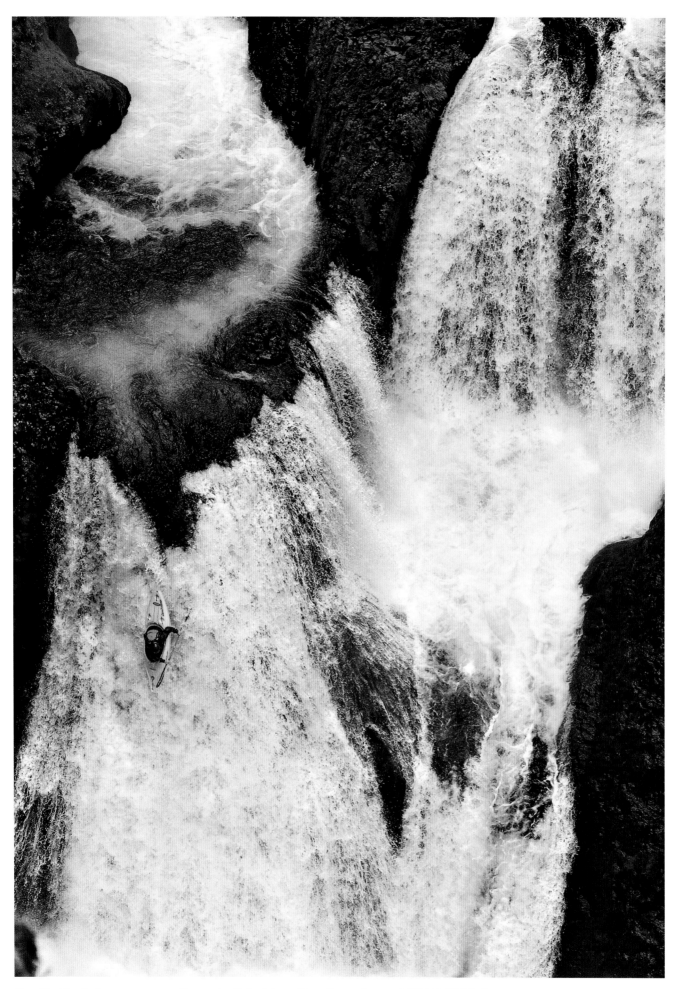

Greg Hoskins finds contentment on Frustration Falls. Salmon River Gorge, Oregon. LANA YOUNG. *Spring 2006*

Overleaf: Hetch Hetchy's infamous O'Shaughnessy Dam with new signage. Yosemite National Park, California. DAVID J. CROSS. *Spring 1999*

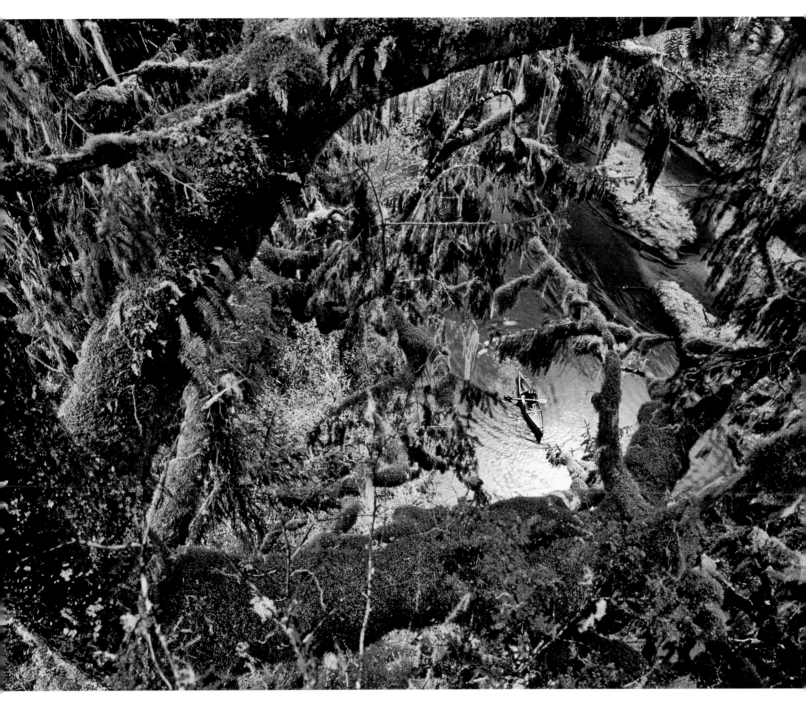

Searching for brown in a sea of green. Bear biologist Karen McAllister on the Waump River, British Columbia.
IAN MCALLISTER. *Spring 1998*

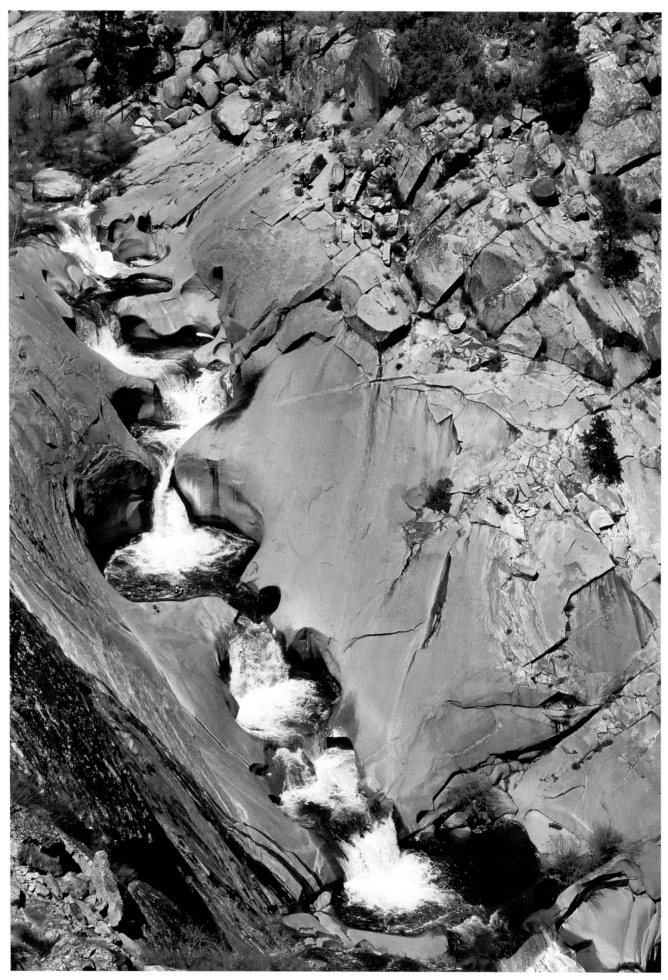

Mister Toad's wild ride. Southern Sierra, California. MICHAEL NEUMANN. *Fall 1997*

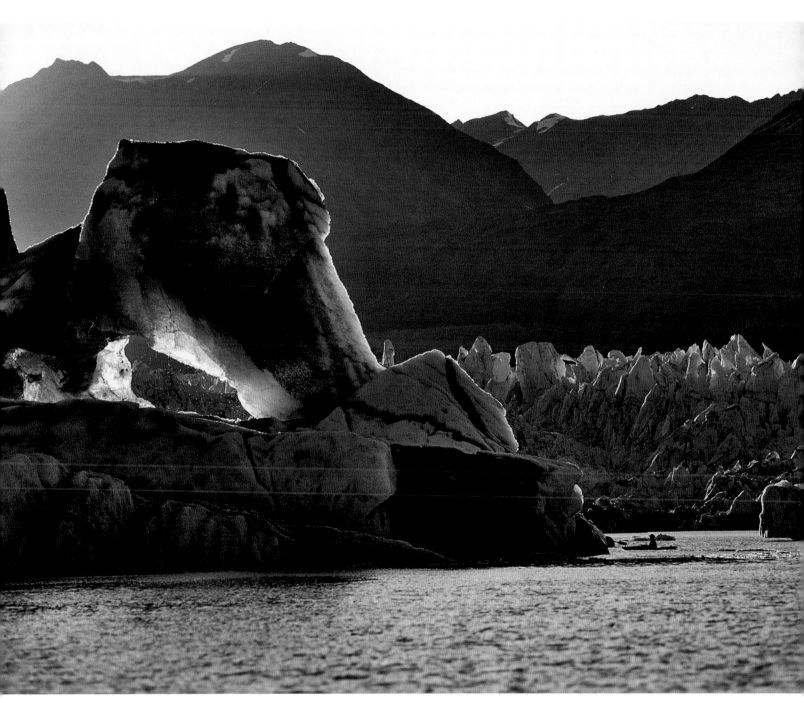

Things seen and unseen. DAVE EDWARDS. *Summer 1999*

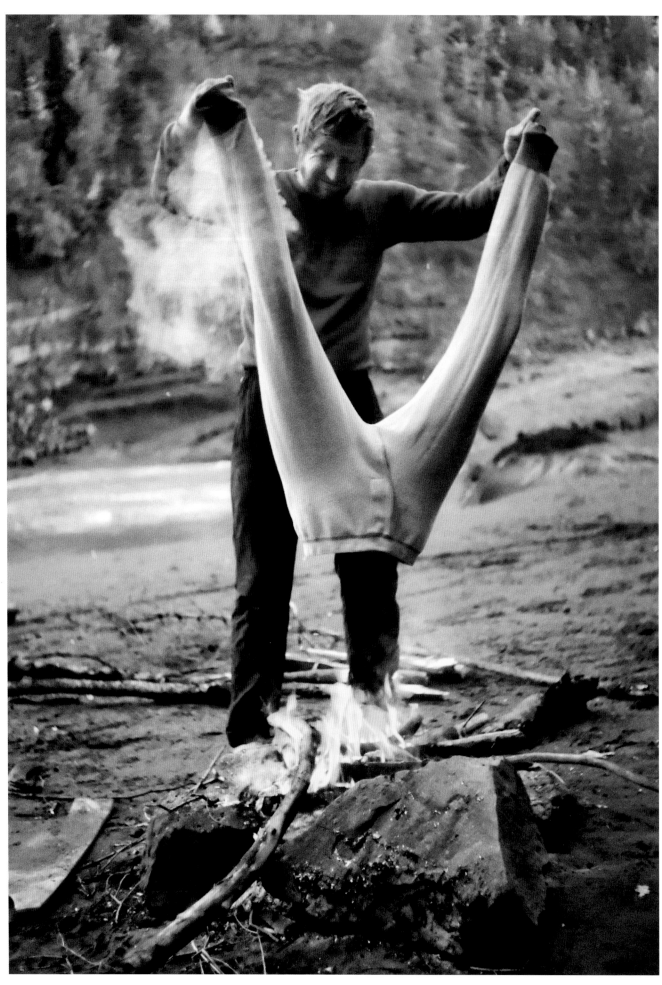

Don't try this: Rob Lesser fire drying his underwear. Camp Two, Grand Canyon of the Stikine River in northern Canada. TOM SCHIBIG. *Fall 1991*

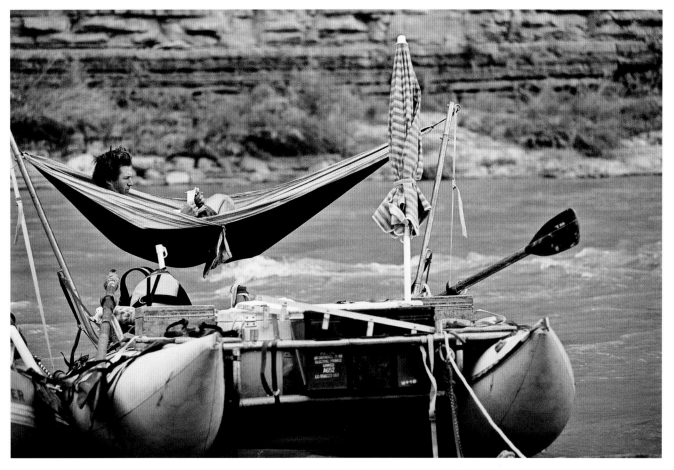

Leisure world. River rat Jeremy Fuller kicks up his feet at the end of a long day. San Juan River, Utah. RANDY BARNES. *Spring 2008*

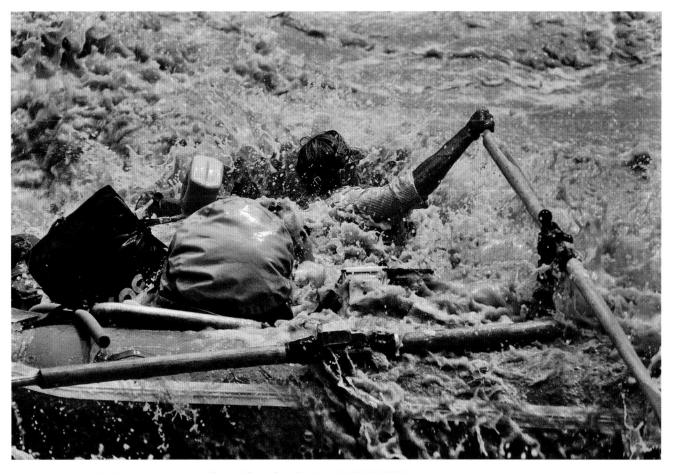

Wesley Smith inhales the 'V' wave, Lava Falls Rapids, Colorado River. DAVE EDWARDS. *Spring 1994*

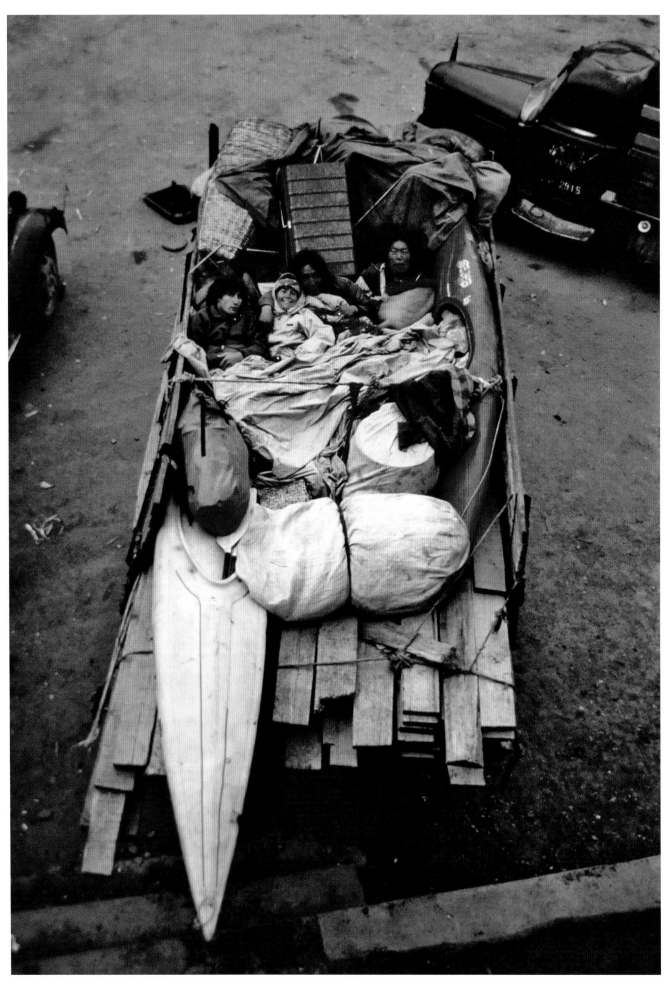

Heading for the source of the Brahma Putra. Dan Dixon and Arlene Burns in Nylam, Tibet. ARLENE BURNS. *Spring 1998*

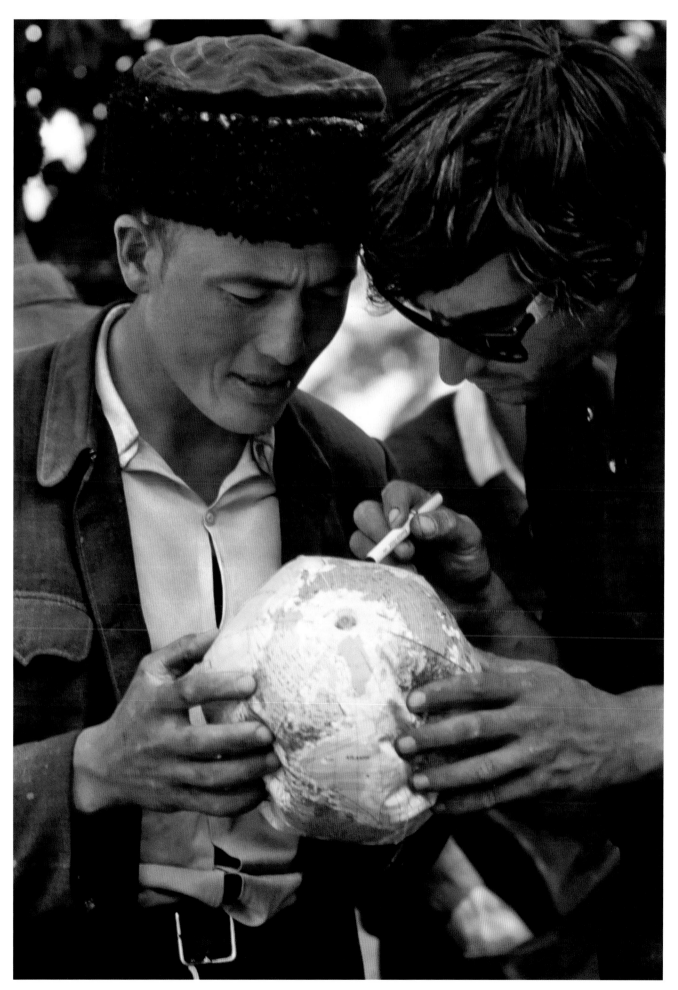

You are here. Mike Friedman with Kirghiz man in Hunterec, Xinjiang Province, China. ERNEST JONES. *Spring 1992*

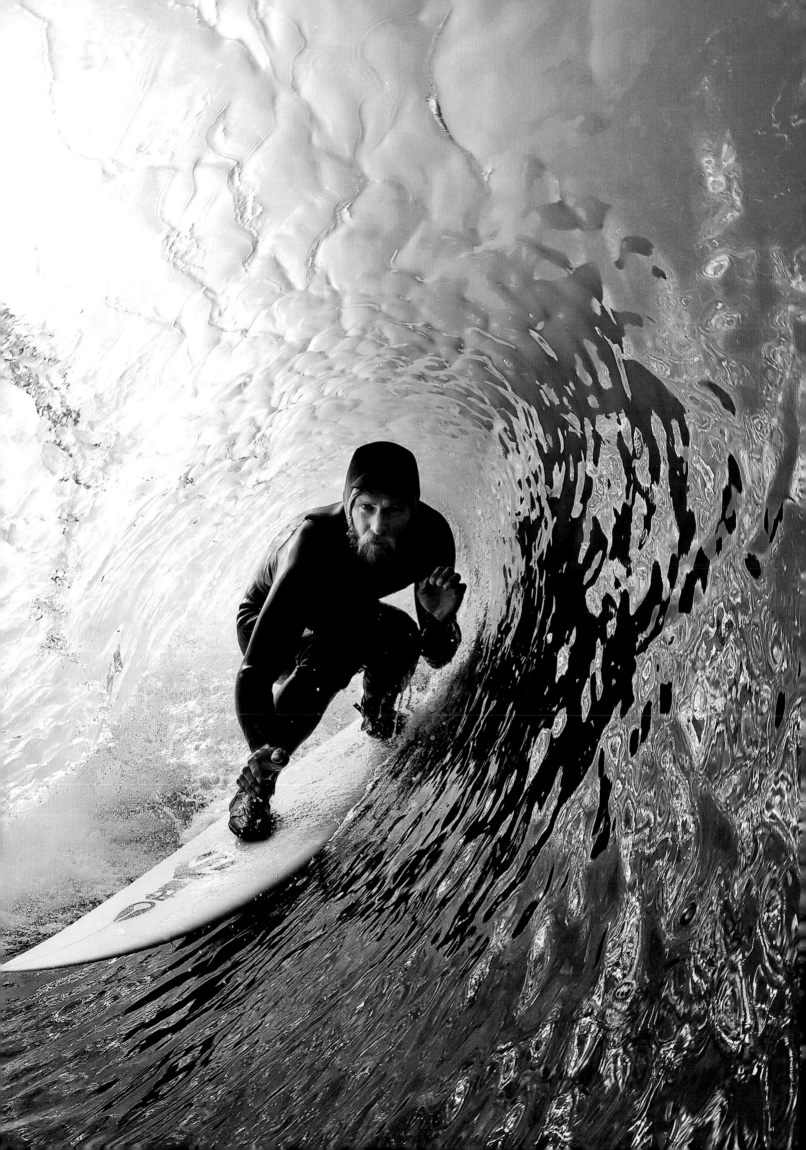

PATAGONIA: FROM ON SPEC TO ON STAFF

Jeff Johnson

LIVING ON THE NORTH SHORE OF OʻAHU, the sport's epicenter, I was surrounded by everything surf. Surf magazines are a staple in every surfer's media diet, but the images that most inspired me were those I saw in *National Geographic* and the Patagonia catalogs. Both had similar journalistic styles; the look and feel was urbane and subtle. I often visited Patagonia's store in Haleʻiwa town and got lost in all the photographs on the walls. The catalogs I took home lingered around my house longer than the surf mags.

Eventually I got interested in taking photos myself. I replaced my point-and-shoot with a more professional SLR camera and started to record my travels. I wanted to make photographs like those I saw in Patagonia's catalogs, focusing as much on culture as athletics.

The first image I ever had published was in *The Surfer's Journal* – of a Hawaiian canoe we rigged in my buddy's backyard. A friend encouraged me to submit shots to Jane Sievert, the photo editor at Patagonia. I guess she liked what I had because she bought a few from that initial batch. The first was an underwater shot of a girl surfacing after a deep freedive. I was beside myself when Patagonia purchased the image for three years, all-rights usage. It was like a dream come true.

Jane's encouragement inspired me to shoot more. She and her crew sent me a steady stream of clothes, not just to shoot but for technical feedback, because I virtually lived in the ocean. I was asked to wear the hell out of the gear and report on the fit, function, durability, and any insights I had on making it better. So began my field-testing.

One day out of the blue, I received a call from Yvon Chouinard, who asked if I'd like to go on a surf trip to the Tuamotu Islands with him and his son Fletcher. He wanted me to write about the trip, take some pictures. I dropped everything to go.

During that trip, Yvon and Fletcher talked about launching a new surf line at Patagonia. I'd been following what they'd done in the past and felt they needed to have a different approach, though I didn't say this to them just yet. When the trip was over, I visited them in Ventura and snooped around Patagonia headquarters, learning what I could about the company.

I had been living with three brothers on the North Shore – the Malloys. They were all professional surfers, a power trio

in the surf industry, and getting burned out on it. I knew they were looking for something different, with more meaning, so I found ways to get them together with the Patagonia crowd. It seemed like a perfect match. The brothers had already begun a relationship with Yvon. Keith, the middle brother, had moved in across the street from the Chouinards, and they occasionally hung out together. In the spring of 2004, the Malloys quit the "surf" industry and signed on with Patagonia as ambassadors and consultants.

At the time, I was still making my living as an international flight attendant and worked as a lifeguard on the North Shore on my days off. The airline job felt like golden handcuffs – great lifestyle but with a work atmosphere against the grain of how I wanted to live. I felt claustrophobic, stunted. I too wanted work to have meaning and be something to believe in. One day after a red-eye flight from Tokyo to Honolulu, I gave Chris, the oldest brother, a call.

I said, "Chris, I want that to be the last flight I ever work."

And it was, thanks to his encouraging words: "Get on over here!" he said.

A few days later, I found myself at Patagonia headquarters in Ventura, snooping around again – this time to see what I could do to help with this new surf line. The only truly quantifiable thing I could offer, though, was my photographs. If I was an employee, Patagonia could have all rights to whatever photos it wanted. It all happened organically; there was no application to fill out. Even the interview process was casual. It began in Yvon's living room during morning tea and coffee.

I told Yvon I thought there were some opportunities Patagonia was not taking advantage of. With access to all these great athletes and photographers around the world, you could celebrate their adventures in books and film projects. I even dug into Patagonia's T-shirt program, which was nearly nonexistent at the time, and said that T-shirts alone were a wide-open opportunity. Yvon told me to share some of my ideas with this guy wearing a T-shirt and flip-flops who sat facing me on the couch. He didn't bother telling me this guy was the CEO. So by the end of the meeting, there I was – Patagonia's first staff photographer. The book and film projects came later.

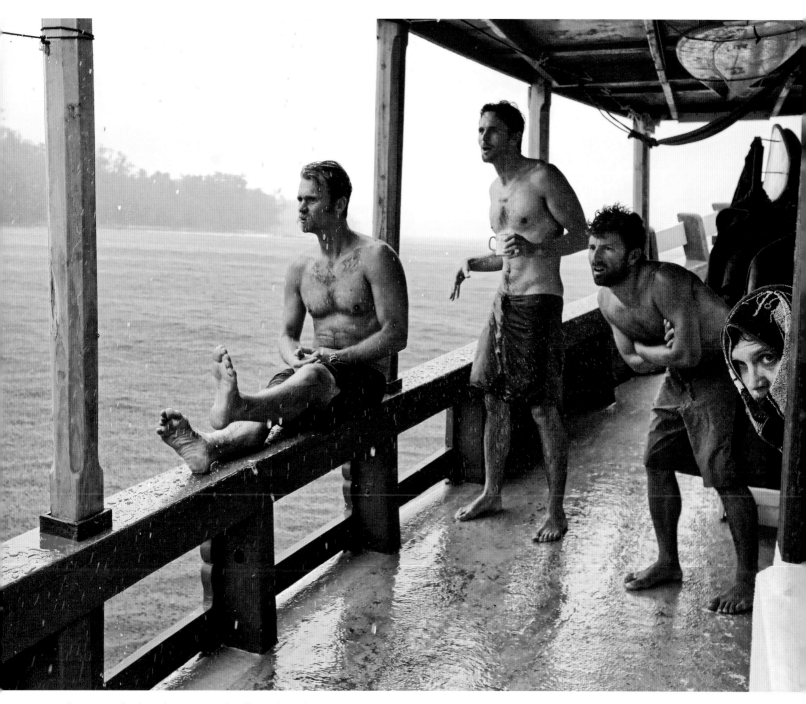

Chris, Dan, Fletch, and Wayne caught off guard as Adam Kobayashi pulls into a freak tube. Aboard the *Mikumba*, Indonesia. JEFF JOHNSON. *Spring 2010*

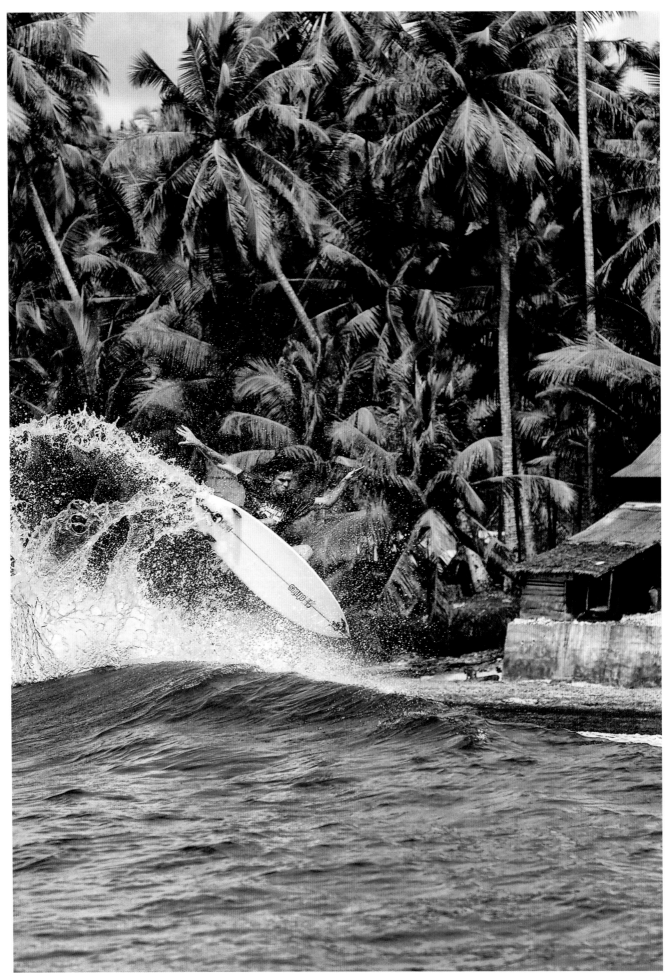

Patagonia ambassador Dan Malloy hanging out in Northern Sumatra, Indonesia. JEFF JOHNSON. *Spring 2010*

It's what we do around here. TIM DAVIS. *Spring 2009*

Eli Knoke and Kyoko Nakayama swim in the To Sua Ocean Trench near Upolu, Western Samoa. TOR JOHNSON. *Summer 2010*

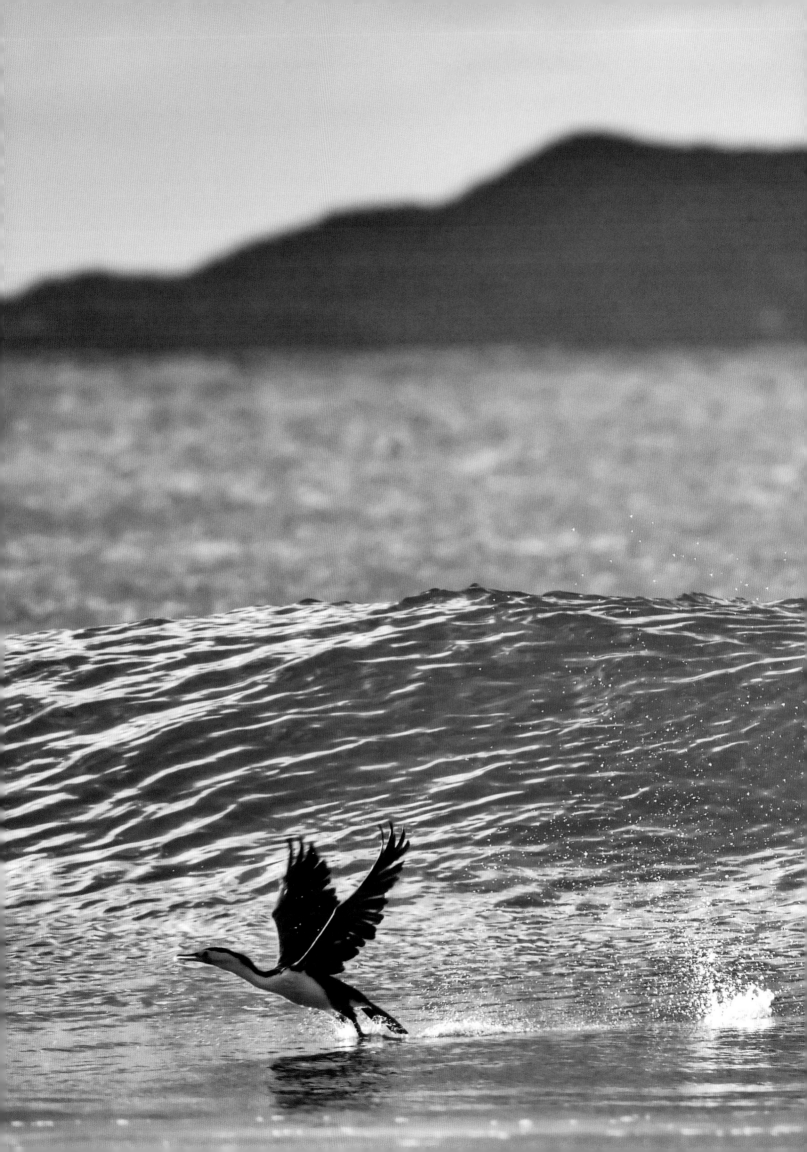

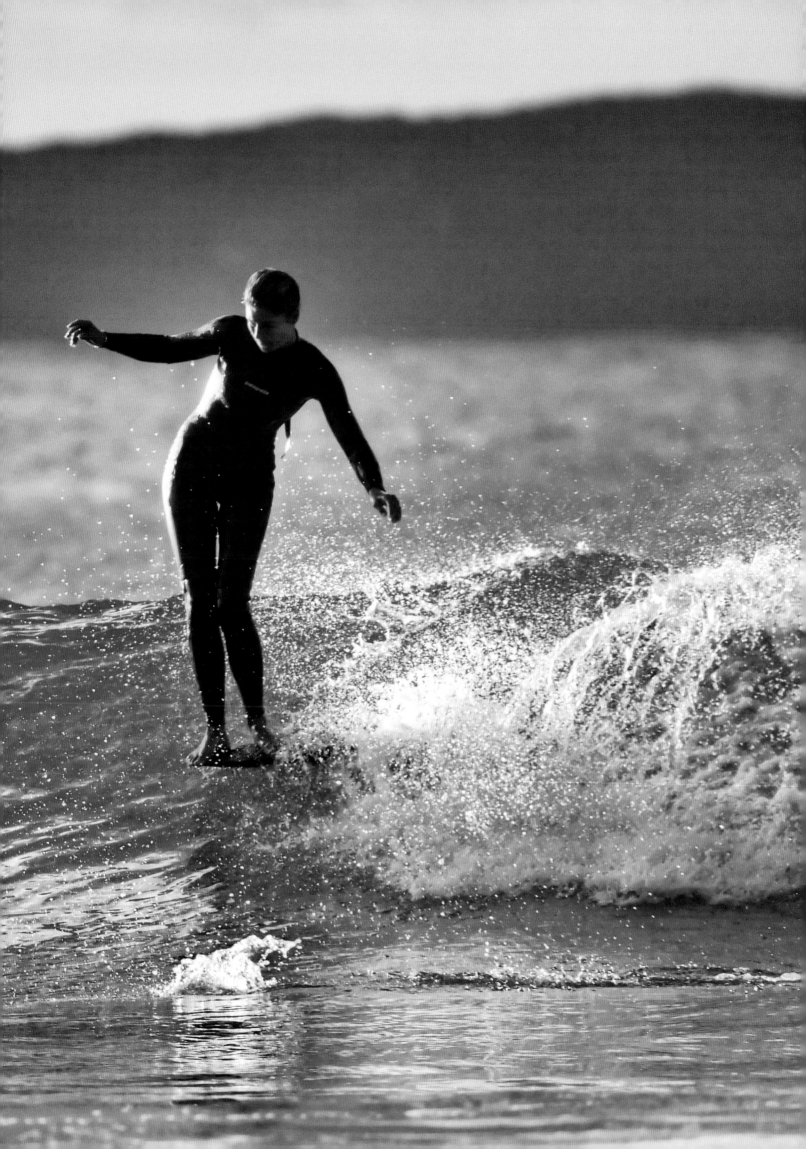

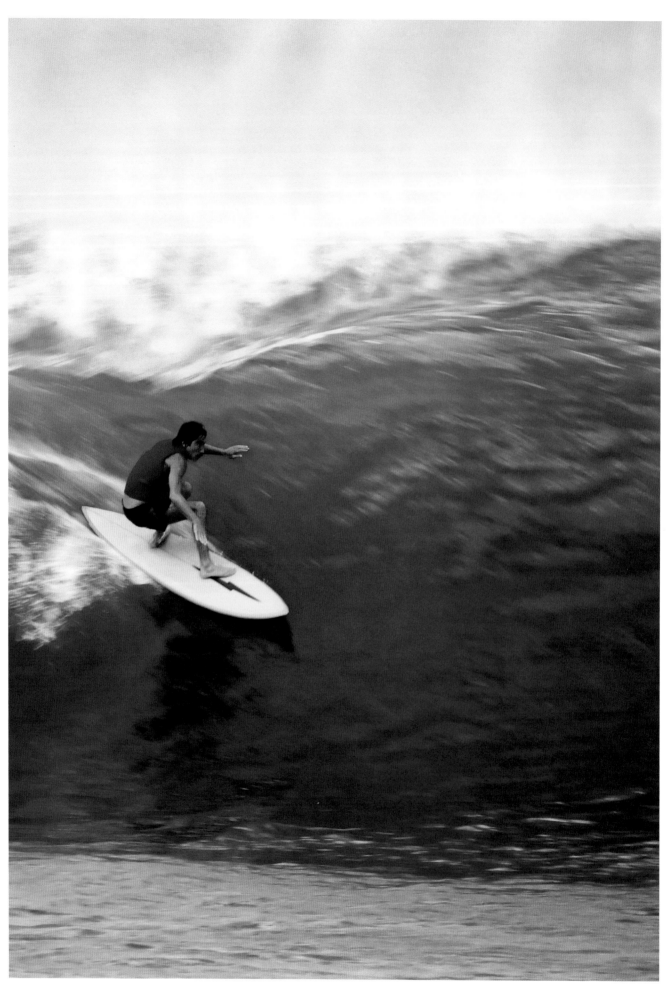

Gerry in the zone, circa 1970. STEVE WILKINGS. *Spring 2008*

Overleaf: Nature drops in to share the ride: Belinda hanging five at Noosa Heads, Australia. DANE PETERSON. *Spring 2009*

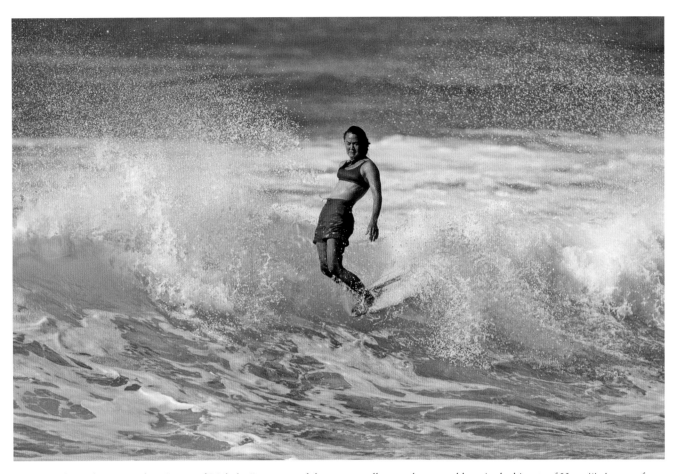

Rell Sunn, better known as the "Queen of Makaha," was one of the greatest all-around ocean athletes in the history of Hawai'i. As a professional surfer, radio personality, community leader, canoe racer, free-diver, and hula dancer, Rell was the essence of grace and generosity. She died of breast cancer in 1998. TOM KECK. *Spring 2001*

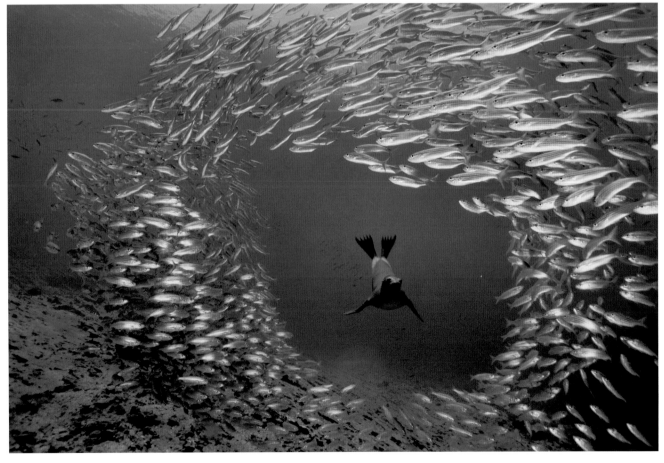

A school of salema cut a wide berth for a Galapagos sea lion. Cousins Rock, Galapagos Islands, Ecuador. DAVID DOUBILET. *Summer 2006*

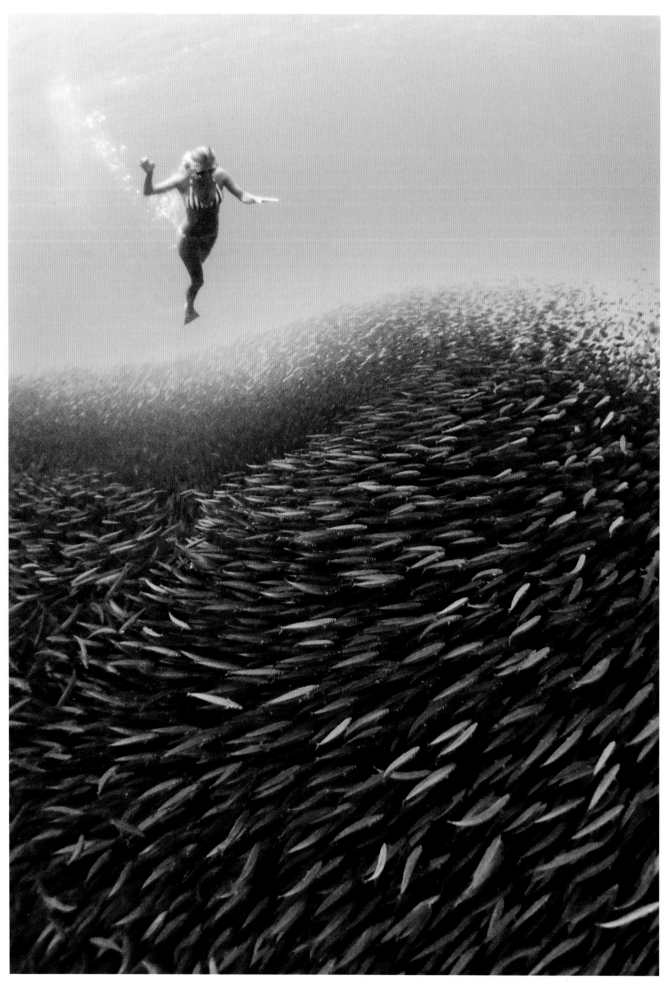

Amy Hodel suspended above a school of 'oama and halalu, a magical sight in the summertime waters off Hawai'i. Waimea Bay, O'ahu. DAVE HOMCY. *Summer 2008*

Chef Ben making the best of an overcrowded boat in Nicaragua. TOM SERVAIS. *Spring 2006*

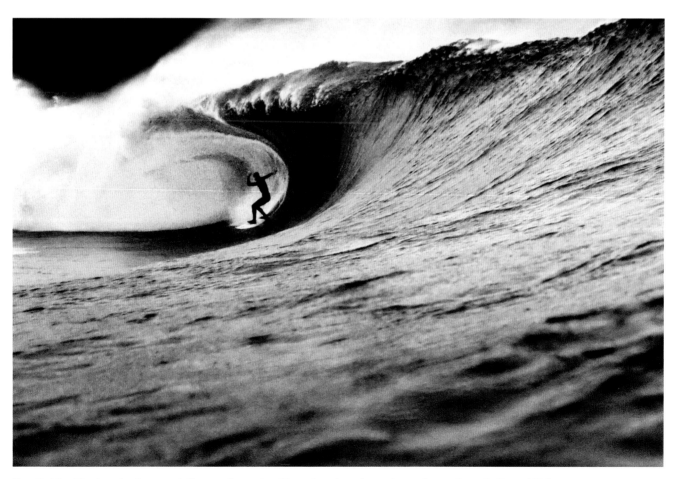

Tom Doidge-Harrison (underground ding-repair guy, local legend, and regular guy) gets the goods on the Emerald Isle.
MICKEY SMITH. *Fall 2008*

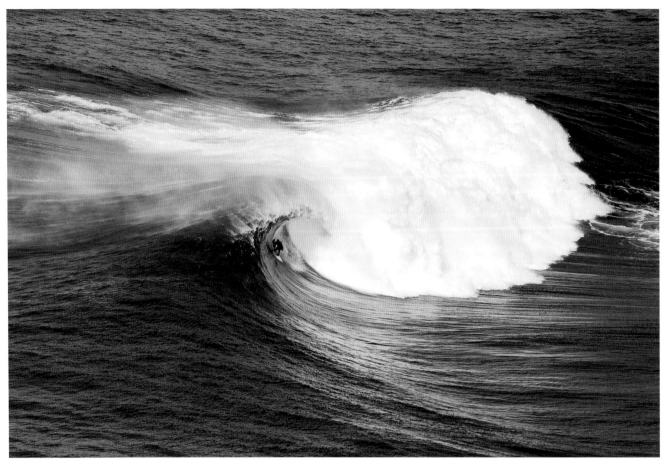

If you think this is hairy, you should see the hike out. Tom Doidge-Harrison product testing in Ireland. AARON PIERCE. *Fall 2009*

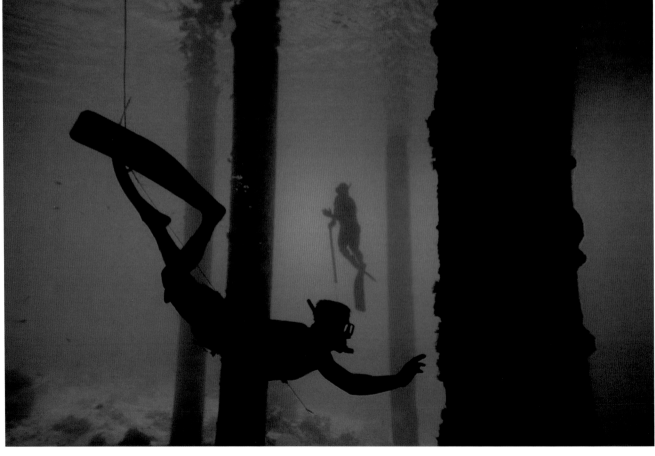

Fletcher Chouinard enters the food chain. Oceania. BRANDEN AROYAN. *Spring 2006*

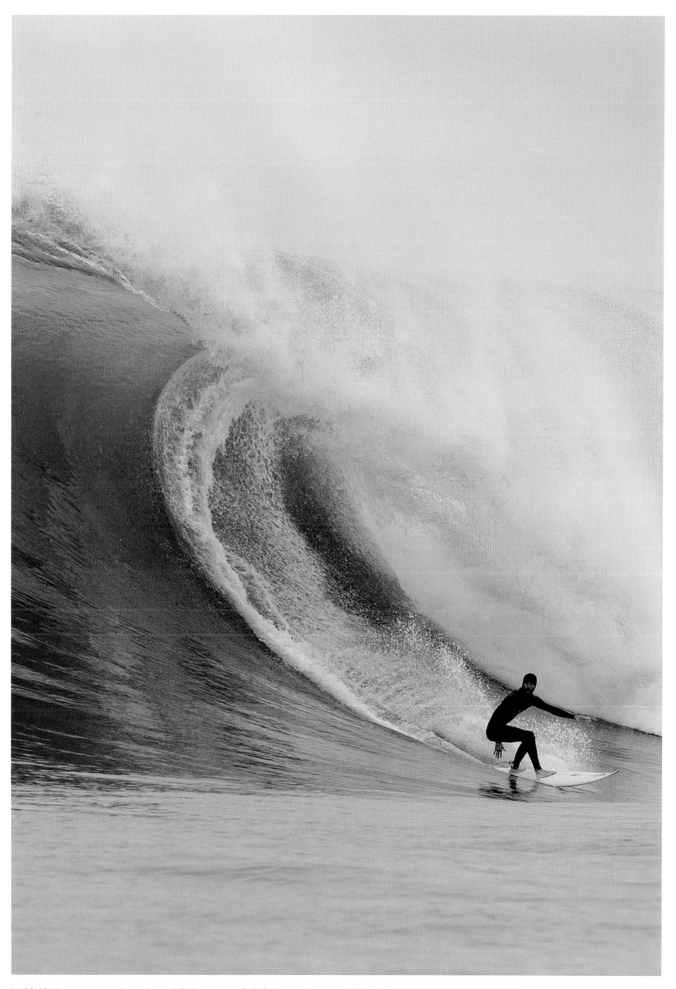

Kohl Christensen wetsuit testing at El Buey, one of Chile's most threatened breaks. BRUNO VEIGA. *Fall 2010*

Grin and bare it. COREY RICH. *Fall 1998*

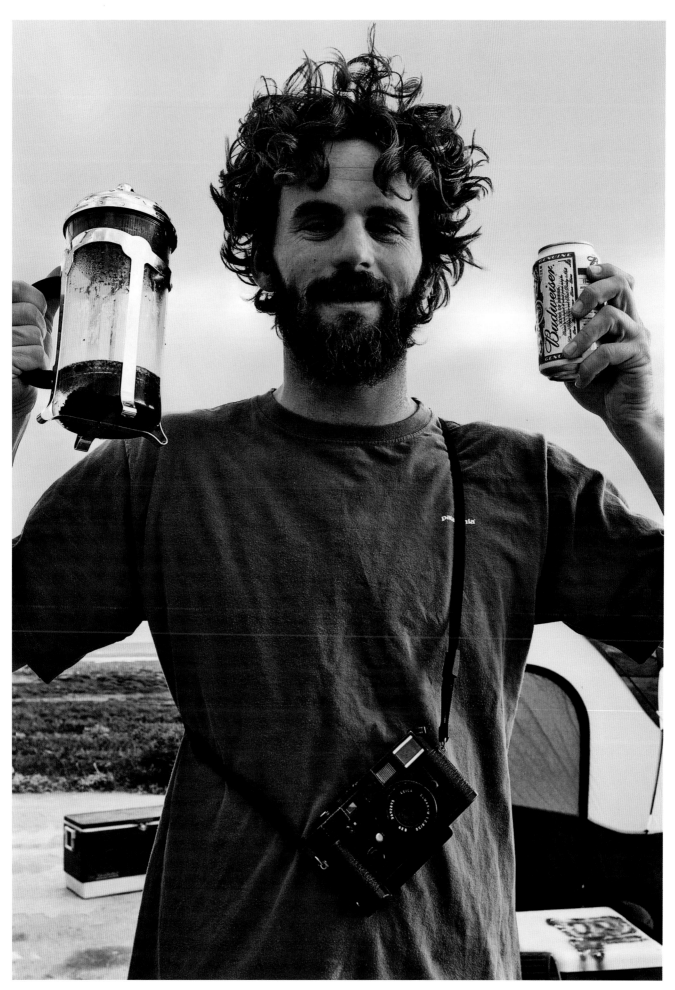

Coffee or beer: Patagonia surf ambassador Dan Malloy considers one of life's deeper questions. Baja California.
JASON MURRAY. *Early Fall 2009*

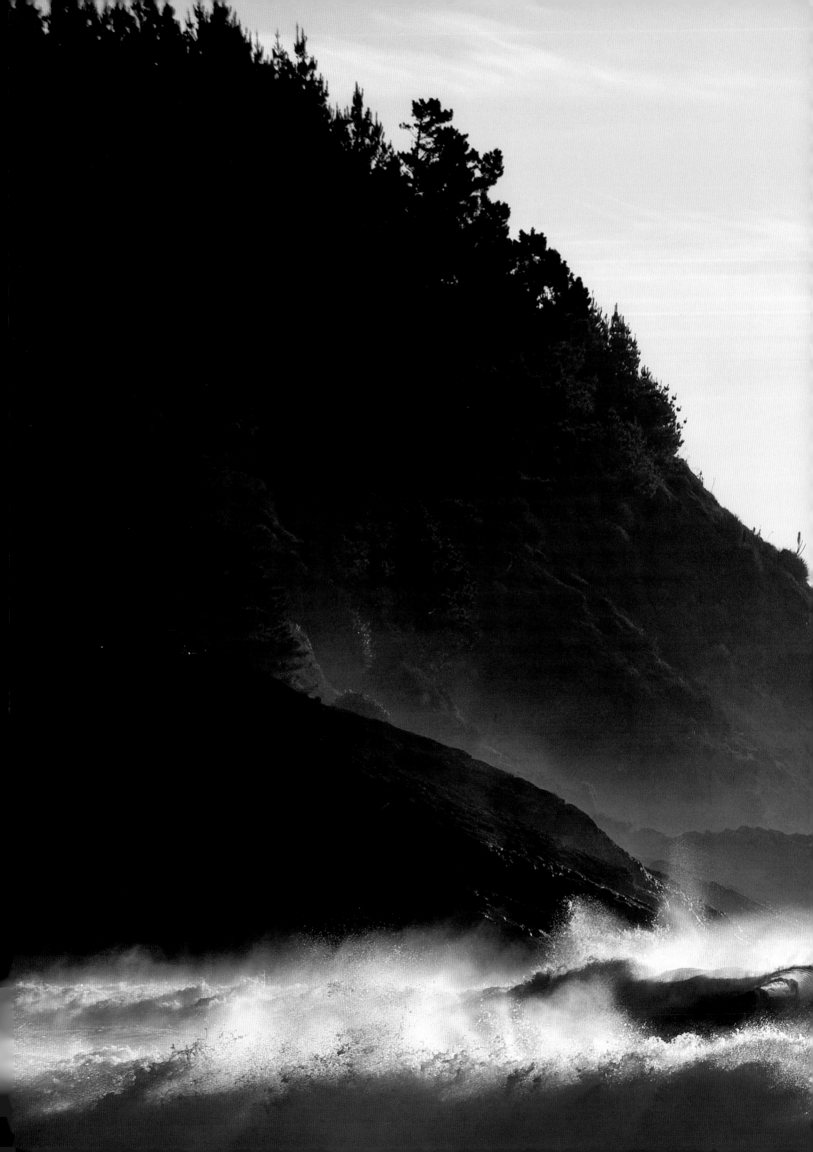

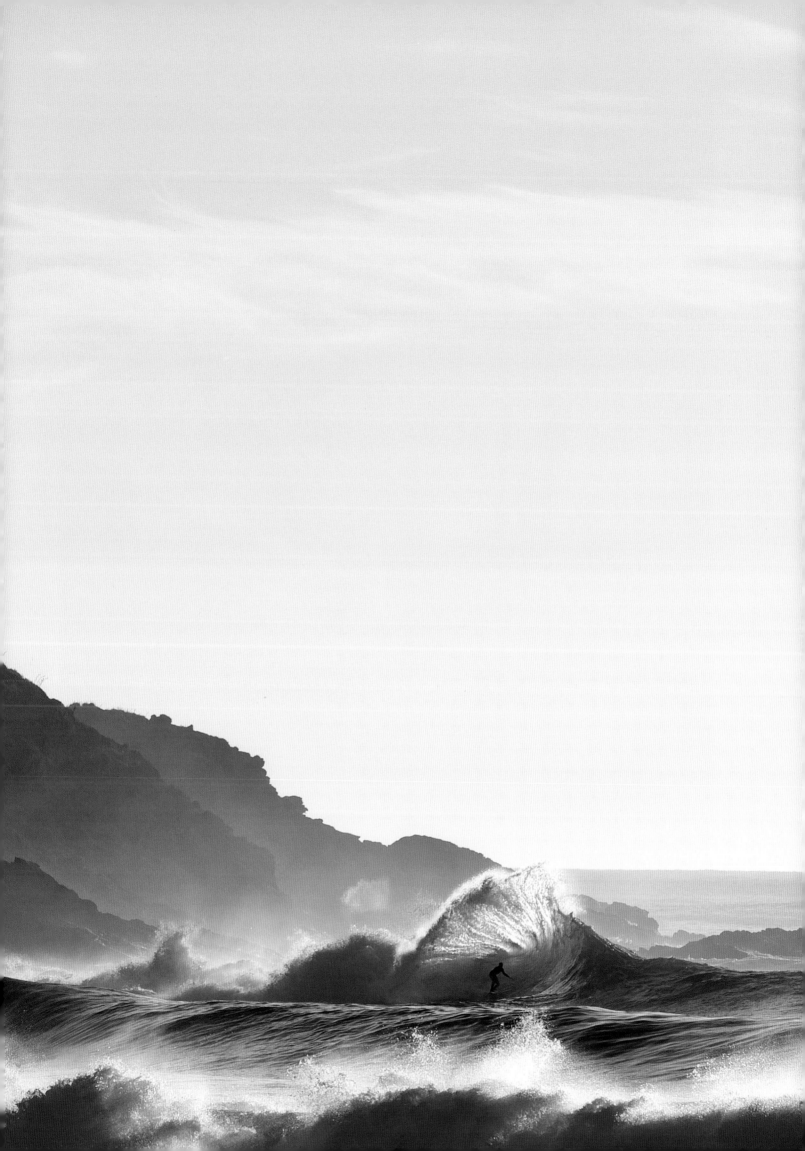

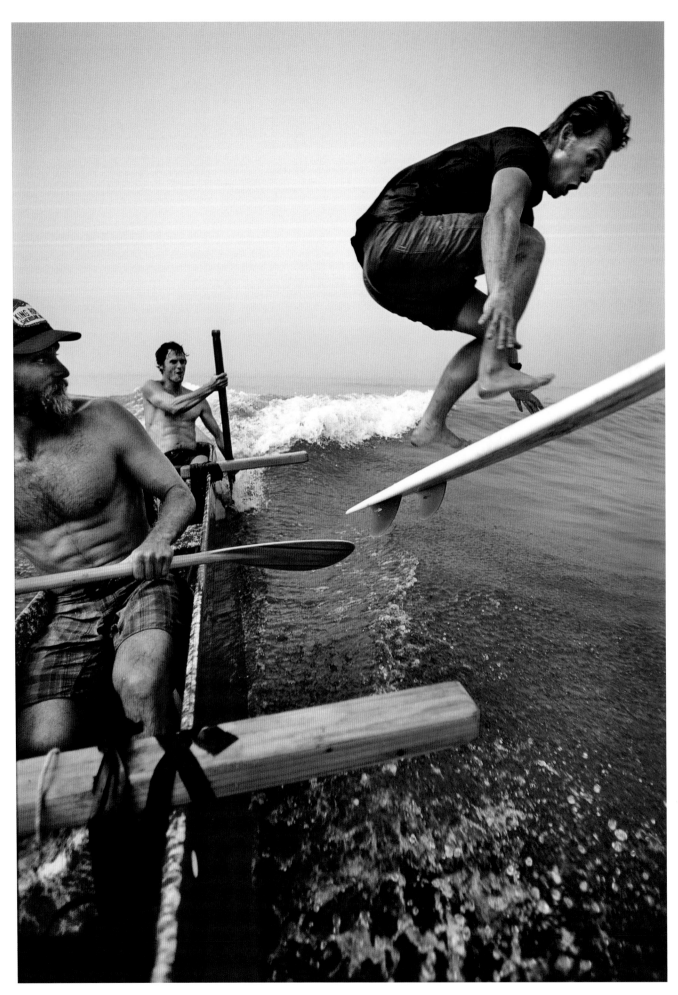

Chris, Keith, and Dan Malloy translate the ancient Hawaiian practice of canoe-assisted takeoffs. BRANDEN AROYAN. *Summer 2009*

Overleaf: Remote pointbreak in southern Chile. "Everything in nature seemed to come together perfect for this evening session. Luckily enough we found ourselves on the inside looking out." CHRIS BURKARD. *Fall 2009*

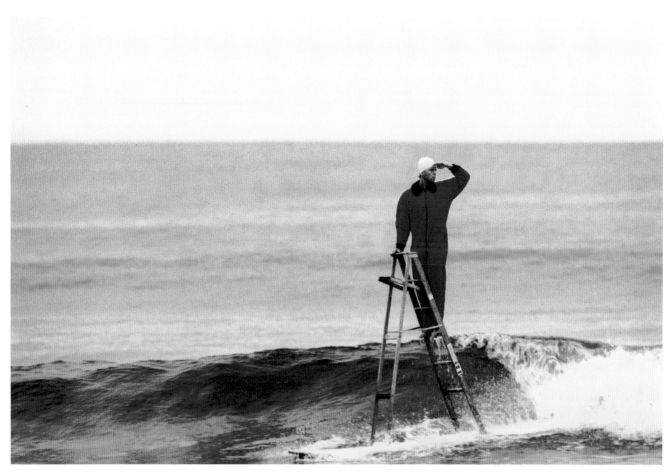

Surf check: Patagonia surf ambassador Chris Malloy during the making of Thomas Campbell's film *The Present*.
DEVON HOWARD. *Early Fall 2009*

Aft-deck debris. The fish fork is always a good omen. Indonesia. ADAM KOBAYASHI. *Spring 2007*

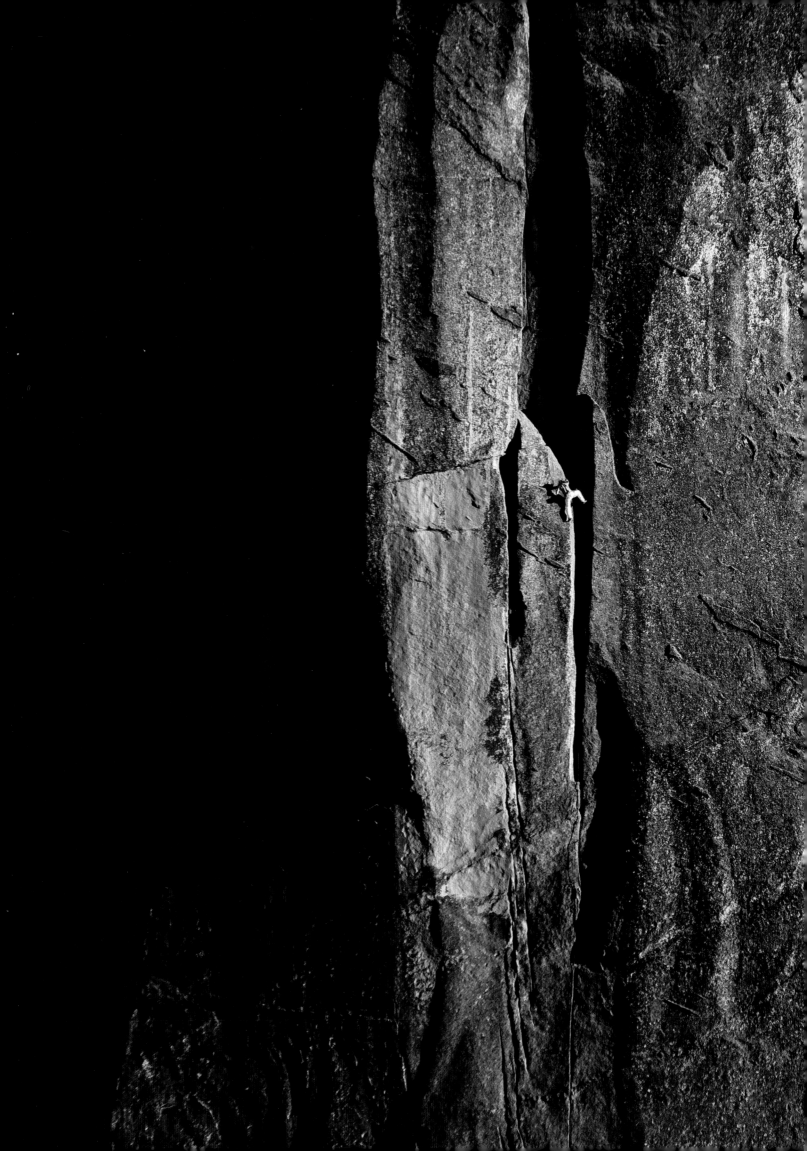

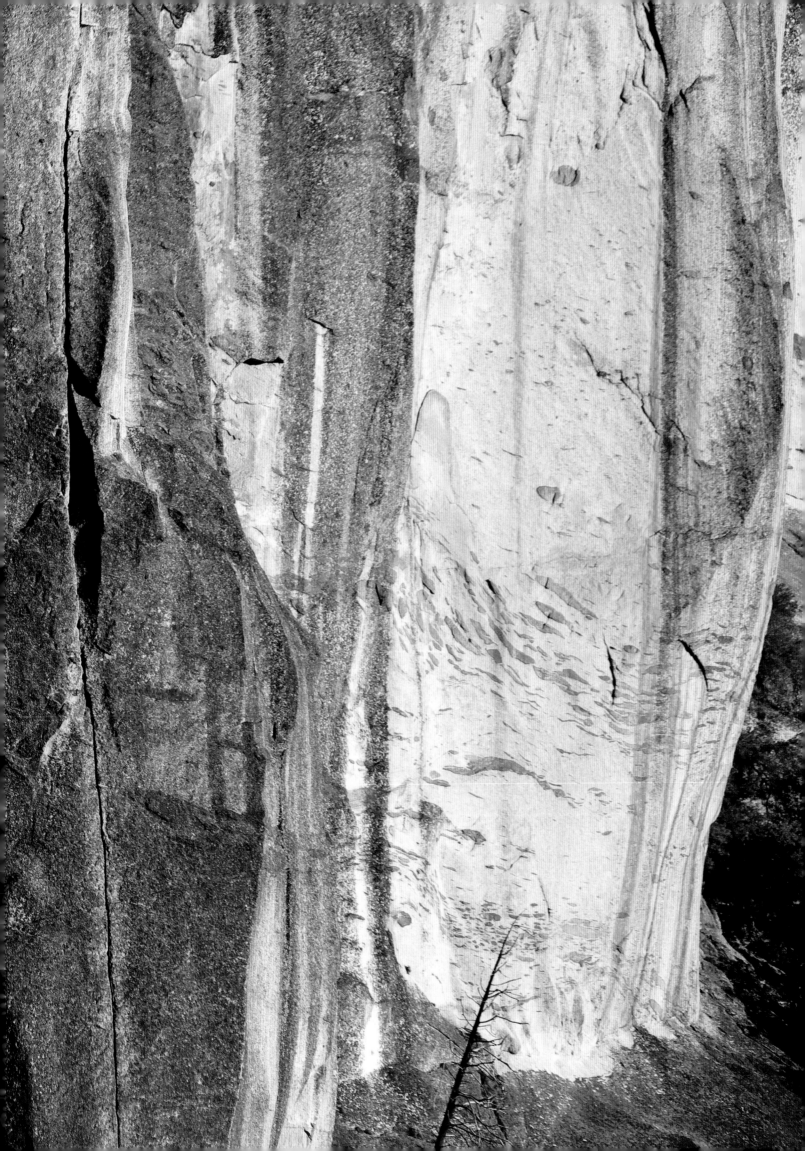

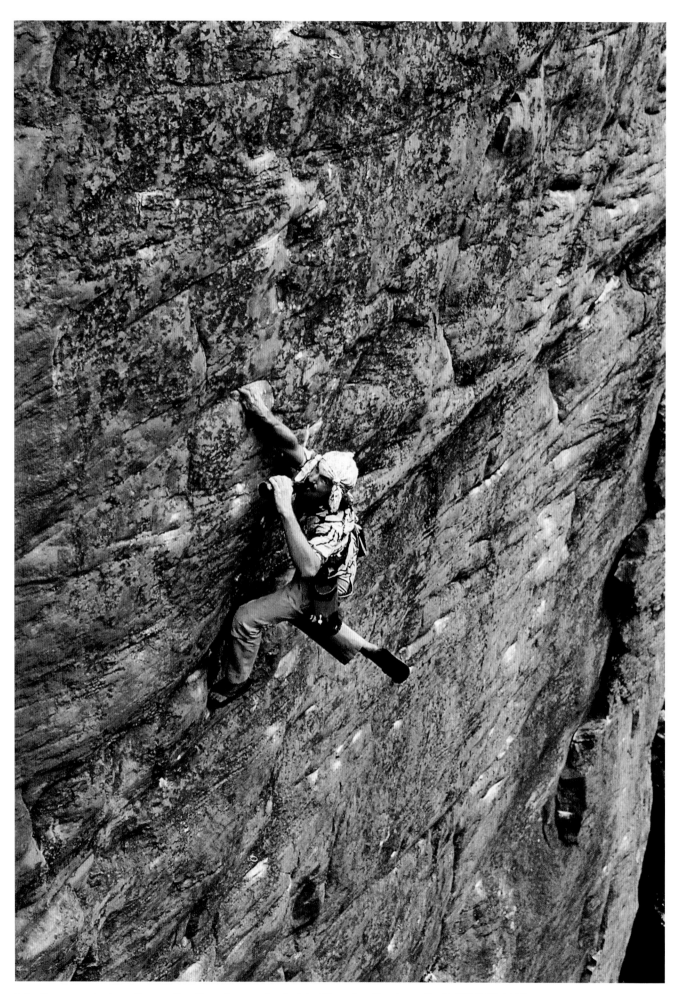

John Sherman enjoying a Coopers Best Extra Stout on Lord of the Rings. Arapiles, Australia. JOHN SHERMAN. *Spring 1988*

Overleaf: Ron Kauk jamming with his way of life on Hotline. Elephant Rock, Lower Merced Canyon, Yosemite, California. GREG EPPERSON. *Spring 2009*

THE TRAGEDY OF THE PATAGONIA PHOTOGRAPHER

John "Verm" Sherman

THE FIRST PHOTO I SOLD TO PATAGONIA was taken on my favorite road trip to Australia. It was the drinking climber shot – the one with the manly dude in the Hawaiian shirt free soloing a virtually blank overhanging wall, sucking on a beer while contemplating the next obviously desperate move.

The picture created quite a stir. The image exuded equal amounts of crazed daring, good-time party feel, and reckless irresponsibility – the cornerstone attributes of the Mythical Patagoniac. Clothing sales soared higher than K2, but not without a fight. Mothers Incensed by Lit Climbing decided to launch an anti-Patagonia boycott. Somehow MILC got it in mind that when the climber topped out he must have blasted half-a-dozen beer bongs then hopped onto a crotch rocket, gunned it to 140 miles per hour to more easily slice kangaroos in half in his desperate rush to get to the pub before happy hour ended only to force two love-crazed emus into the opposite lane causing a school bus full of kids to swerve off the road into a parked natural gas truck refilling the tanks at the local rest home. Nothing of the sort happened of course, but MILC members carried out a plot to jam up Patagonia's toll-free lines to thwart sales. Yvon's directions to his phone operators couldn't have been more perfect. "Tell them," he said, "we'll be glad to take them off the mailing list. We don't want anyone humorless wearing our clothes."

I don't have the figures in front of me, but I'm pretty sure that photo turned Yvon Chouinard from a cat-food connoisseur into a millionaire. But whatever happened to the guy in the pic? Did his contribution result in a lifetime of riches? Well over 20 years later, that guy still lives in a van. I know, because that guy was me.

You see I just wanted to be like the other Patagonia photographers, traveling to exotic locations, shooting good-looking outdoorsy folk doing the sort of stuff most people only dream of. I'd go climbing and surfing and skiing with all these gorgeous gals, then come home and cash fat paychecks for my trouble. Was it John Russell or John Kelly that inspired me? No, the photographer I envied was someone else. Nay, not a man – a legend. His nickname owed less to his tack-sharp images than to his uncanny ability to attract seductive models. He was the Tripod. We all wanted to be the Tripod because in our hearts we knew a day in his life went like this:

Sexy Model: Gee, Tri, I could really use some shorts. You think you could comp me some?

Tripod (carefully examining would-be model's hindquarters): Hmmm, try these.

Sexy Model (tugging shorts on): Oooh these fit so nice and snug, but they don't match my sport bra.

Tripod: I couldn't agree more. Lose the top and we'll shoot those incredible back muscles of yours flexing on this boulder problem.

Sexy Model: Like this?

Tripod (motordrive whirring): Yes, yes, the camera loves you babe!

Sexy Model (clinging to boulder, noticing The Tripod maneuvering to her side): Uh Tri, I thought you were going to shoot my back muscles.

Tripod: The light is better from this angle....

Years ago, I tried the Tripod route. I had my girlfriend Jackie don a Patagonia top while doing some masonry work. Auburn hair swished down her back while torn jean short shorts topped legs any pole would be proud to dance with. In one hand she carried a large chunk of limestone. The other hand firmly grasped a sledgehammer. The shot screamed tough and sexy and independent. They loved it back in the photo department. Yvon gave the thumbs-up. But down in marketing it roused jealousy. Turns out Jackie's legs were "too good." The slides came back – sorry, but no sale. While the Tripod was opening his mailbox to find another fat check, Jackie and I returned to our dilapidated 100-square-foot trailer to dine on ramen, again.

I'd become a victim of my early success. Patagonia had dozens of photographers they could go to for the sexy shots. They didn't want those from me. What they wanted from me was another crazed idiot pic.

So I dug into the files and found the "tent-warming party" shot. It was taken on my last day at the end of another memorable Australian pilgrimage. I had returned to Arapiles a hero on account of a piss-up in the Natimuk pub the last night of my previous visit. From what I'm told, I outdrank the publican. The sheepshearers were glad to see me back and each night challenged me to games of skill – they got free beer every time I lost a game of darts or pool.

Grateful for the windfall, the locals came out to the crag my last day there. We had an epic party. (Years later, one of

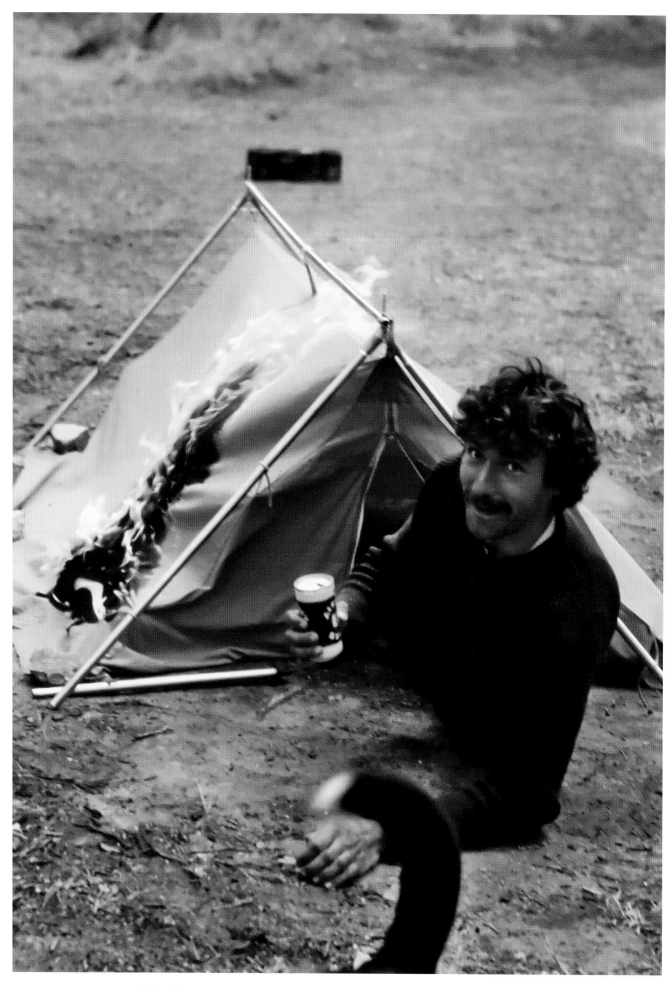

Self-portrait, with flames. JOHN SHERMAN.

the locals thanked me for the injuries he sustained that day when he prematurely launched from the giant rope swing set up at the top of the cliff. "I didn't have to go to work for six months," he said with a grin.) Climbers and shearers were jumping from the roof of one Holden sedan to the next while fresh mutton turned on the barbie's spit. At one point, someone got the grand idea that it would be fun to light a tent on fire. And wouldn't it be cooler if someone was in the tent?

The flames spread so fast, the entire tent was consumed in a couple minutes. The friend handling my camera nailed the shot of me propped up on my elbows, crawling out of the tent, cold one in hand. My smile gave the impression I was oblivious to the conflagration surrounding me. Not so. It was hot as hell. Bingo – instant photo sale.

Unfortunately, not every knucklehead stunt photo sold. Down in the Sonoran Desert, I took a shot of my friend Mike way off the deck free soloing a 40-foot tall saguaro. These days, everyone would assume it was digitally faked, but it was a straight shot. This giant cactus had no spines –

I've never seen another like it. The check was already in the envelope and the stamp being licked when the boys in Legal axed it, worried some environmental group – say, Saguaro-Honoring Irate Ticked-off Seniors – would jam up the phone lines over imagined hordes of climbers descending on the desert. Why, within weeks of publication, every *Carnegiea gigantea* in Arizona would be drenched in the blood of impaled climbers.

As I write this, I'm huddled in my van wondering when the next bolt of brilliant stupidity will strike. Such moments can't be forced; day after day goes by and nothing happens. At night however, my dreams bring solace. In them I have a supermodel girlfriend. Her Patagonia blouse is partially unbuttoned. Suckling on her tautly swollen breast is an orphaned albino tiger cub. I set my camera to RAW mode and move in for the tight shot. A grin creases my cheeks, and a chuckle erupts as I know that the Tripod is on a tropical beach at that very same moment. He's focusing on yet another pair of lithe tanned legs, and wishing he was me.

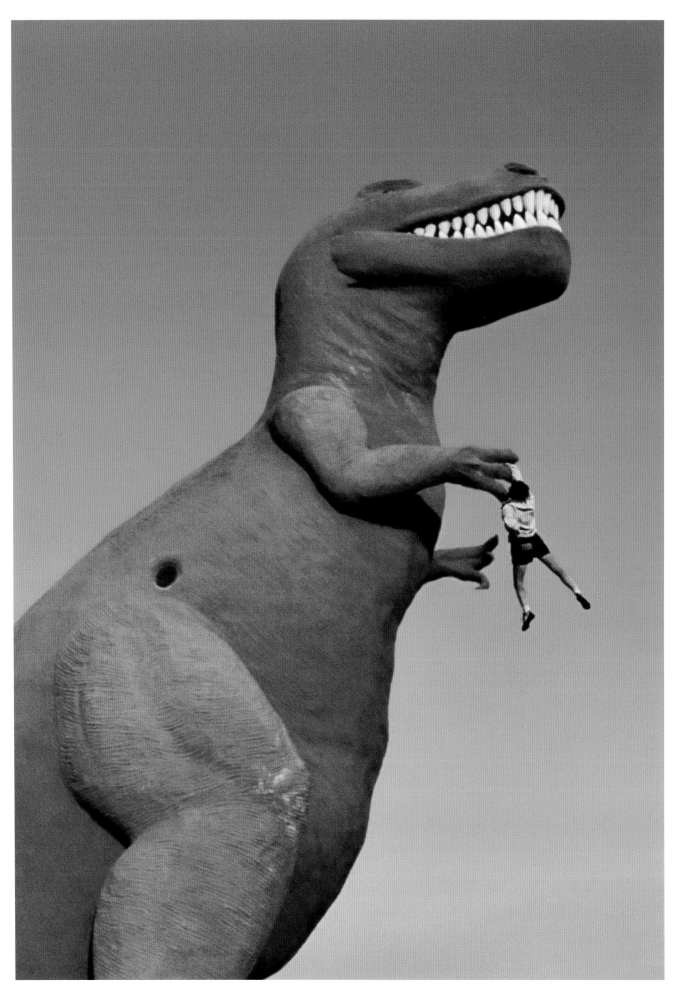

"Rex" the tyrannosaurus and a morning morsel on Highway 10 near Palm Springs. Claude K. Bell, who died last year, spent two decades after his retirement from Knott's Berry Farm building his 100-ton lizard and its companion, "Dinny," on 60 acres of land he owned in the desert. Climbing on them is illegal. GREG EPPERSON. *Spring 1984*

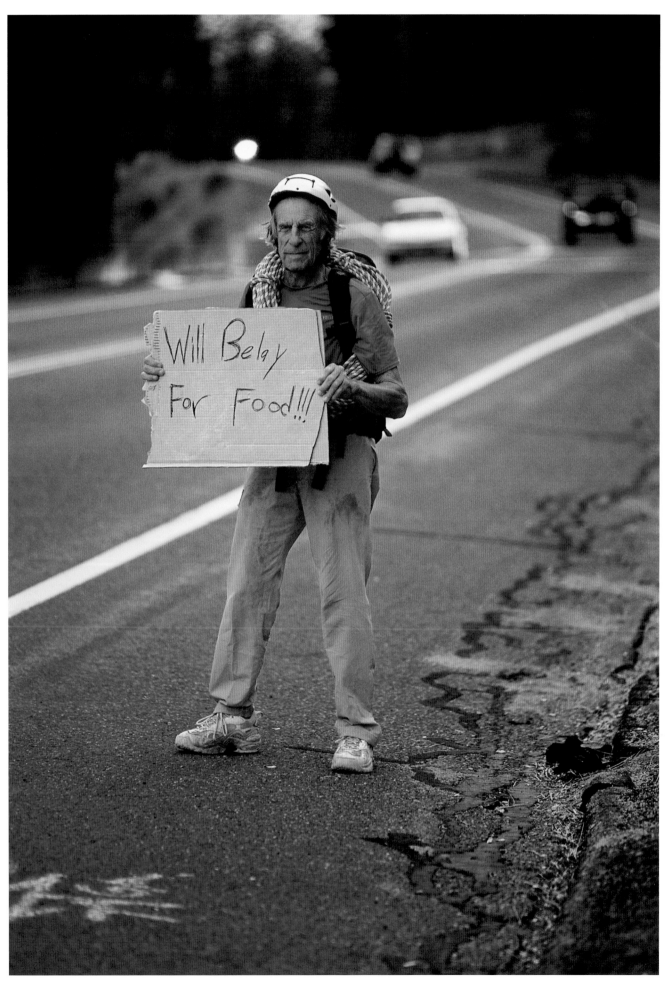

Would you pick up this man? Fred Beckey thumbs a ride to the cliff. South Lake Tahoe, California. COREY RICH. *Fall 2004*

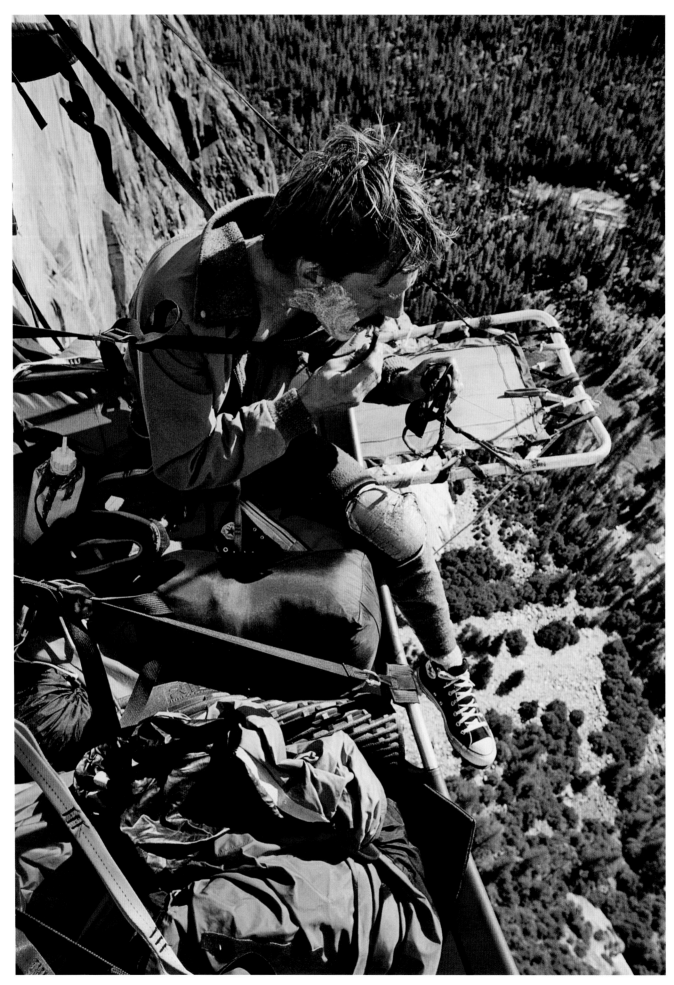

Jeff Perrin maintaining appearances on Aurora, El Capitan. Yosemite, California. GREG EPPERSON. *Spring 2001*

Piton butter sandwich. Jonny Woodward loading at Granite Mountain, Arizona. GREG EPPERSON. *Spring 1991*

Indian Creek manicure. Indian Creek, Utah. DAN PATITUCCI. *Fall 2003*

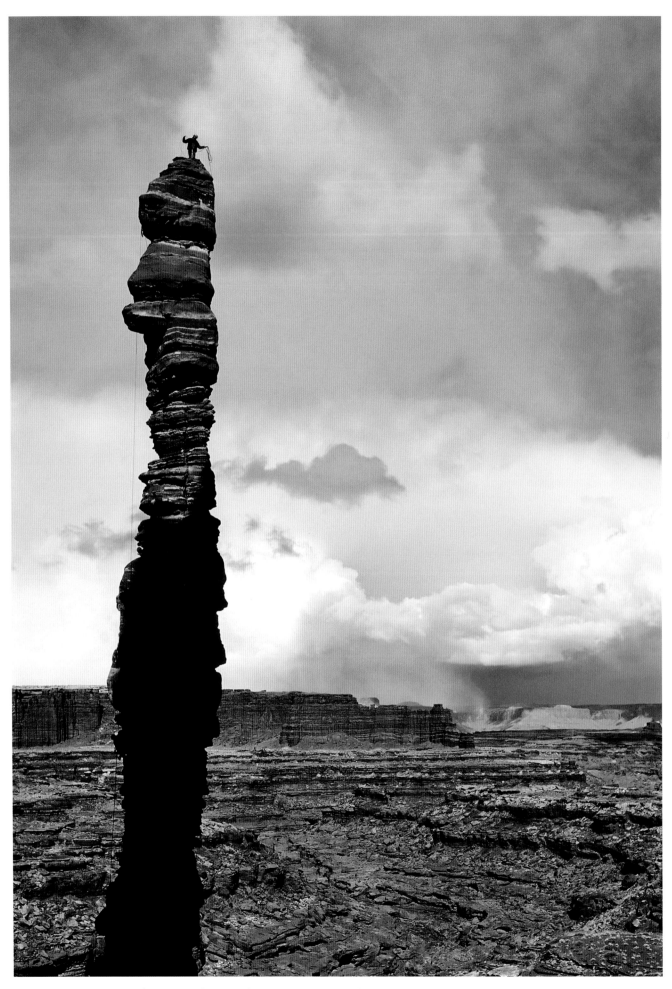

Paul Gagner savors a sweet first ascent of Pixie Stick. Monument Basin, Utah. BILL HATCHER. *Spring 2000*

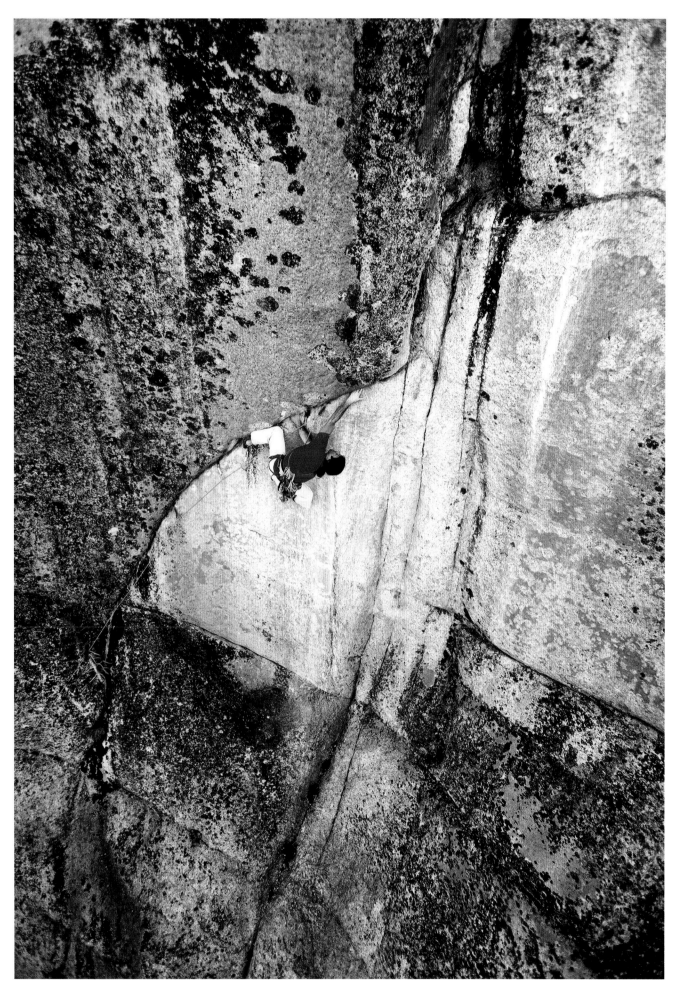

The consummate optimist, Ron Kauk, on Positivity (5.13a). Tuolumne Meadows, California. GREG EPPERSON. *Spring 2007*

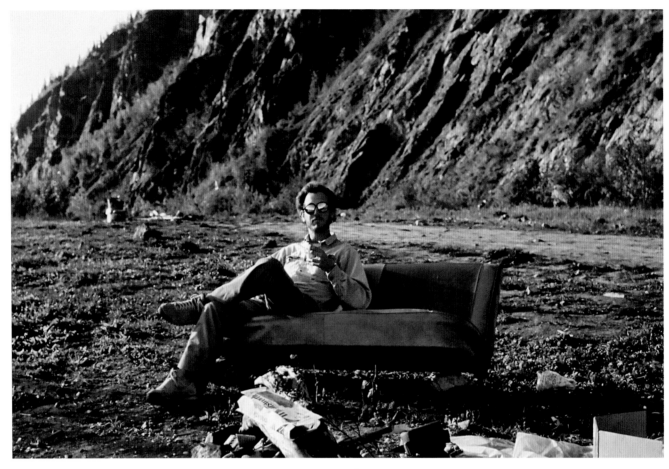

Self-portrait: Duncan Lill at the cocktail hour. Yukon. DUNCAN LILL. *Fall 1985*

Home sweet home. Brian Conry 2,000 feet up the Shield, El Capitan. Yosemite, California. CHARLES FIELD. *Spring 1984*

Cabernet to pale ale four. Hector and Gatito taking a rest day in Camp Four. Yosemite Valley, California. MICHELE BIANCHI. *Fall 2000*

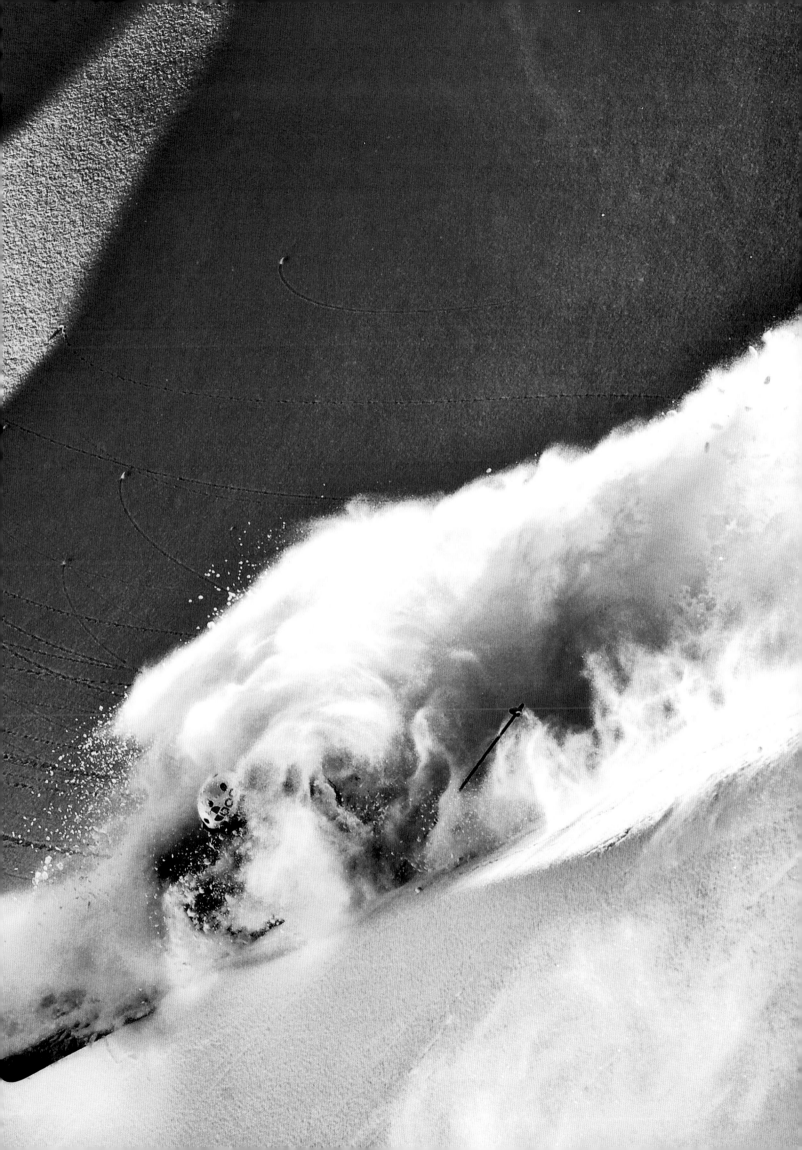

Norm Clasen, Patagoniac in the Cariboos. MICHAEL KENNEDY. *Spring 1983*

Overleaf: Per Huss revels in the cold smoke at Kicking Horse. Golden, British Columbia. NICKLAS BLOM. *Fall 2009*

Georgio Diadola above the Xixa Pangma Glacier, Tibet. DIDIER GIVOIS. *Winter 1989*

Lamb Chop Dag about to set a World Lamb Speed Record. GARY BIGHAM. *Winter 1989*

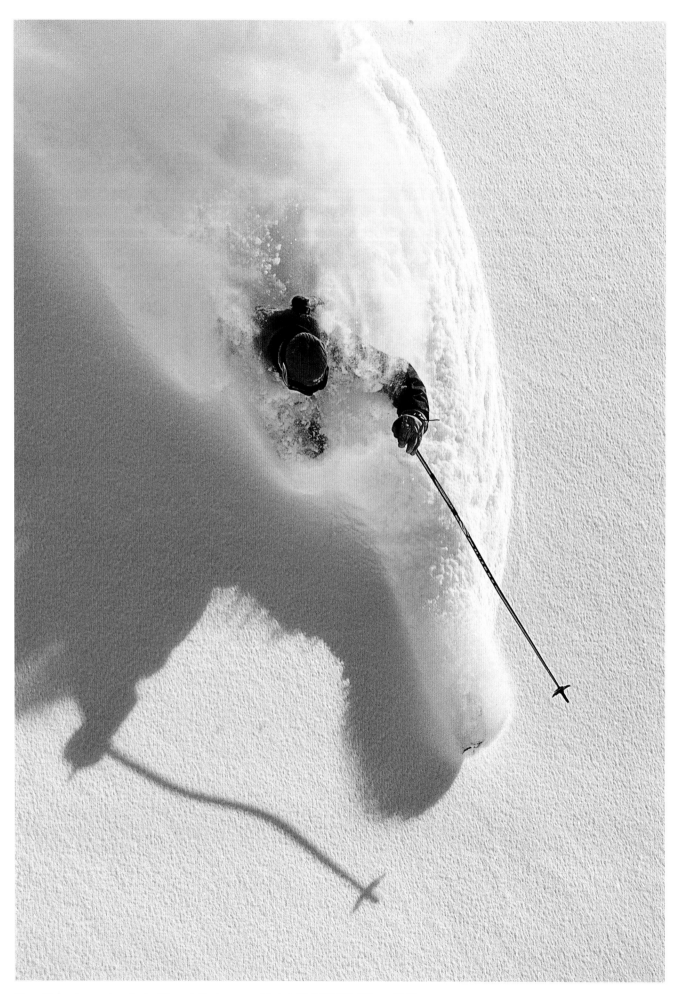

Dave Richards gets deep in the Wasatch Backcountry, Utah. LEE COHEN. *Winter 2002*

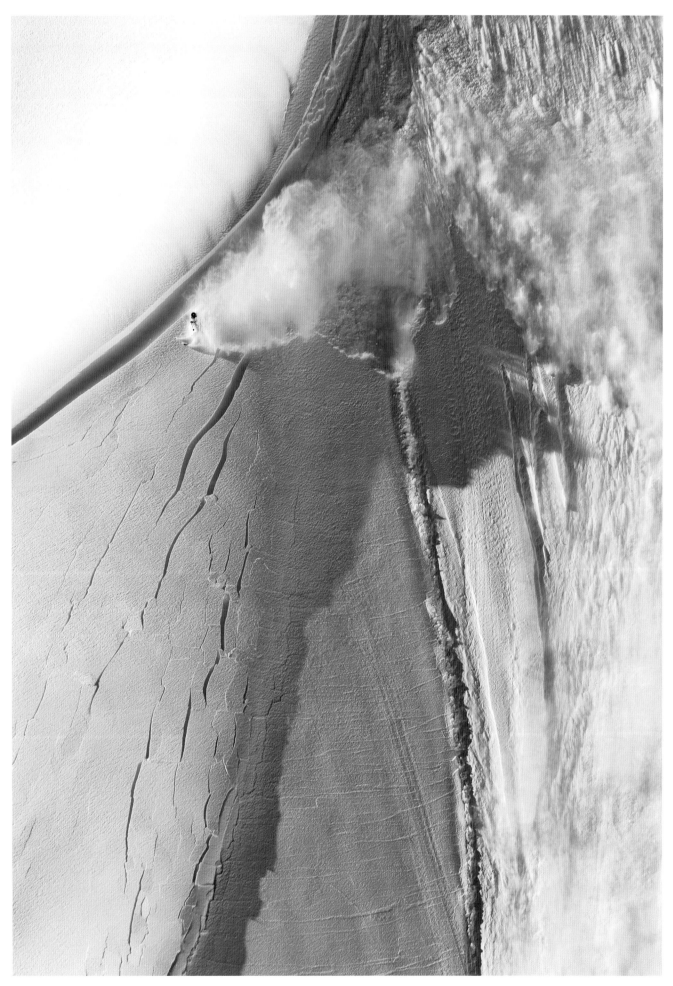

Slough slide to a slab cut, Reggie Crist exits stage right. Haines, Alaska. OSKAR ENANDER. *Winter 2008*

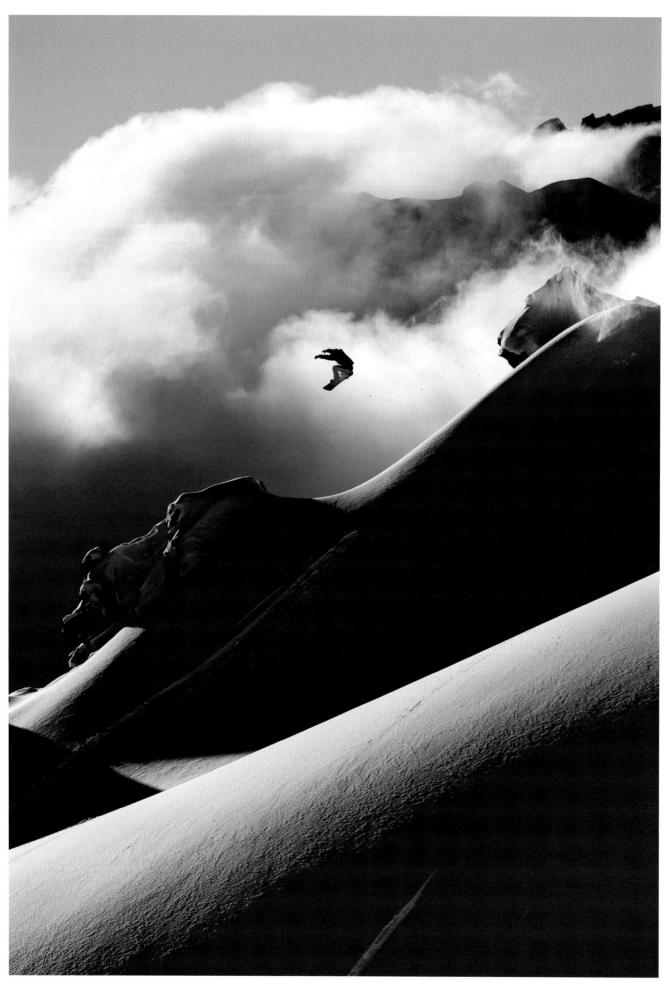

Snowboarder Nicolas Muller rolls up the windows near Methven, New Zealand. JEFF CURTES. *2009*

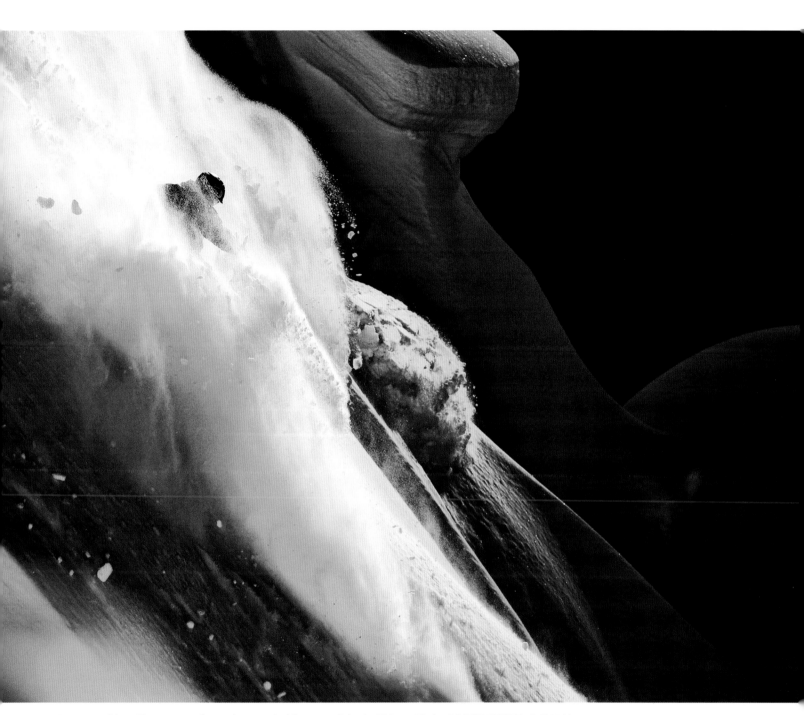

Jeremy Nobis sniffs out a powder stash on a wind-hammered day in Haines, Alaska. MARK FISHER. *Fall 2009*

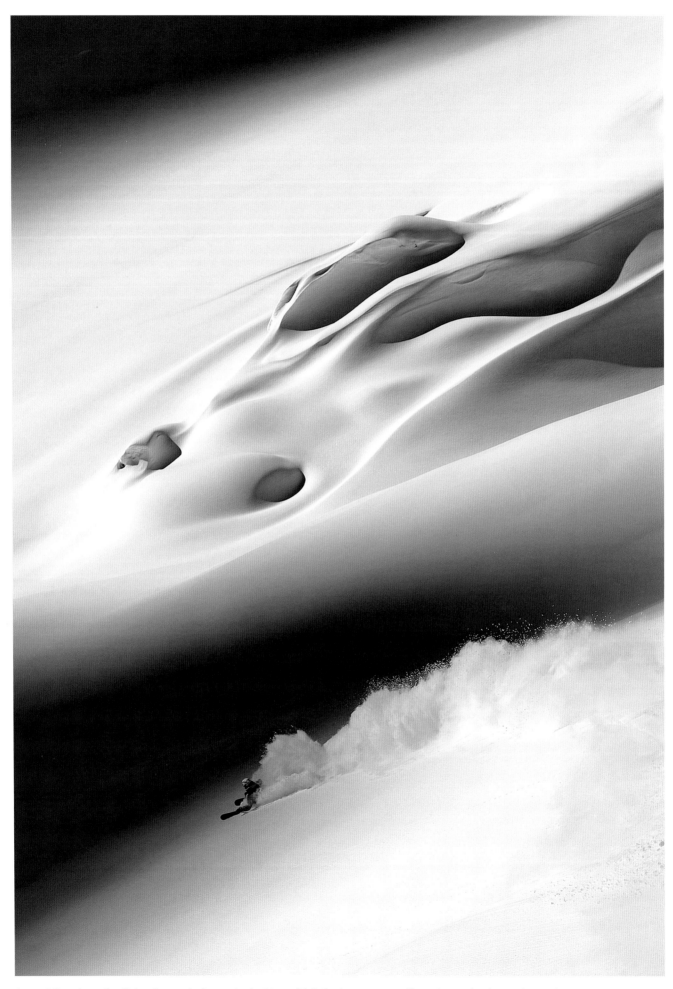

Sverre Liliequist makes light of untracked snow in the Mount Titlis backcountry. Engelberg, Switzerland. OSKAR ENANDER. *Winter 2010*

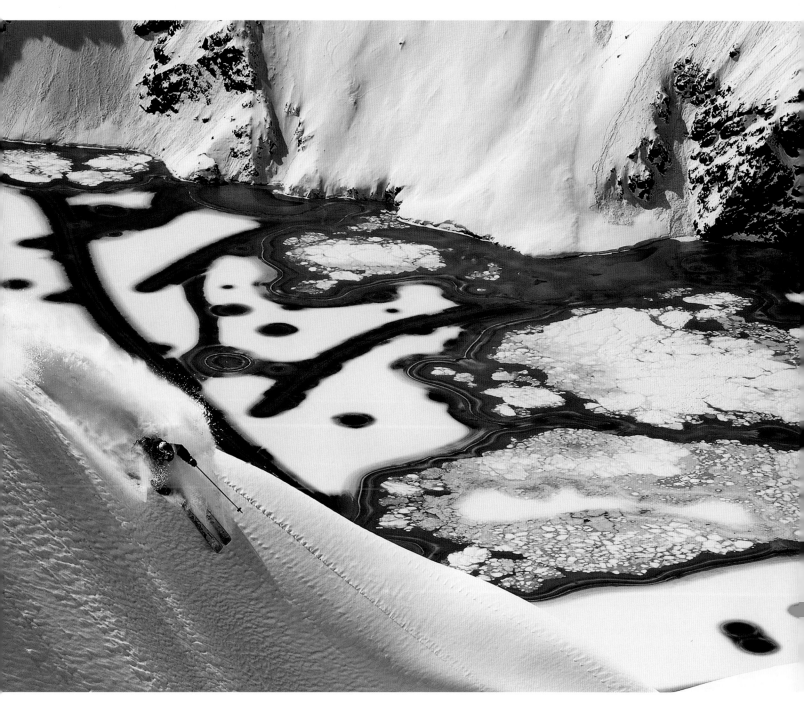

Four days of "summer" in 10 feet of fresh above the eerie ice melts of Inca Lake. Portillo, Chile.
CHRISTIAN PONDELLA. *Heart of Winter 2010*

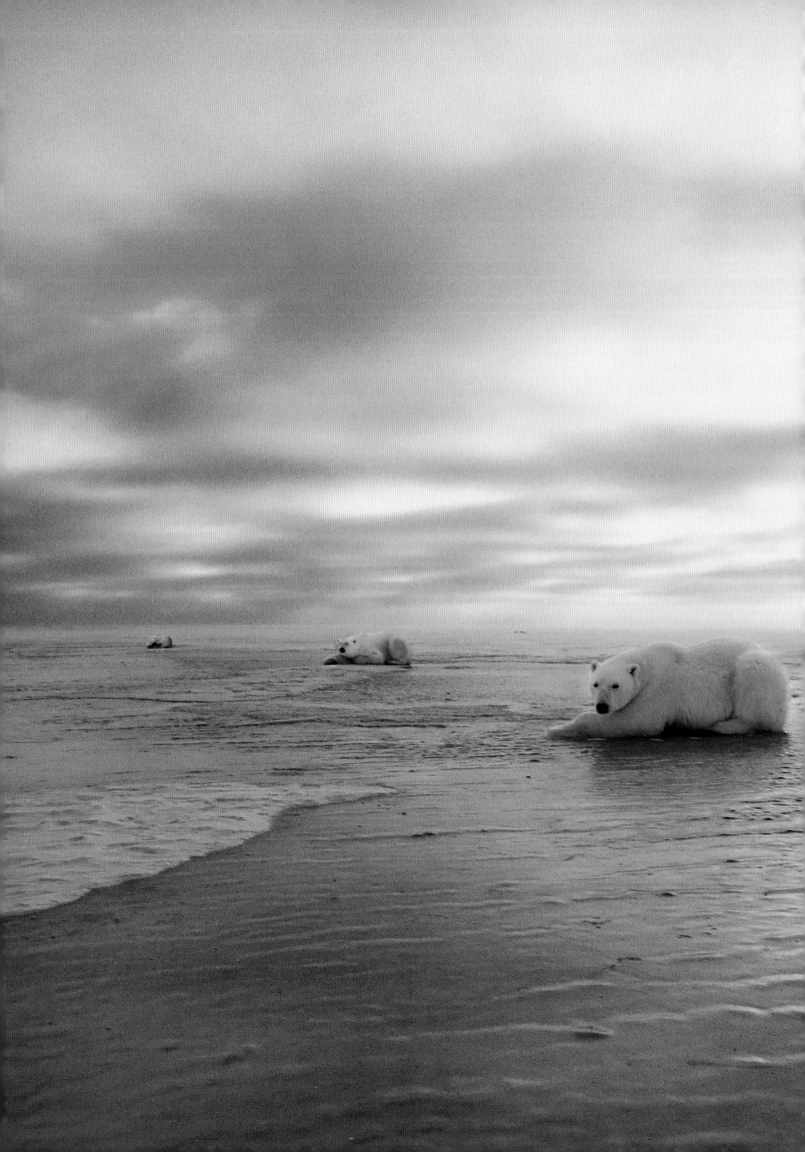

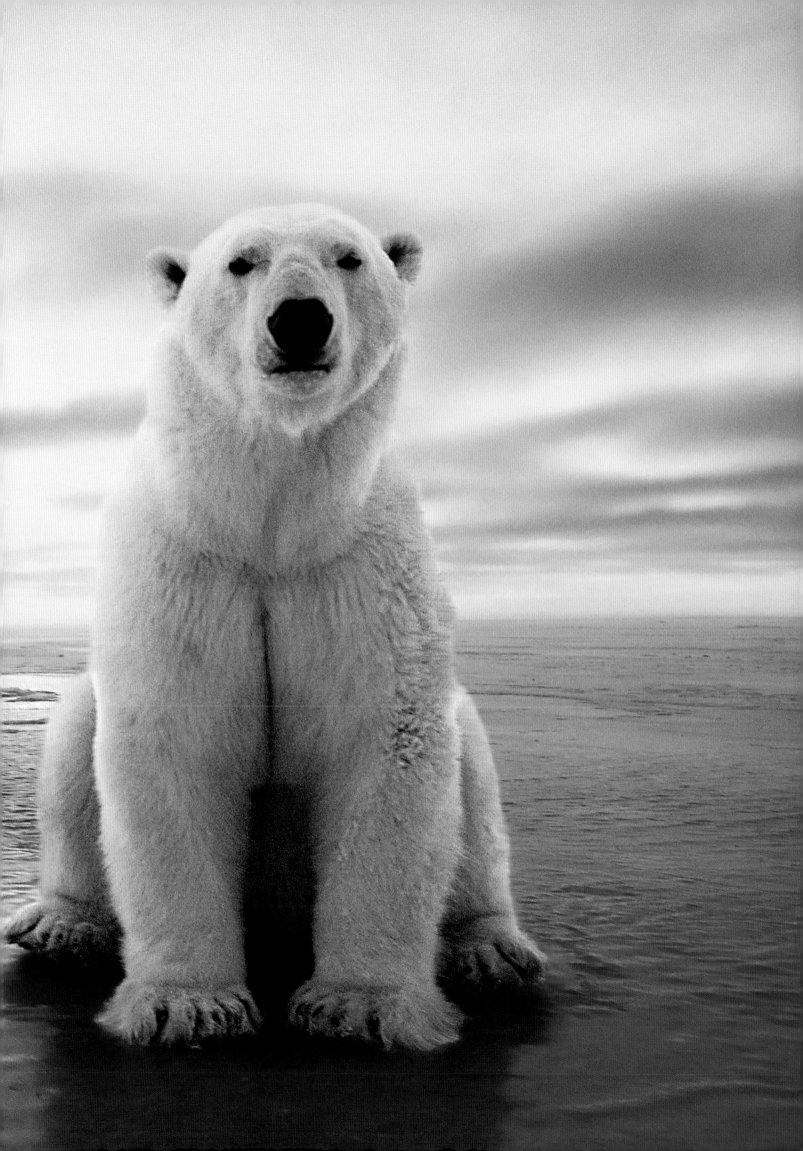

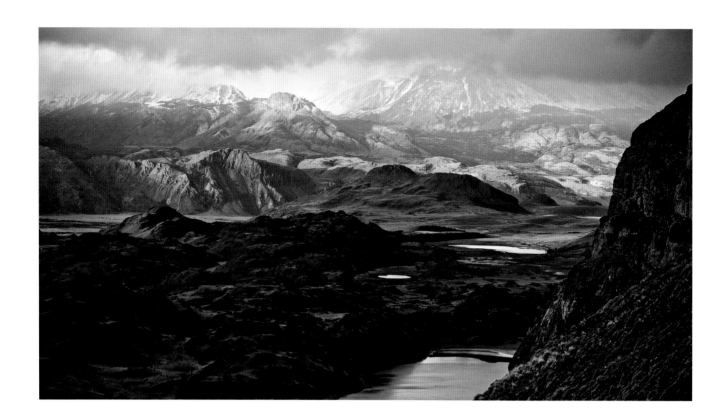

THE ABSENCE OF FENCES

Beth Wald

CROSSING THE FEW KILOMETERS OF NO-MAN'S LAND from Argentina into Chile, we could hear the wind howling across the steppe. We were leaving the dry steppeland behind, traversing a broad, almost imperceptible pass over the Continental Divide. Ahead, the cloud-capped Cerro Lucas Bridges stood sentinel over the entrance to Valle Chacabuco, the long winding corridor that would lead us down to the Pacific. The bad road soon got worse, and the bone-shaking washboards threatened to rattle our old truck to pieces, but neither of us paid much attention to the din.

This was the first time my husband, Rolando Garibotti, or I had traveled through this remote corner of Patagonia, and the anticipation kept us focused on each bend of the road. The valley gradually became more lush, turned to grasslands and wetlands as the road crossed and recrossed the Chacabuco River on rickety bridges. To the south, low-scudding clouds hid the mountaintops, but dense beech forests skirted their flanks – with no roads to violate the green expanse.

Miles of fences lined the road and cut across the valley, but we passed only a couple of ramshackle farms, with cows and calves waist deep in grass and sprawling flocks of sheep. We stopped to watch guanacos prance along a hillside and condors soar on updrafts. We picked mushrooms for dinner and took photos of a rare, tall orchid. We were veterans of many spectacular Patagonia landscapes, and although

Chacabuco was not as dramatic as the glaciers and granite spires of the Fitz Roy and Cerro Torre Massifs in the more southerly Andes, it had a complex, mysterious beauty. We felt as though we were traveling through a special place.

I was here on behalf of my friend Kristine Tompkins and her land trust, Conservación Patagónica, to photograph an estancia CP knew to have a high conservation value. Kris had lived in Chile since 1993, when she left her job as head of Patagonia, married Doug Tompkins, and moved with him to a remote fjord on the Pacific coast. There, she threw herself into the wildland conservation work Doug had begun several years before. Over the years, they bought up nearly 800,000 acres of abandoned or unused land in the surrounding area, including the last great stands of virgin temperate rainforest.

Every autumn, they would leave the rainforest to backpack and explore, farther south and east, the drier, more open spaces of Patagonia. In 2000, Kris created Conservación Patagónica with the goal to preserve the most critical, beautiful and endangered habitats in Patagonia. In 2001, CP bought an old estancia on the Atlantic coast in Santa Cruz Province, Argentina, and created Patagonia's first coastal national park, Monte León, safeguarding the region's largest penguin rookery, nesting habitat for seabirds, a large sea lion colony, and over 25 miles of coastline.

Valle Chacabuco, Chile. BETH WALD.

Now, in 2003, Estancia Valle Chacabuco had come up for sale – and deserved protection. Due to its varied terrain and its position between the desert steppe to the east and the maritime climate to the west, Chacabuco contained a nearly complete representation of Patagonia ecosystems (from steppe to high peaks) that still supported all the original native species of that part of Patagonia: guanaco, puma, fox, viscacha, condors, flamingos, swans, and myriad other wildlife. Most importantly, the endangered huemul deer still inhabited the valley's extensive beech forests.

My friendship with Kris goes back to the early days of Patagonia, the company. I first met her – along with photo editors Jennifer Ridgeway and Jane Sievert – in the mid-1980s, at a trade show in Las Vegas. I was running around the United States then in a beat-up Corolla, a committed member of the dirtbag climbing community and a wannabe climbing photographer.

The first photo I ever sold, a shot of climbing in Fremont Canyon, Wyoming, was published in the Patagonia catalog. I still remember opening up that issue, flipping through the pages and seeing my photo, full page, looking far more dramatic than the 35mm Kodachrome slide I had peered at on my little portable light box. I was now in the company of photographers whom I looked up to and whose work I admired – John Sherman, Uli Wiesmeier, Greg Epperson.

Validation gave me confidence, and the paycheck that followed kept gas in the tank and film in my camera for several more months. I worked hard to improve my skills – to develop an eye for composition, color, perspective, light. I started to bribe my friends to get up before dawn or stay at the crag past sunset instead of heading back to camp for beers. I turned my camera, too, on the gatherings around the campfire, on climbers eating, sleeping, fiddling with their old cars or their colorful gear.

Through trial and error, I learned that I loved, and rather excelled at, capturing life as it happened in front of me. I liked keeping my radar tuned for those moments of serendipity, of action or humor, of light, or any combination of these. Patagonia was a good partner for me in this process, preferring the gritty, spontaneous, and real to the polished or staged – and always interested in new ideas. It was for Jane that I hauled a massive panoramic camera up a frozen Banff waterfall in a snowstorm to shoot an ice climb. And when I started experimenting in grainy black-and-white, Jane was one of the first to show interest.

What I first loved about climbing, coming to it as a girl from the Minnesota flatlands, was that it offered a whole new world. I could immerse myself in an underground but international culture, travel to some of the most spectacular places in the country and eventually around the globe, and viscerally engage in the natural environment in a way that required laser focus and being completely in the present. It was scary but exciting the way the rest of the world dropped away when I was trying some hard move high on a cliff.

Once I started taking pictures, it thrilled me that a photo could communicate to people who had never climbed what it felt like to cling to sharp granite edges three pitches up or spend a night shivering on the side of a mountain.

As photography began to absorb me more, I turned my lens on other worlds that fascinated and compelled me, on faraway cultures and wild places. Such work demanded a laser focus similar to that required in climbing. I needed to be completely tuned in to the environment, the light, the actions and reactions of the people in front of my lens. And if viewers would gasp at a photo of a climber making a pendulum over Yosemite Valley, I thought, maybe they would also be moved by photos of the traditional Raramuri people of northern Mexico – and horrified by the illegal logging that threatened them.

As much as I could, I researched and planned projects and stories that interested me, cobbling together grants and assignments. Sometimes I would just pay for the trip myself. Often, I would call Jane several days before departure, looking for clothes for my companions on the likely chance that we would encounter great "Patagonia" situations. Then off I would go to shoot the story and, in the process, the clothes: to Panama to photograph the effect of industrial banana production on the forest and local people, to the Rift Valley of Africa to cover a mountain bike expedition (and chronicle interactions of wildlife and people), to Afghanistan's Wakhan Corridor to document a wildlife survey and local tribes, and of course, to Patagonia, the place.

I made my first trip to the Fitz Roy Massif and Patagonia Ice Cap with Rolando, from his hometown of Bariloche, Argentina. Patagonia overwhelmed and fascinated me – the crushing vastness and barrenness of the steppe, the surreal blues of huge lakes appearing suddenly out of the desert, the fairy tale peaks crowned with ice, and over all of it, a disconcerting sense of isolation.

It was on a second trip south that I decided to look up Kris in her corner of that southern wilderness. I sent a fax to Doug's office in Puerto Montt and received a fax back with an enthusiastic invitation – and a suggestion that maybe I could help them document illegal logging in the Chilean forests.

It was a hallucinatory journey. Just to get to their farm on the Reñihue Fjord required traveling by plane to Puerto Montt, then by truck and ferry to the settlement of Caleta Gonzalo. From there, a large boat took us into the fjord, where we transferred into a small open skiff to travel to shore. A half-mile slog in rubber boots across muddy tidal flats completed the journey to a cozy wood-shingled house warmly lit by candles and lanterns.

In the days that followed, we explored the moss-choked forest that loomed on all sides of the farm. I photographed both the tangled beauty of the forest and the logging that threatened as-yet-unprotected tracts. On subsequent visits, I traveled deeper into the park to photograph trails and camp-

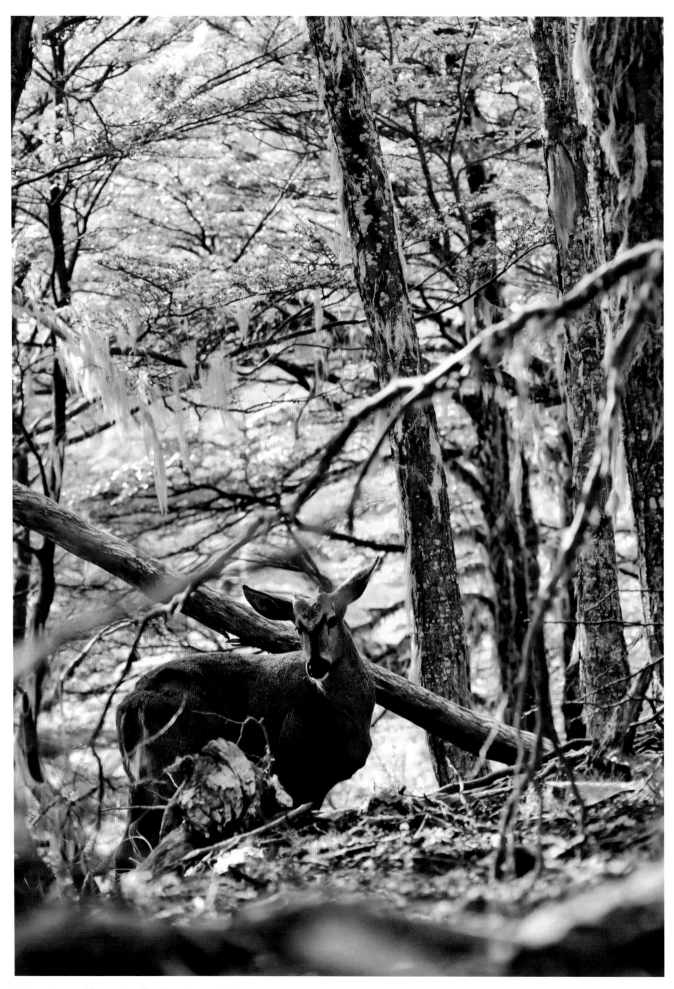

The endangered huemul, Valle Chacabuco, Chile. BETH WALD.

grounds being built, as well as nurseries for native trees and sustainable farming projects. I flew with Kris and Doug to photograph the granite peaks, alpine lakes above the forest, and distant fjords farther down the coast.

Kris and Doug weren't there to guide me during that first trip to Valle Chacabuco – and the task was daunting. From the border we had driven nearly 70 bruising kilometers before cresting a hill to glimpse a turquoise slice of water in the distance – the Rio Baker and the end of the valley. All I could do was try to capture some slice of beauty, some essence of the valley with the time I had. The next morning, the alarm went off at 3:30 am, plenty early so I would have time to find a good spot to shoot before sunrise – a miracle of light and landscape can happen when you least expect it.

There were no stars, no moon, only low clouds and a steady drizzle. As the sky lightened, the clouds lifted a little, revealing a landscape covered in snow, though it was early summer. This was, I decided, my little unexpected miracle and the only one I had to work with that morning, so I started shooting – clouds swirling over peaks, distant beech forests coated in white, and then, on a pond near the road, a pair of black-necked swans floating on reflections of snowy peaks. The swans are shy birds, so I carefully slid my way out of the car with a tripod, snuck a few steps closer before they started to get nervous, and got ready just in time for them to take off.

Days of rain and frustrated shooting followed, soaking my clothes, camera equipment, and ambition. We headed north in search of drier ground, knowing that the work was unfinished, that I would have to return. I have learned that Patagonia requires time, patience, a great deal of desire, and willingness to risk failure. Often, I have had to return again and again to accomplish what I set out to do. I have slogged through horizontal rain, laden with camera gear; spent days pinned down by storms in a tent; climbed all day to a ridge only to see the next morning's sunrise obscured by thick clouds. But then, when I am least expecting it, a ray of pink dawn light strikes a distant peak above blue glacial ridges on the ice cap or a huemul deer steps delicately from her forest hideout into a clearing and the frame of my camera.

Conservación Patagónica purchased the Estancia Valle Chacabuco in 2004, soon after my first visit. The estancia had comprised the whole valley – from the border to Rio Baker and both sides of the river, south to the higher peaks and Jeinimeni Reserve – and it could now be connected to existing reserves on either side to create one vast protected area the size of Grand Teton National Park.

Rolando and I were able to return to Chacabuco in March, 2008. We drove again through that same no-man's land between the borders, crossed into Chile, and again passed Cerro Lucas Bridges, which guards the eastern entrance to the valley. This time, the day was crystalline, and as we drove west, the skyline of peaks to the south etched a hard, jagged line against a blue sky with a few fluffy clouds. The vegetation was the faded yellow of late summer.

The landscape felt somehow changed, and soon we noted the absence of fences. Rolls of the old barbed wire fencing lay scattered here and there along the road like giant prickly caterpillars. Rounding a bend, our truck rattled into one of the large open meadows with tall, wavy grass stretching into the distance. Instead of cows, however, the valley was full of guanacos. We startled those close to the road, and they loped away for a few yards, then stopped to peer at us with dark curious eyes, ears erect. We stopped and returned their gaze in amazement and delight, feeling we had stepped back 200 years into the primeval landscape. I took no pictures. Sometimes the cameras have to stay in their bags and you have to just let wonder wash over you.

Break at the Refugio Upsala. Kris McDivitt in Patagonia. KATE LARRAMENDY. *Fall 1991*

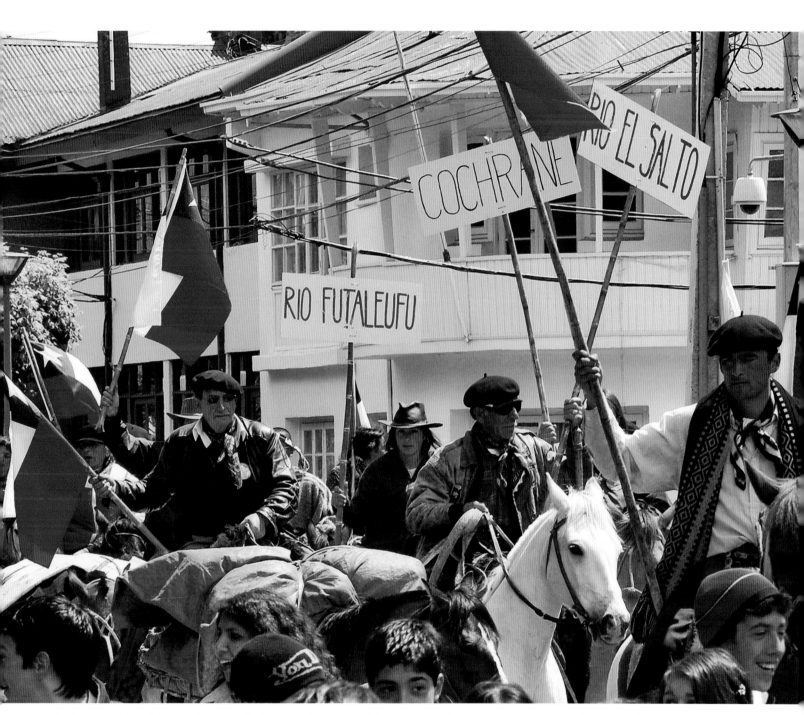

Riders in the 2007 Cabalgata Patagonia Sin Represas (Horseback Ride for a Patagonia without Dams) protest HidroAysén and its plan to put five massive hydroelectric dams on the Río Baker and Río Pascua. HENRY TARMY. *Fall 2010*

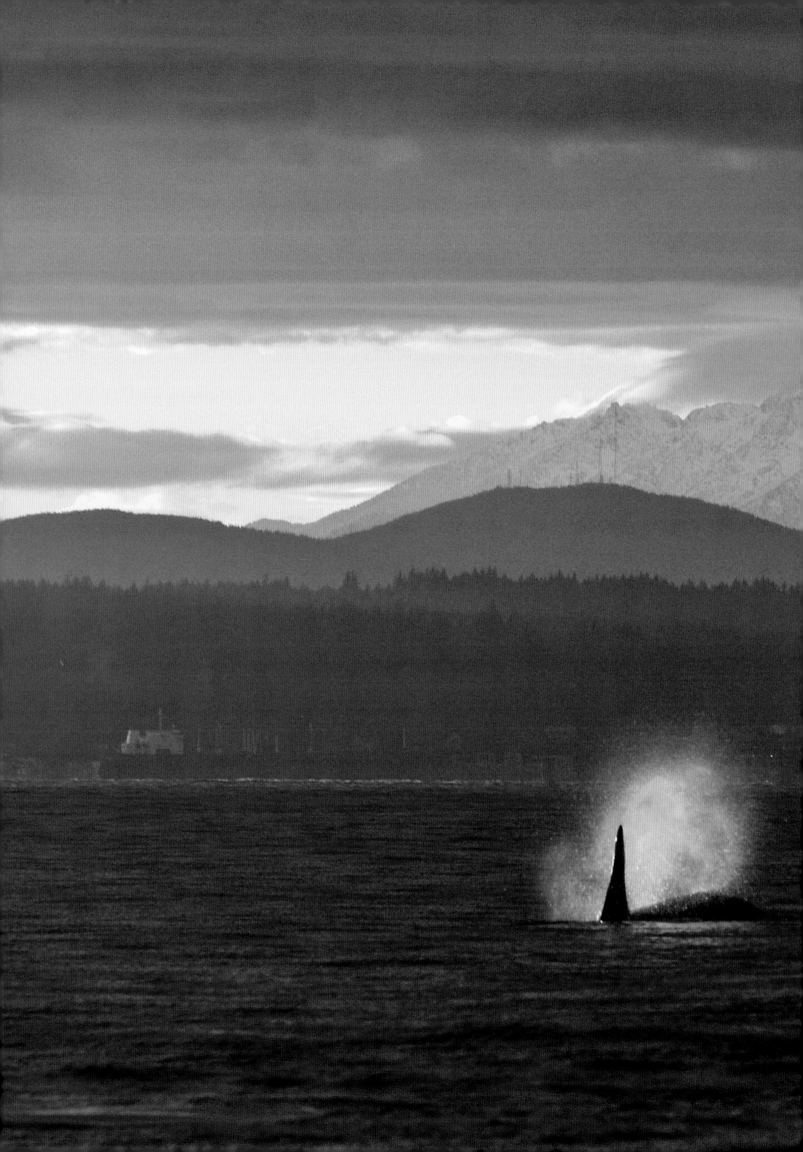

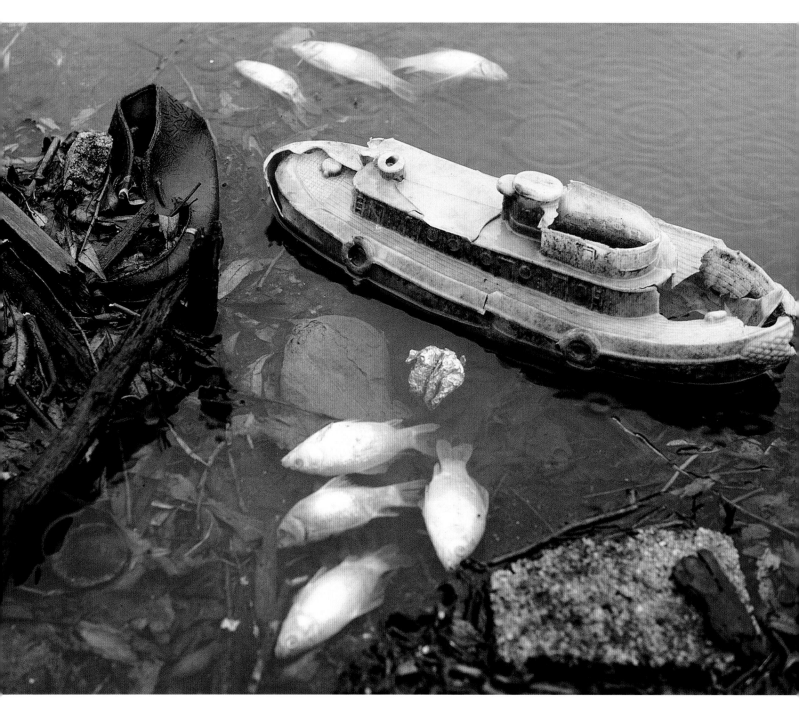

Water pollution. Spectacle Pond, Lincoln, Rhode Island. JACK SPRATT. *Spring 1989*

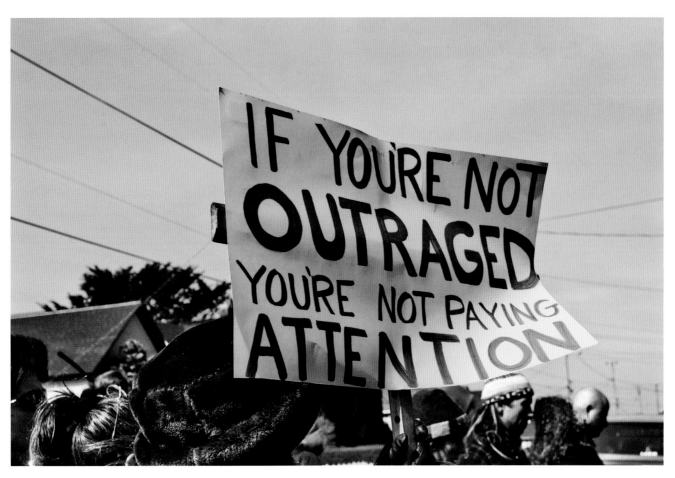

Iraq war protestors demand attention at an annual peace rally. Eureka, California. AMY KUMLER. *Spring 2008*

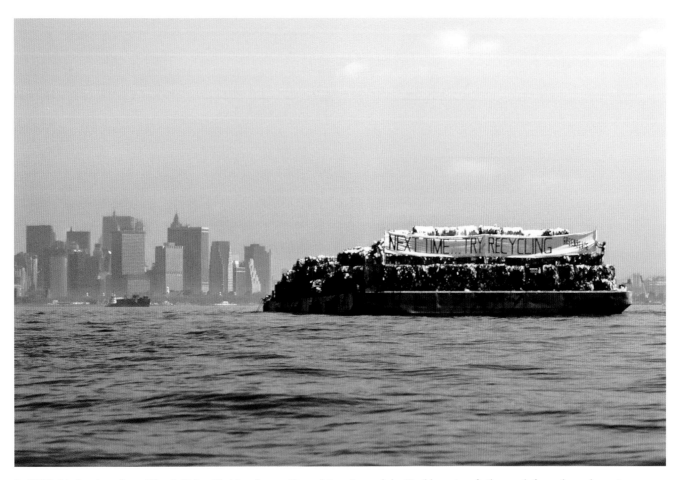

In 1987, this "garbage barge" hauled New York's refuse to Central America and the Caribbean in a futile search for a cheap dumpsite. Since 1986, U.S. toxic wastes have been dumped in some of the world's poorest countries, including Haiti, Guinea, and Zimbabwe. DENNIS CAPOLONGO/GREENPEACE. *Fall 1993*

Day 75: Julia Butterfly treesitting in an ancient redwood slated for cutting by Pacific Lumber. Headwaters Forest, California.
ERIC SLOMANSON. *Winter 1998*

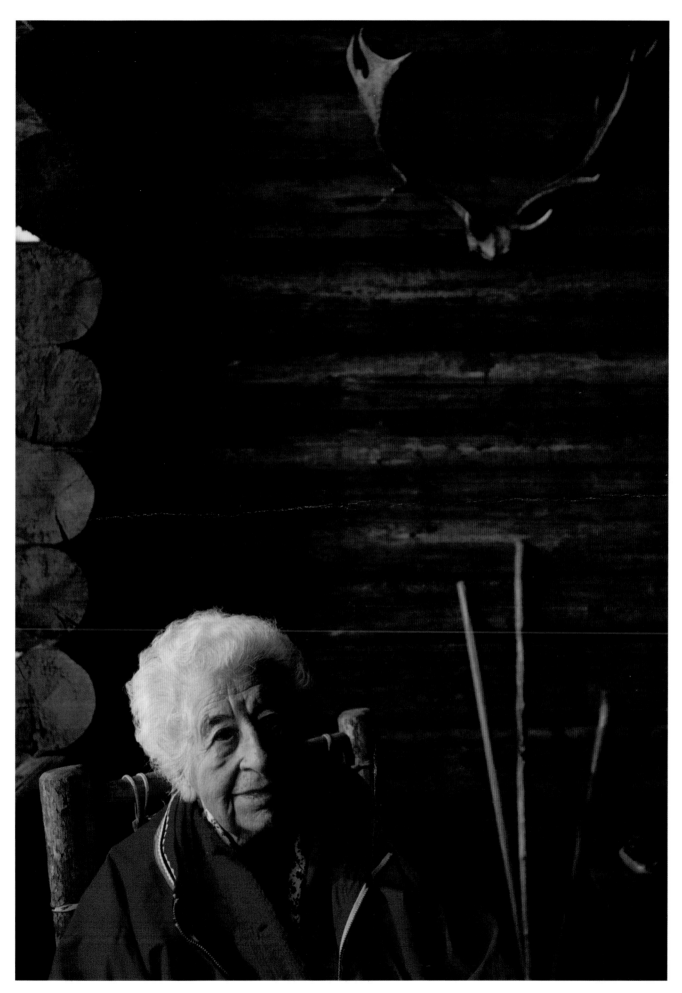

Mardy Murie on the front porch of her home in Moose, Wyoming. October 18, 1990. GREGORY HEISLER. *Spring 1991*

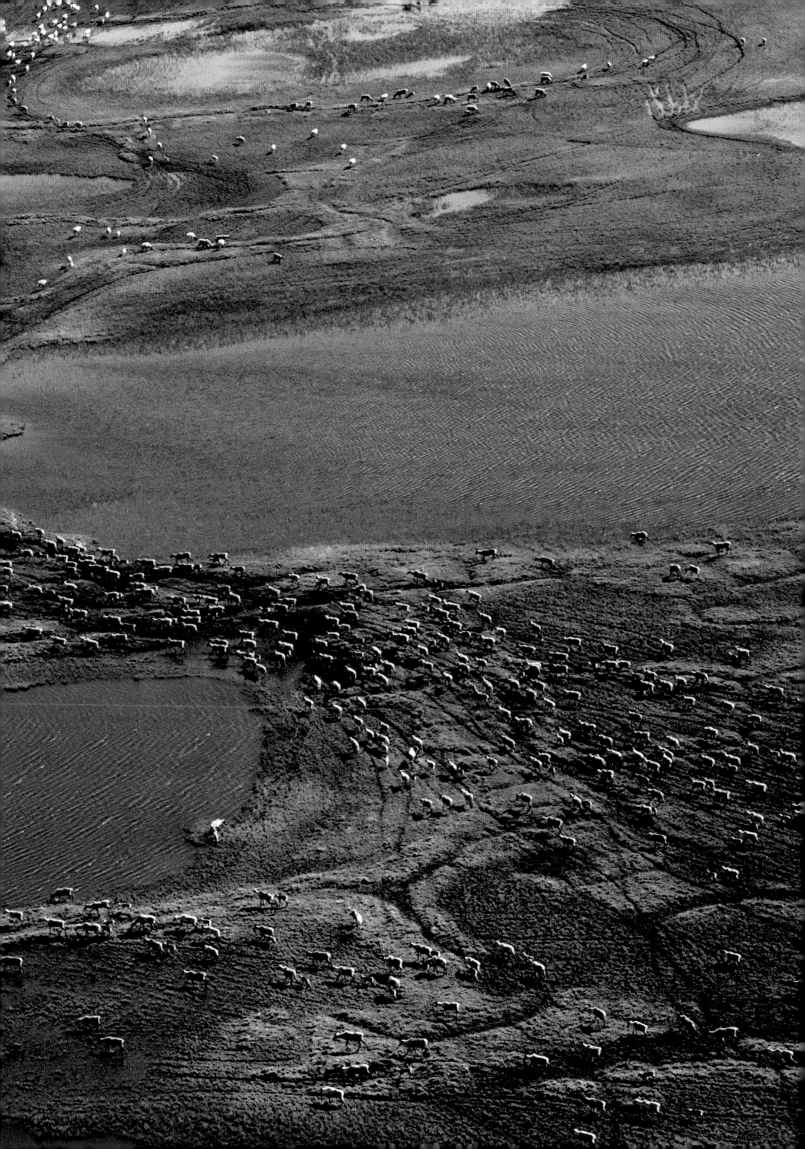

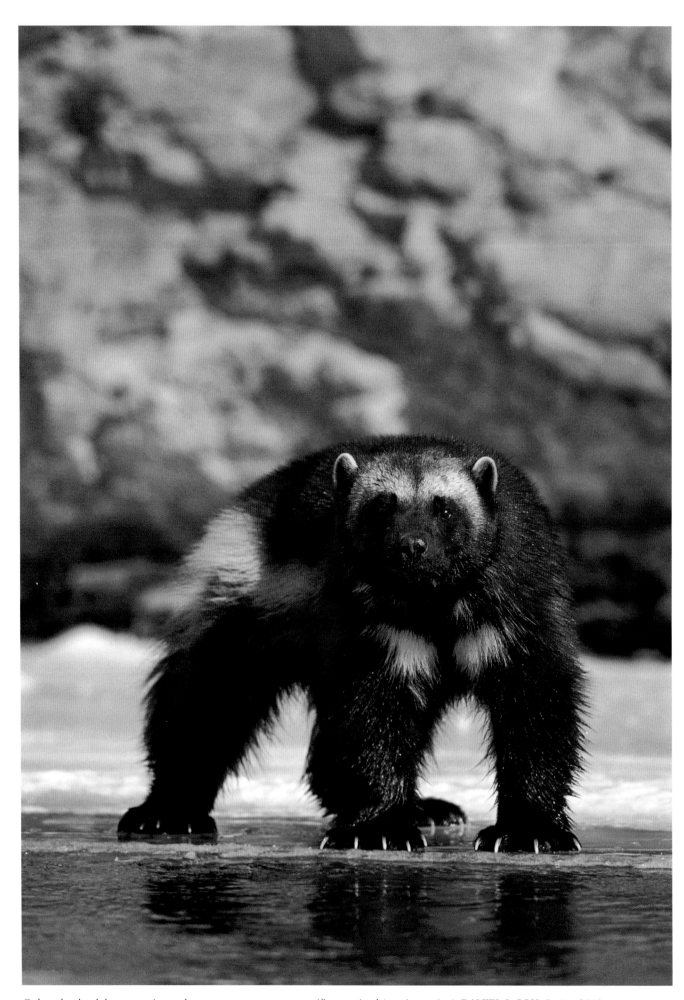

Gulo gulo, skunk bear, carcajou, gulon – many names, one magnificent animal (captive setting). DANIEL J. COX. *Spring 2010*

Overleaf: Porcupine caribou in velvet, crossing the Kobuk River during their fall migration. Brooks Range, Alaska.
MICHIO HOSHINO. *Fall 2004*

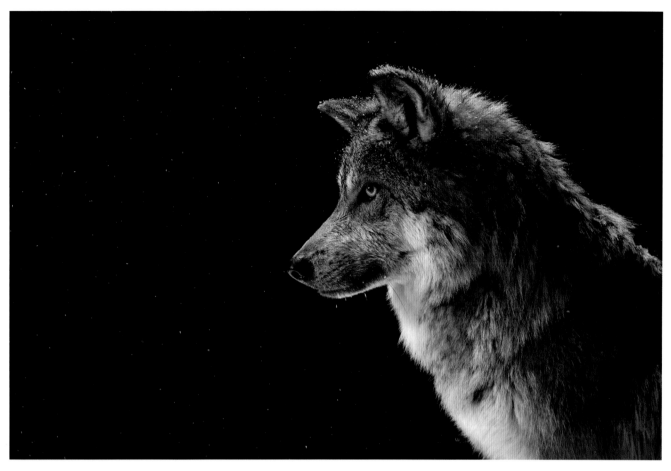

An endangered Mexican gray wolf (*Canis lupus baileyi*) at the Wild Canid Survival and Research Center in Eureka, Missouri. For general info on Mexican gray wolves, see wildcanidcenter.org/Home/default.htm. JOEL SARTORE. *Winter 2009*

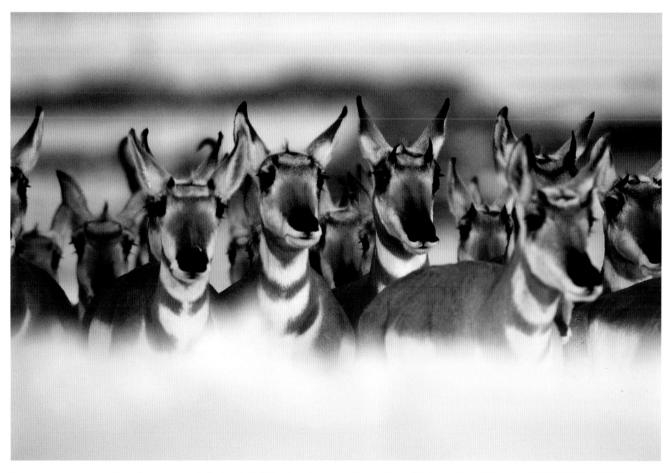

Female pronghorn on Cora Butte, part of the herd of 300 migrating from Grand Teton National Park, Wyoming. JOE RIIS. *Fall 2009*

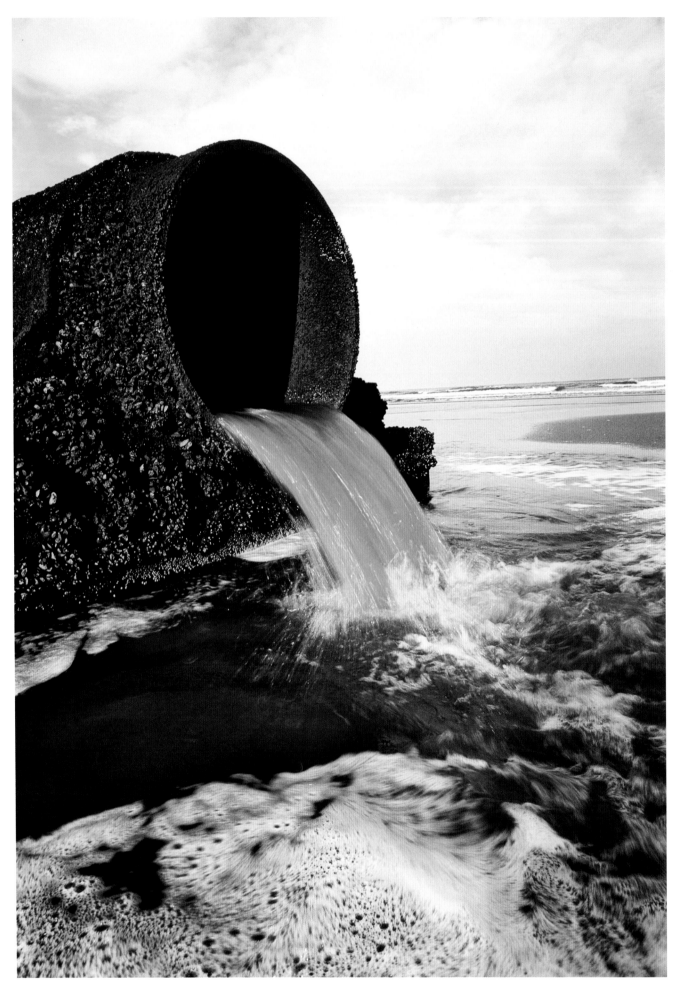

The effluent society. DAVID WOODFALL. *Spring 2006*

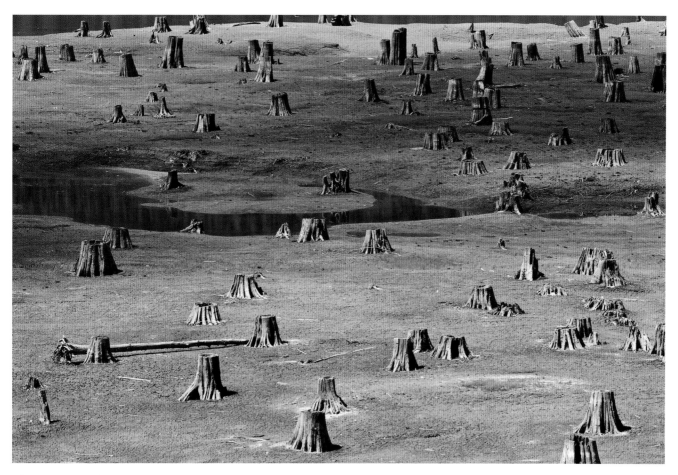

These remnants of a once-magnificent old-growth were victims of ill-conceived dam projects along the Duncan River in British Columbia. STEVE OGLE. *Spring 2009*

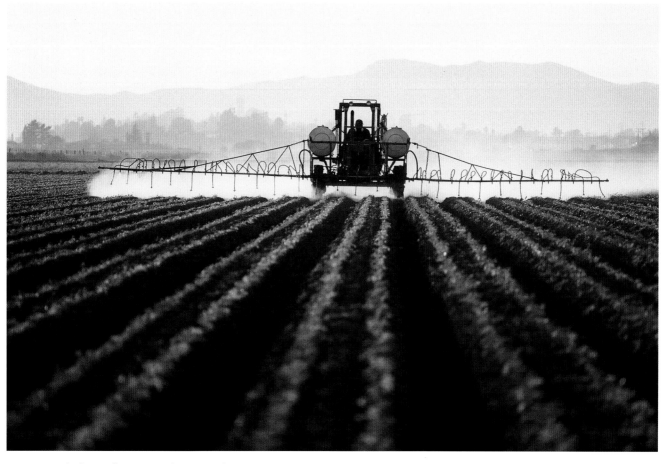

Conventional, chemically intensive farming techniques. MICHAEL ABELMAN. *Spring 1998*

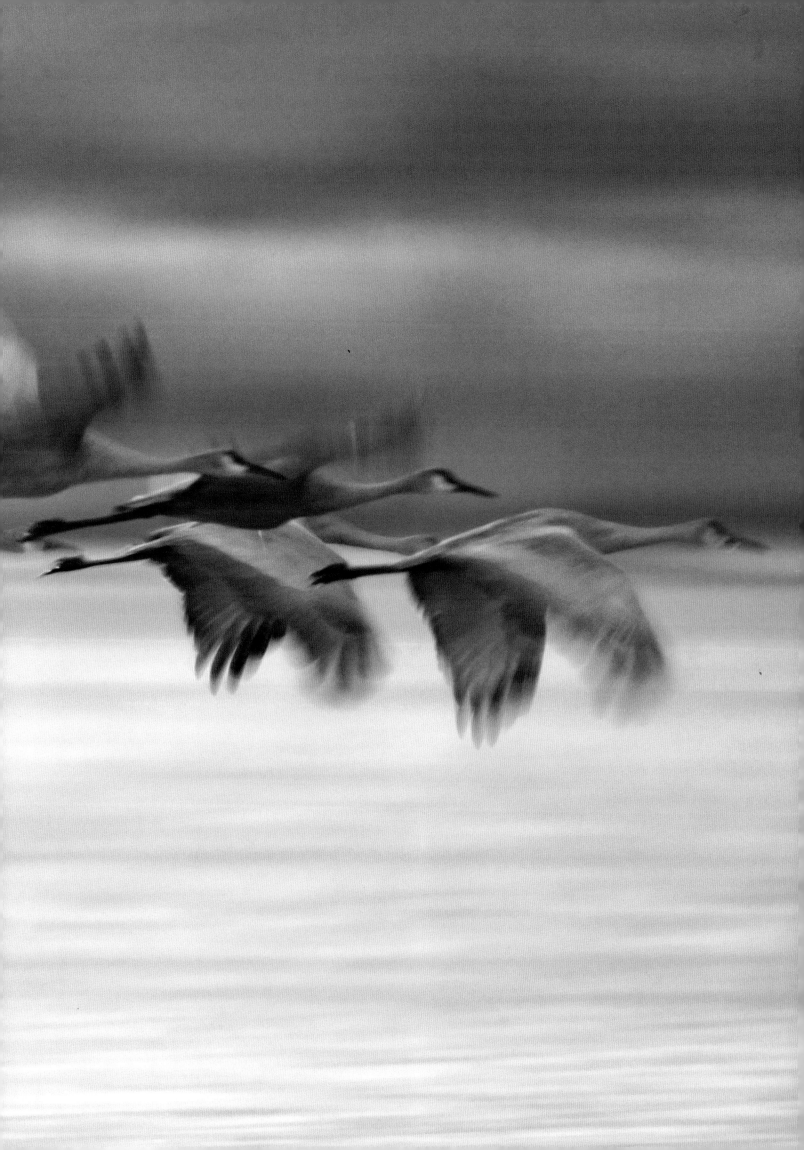

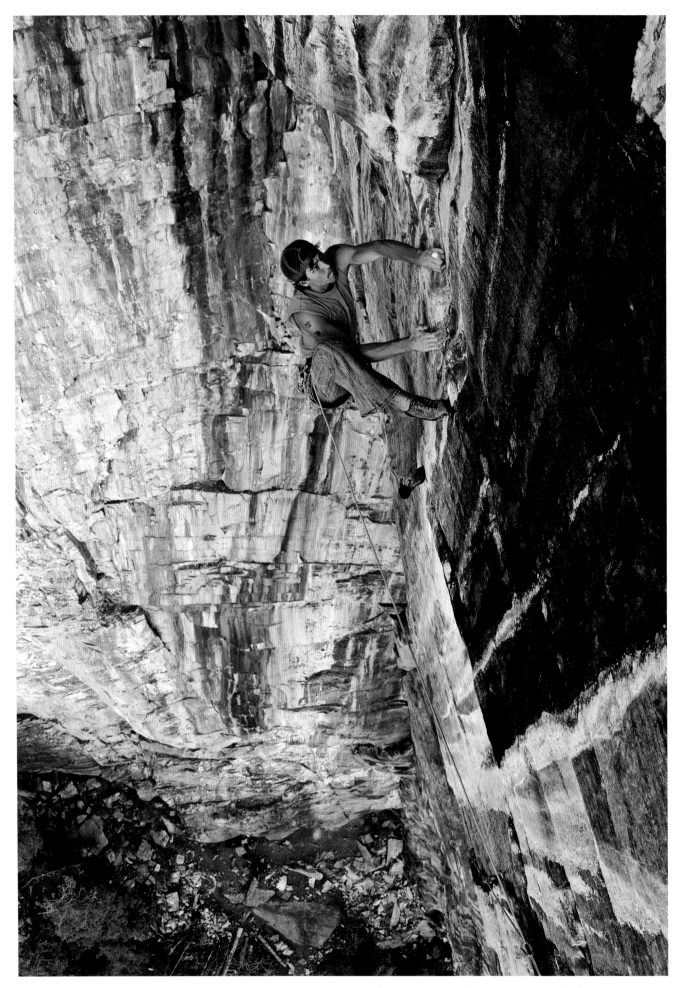

Patagonia climbing ambassador Sonnie Trotter, through the crux and gunning for the anchors on the crimpy 5.12 headwall runout of the Path (5.14R) at Lake Louise, Alberta. CORY RICHARDS. *Late Summer 2008*

Overleaf: Form follows function: spring migration of sandhill cranes. Platte River, Nebraska. THOMAS D. MANGELSEN. *Early Spring 2001*

PERSPECTIVE

Cory Richards

IT'S 9:24 PM AS THE DIM LIGHTS OF IMLAY, Nevada, rush past in arid darkness. We've been on the road for two weeks, driven over 3,000 miles, and I am exhausted at the wheel. My dozing copilot, Will Stanhope, drools on himself. His savaged, chalk-covered fingers twitch in his sleep.

In the rearview mirror, the glow of Sonnie Trotter's laptop lights up his tired face and pursed lips. He's slouched in a legless brown pleather waiting-room chair we picked up back in Ventura as a fancy replacement for the missing back seat of his '89 GMC Safari. A package of double chocolate Chips Ahoy lies empty in his lap. I sip my 53-cent roadside coffee and gaze out onto the straight black pavement stretching into the desert's infinite night. I hear only the tap of Sonnie's fingers and Will's heavy breathing. Reaching for my camera out of instinct, I grasp it firmly, pause, and gently set it down.

The first time I realized I wanted to meld work and passion, I was camped in the Don Sheldon Amphitheater, deep in the heart of the Alaska Range. I was 18, locked in the Ruth Gorge, doing typically mild ascents up the backsides of the infamous peaks that rise like the great granite teeth of a sleeping giant. I wanted to climb them by their fierce passages and take photographs of everything that surrounded me. So I did.

A year later, steps from the summit of Denali, I was feeling proud of myself – until Mark Twight, Scott Backes, and Steve House motored past me at the Football Field. While I was ready to vomit, they seemed to be enjoying a light jog at 20,000 feet. I reached for my 1984 Ricoh point-and-shoot and snapped a few shots of them as they passed me and the rest of the mongrel horde slogging its way to the apex of North America.

Two weeks after returning from Denali, I packed my bags and boarded a plane for Lima and the Cordillera Blanca of Peru. I was hell-bent on becoming as amazing as my heroes – and documenting the process. I wanted to – had to – climb, travel, be in the mountains, and stare every morning onto foreign landscapes washed pink by the rising sun. I didn't recognize that I was rapidly approaching an awkward disjuncture between what I wanted to *do* and what I wanted to *be*. I don't think I would have cared had I known.

When I returned from Peru, I began my first painstaking editing process. I spent hours bent over an 8" × 8" light box, puzzling over hundreds of slides going nuts, unable to recognize my best work. Eventually, I sent 20 slides from the previous two summers to Jane Sievert at Patagonia – and got a letter back.

Dear Cory,

Thanks so much for your submission. You have some really great images here. Unfortunately, your work does not fit our immediate photographic needs. Thanks for considering us and please don't hesitate to submit more material in the future.

Best, Jane

P.S. I think you can probably turn the date-and-time feature "off" in your camera to avoid those annoying little numbers in the corner.

How cool – a response! I fell instantly in love with Jane. After all, she had said that I had "some really great images." Familiar with the trials of all great artists throughout history, I felt like a bona fide photographer with my first rejection in hand.

During the summer of 2000, high on the Frendo Spur above Chamonix, I snapped what would be my first published photograph – of Stian Hagen as he climbed steadily toward me, the valley below cloaked in shadow while the high peaks began their daily bath in early morning sun.

I moved to Europe to study fine art photography under an American named Andrew Phelps. He believed in me, and I began to believe in myself. But the road to melding passion and work proved to be longer than anticipated. A year later, I moved back to the States, ultimately landing in Seattle. I spent several years taking photographs, going to school, and getting rejection letters. I began to wonder if all these editors were just saying nice things, afraid to tell me that I was in fact a terrible photographer and should do something else. But I kept taking pictures.

Eventually, I quit school to take a job as an assistant for fashion photographer Bill Cannon. I justified my decision by telling my parents and myself that I was a better "hands-on" learner. That turned out to be the truth. I could study the craft and make money doing it – and it helped fund my next road trip or flight.

The summer of 2003 found me emerging from a tent high on Mt. Logan, greeted by what would be my next published image. Exhausted from 20 days on the mountain, Dave

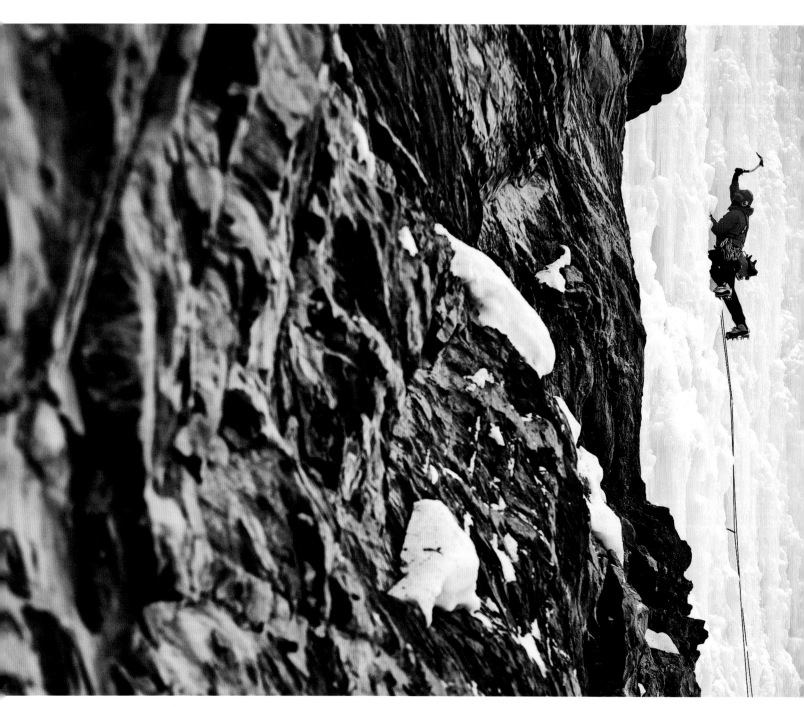

Making steep ice look tame is how Patagonia alpine climbing ambassador Barry Blanchard made his passion into a profession. Just another day on the Carlsburg Column. Canadian Rockies, British Columbia. CORY RICHARDS. *Summer 2008*

Garrow sat in spindrift, as though he had given up all hope, a 1,000-yard stare shining with dull intensity from behind his goggles. I reached for my Nikon F100 and fell in love with Jane all over again when the image appeared on page 84 of Patagonia's Winter 2004 catalog.

After returning from the mountains, I turned my attention to the South Seas. Packing my cameras and board shorts, I hopped a plane bound for Cairns, Australia. I paddled a sea kayak for 41 days along 1,000 miles of the Great Barrier Reef with five friends. I watched my lenses fog and bodies corrode. It was an education defined by saltwater, crocodiles, and sand flies. I shot hundreds of rolls of film – not a single image was bought or ever made it to print.

Photography, travel, and adventure – they added up to the sum of my early 20s. I fell in love with a wonderful woman eight years my senior and started to live a regular life, shooting fashion photography, filing invoices, and paying bills on time. But while I dreamed of the next journey, she dreamed of little ones. I spoke of names like Jimmy Chin and Steve House; she spoke of names for our children. We fell apart, and I retreated into film and travel. I got depressed, slept in, ran 40 miles on Sunday, got stoned, and literally constructed a bed (far more impressive for a potential girlfriend than my Therm-a-Rest and sleeping bag). She moved on.

I drove out of Seattle, embracing a broken heart and letting go to the future. The U-Haul smashed my rear shocks into the ground and nearly lifted my front tires off the pavement. I drove north on icy roads, parked in Canmore, Alberta, and proceeded to a local bar, Zona's – it was Thursday night.

"I'm Will," a guy at the bar said. "Do you climb?"

"Cory," I said. "Not very well." The truth was, I had not yet become a strong climber. I'd moved north to close the backdoor and rid my life of excuses. As an American unable to legally work in Canada, I'd need to push myself harder to succeed as a freelance photographer. It was an exercise in tenacity; the only way to go was forward. I hoped that along the way I'd gain enough skill as a climber to get the shots I wanted. Now things were looking good on all fronts. I'd been in town 15 minutes and already met the world's best mixed/ice climber, Will Gadd. How rad was I?

I climbed and got behind on rent. I lived on black beans and eggs, worked, and worked harder. I flew back and forth to the States to assist fashion shoots just to stay afloat. I climbed more. I shot more. I wore flip-flops in minus 20 degree weather and made friends.

The line between work and play blurred as my career began to blossom. More often than not, I produced more, and better, work on the days when I simply climbed and shot from the hip. I was better when I did what I loved and shot what I wanted than when I concentrated on the saleable image.

At first, I worried that the pure joy of pursuing climbing for its own sake would get lost in the mix and that I was falling into the habits of a workaholic. I feared, in bouts of gut-wrenching anxiety, that I would flame out if the line were not clearer. I thought I'd lost something, and I paced ruts into the carpet around my computer, wondering how I could be more productive. In the end, however, the answer was always easy: Travel more and fall in love with every moment in the process – take a picture.

The truth is that I am young. With my youth, I breathe angst, energy, and ideals. I want to have it all figured out. But I don't. I long for clarity that only comes with the experience I lack. I have a long way to go. It's becoming ever clearer, however, that the blurred lines between work and passion, and who I am and who I want to be – that the definition of all lines – is a matter of perspective. And perhaps my lens can lend some focus to that.

It seems, too, that the best cure for struggle is time. I might not be living in a villa in Spain (yet), but my bills and rent are current. I still eat black beans, but only because I like the taste. Climbing is now less important than it once was, and because of that, I'm stronger than I have ever been. Everything is as it should be. That said, if it all fell apart tomorrow, I wouldn't regret a single moment I've poured into it. The ride has been real, and I see no end in sight.

Sonnie's head is slumped forward as we rattle through the fading darkness. Hours later, Will stirs in the dull predawn desert light. The road in front of us stretches on to meet a crisp horizon as the sun begins to crest. Downing the last swig of my long-cold roadside coffee, I reach for my camera and begin another day of work.

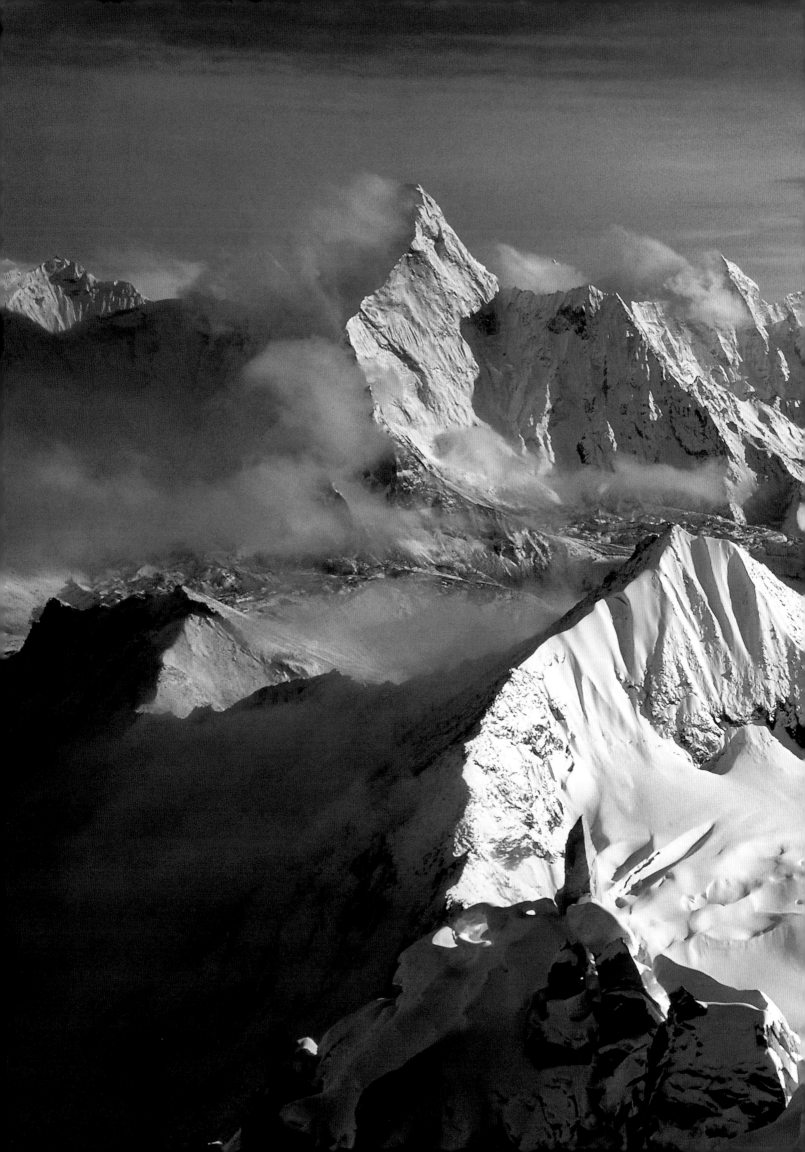

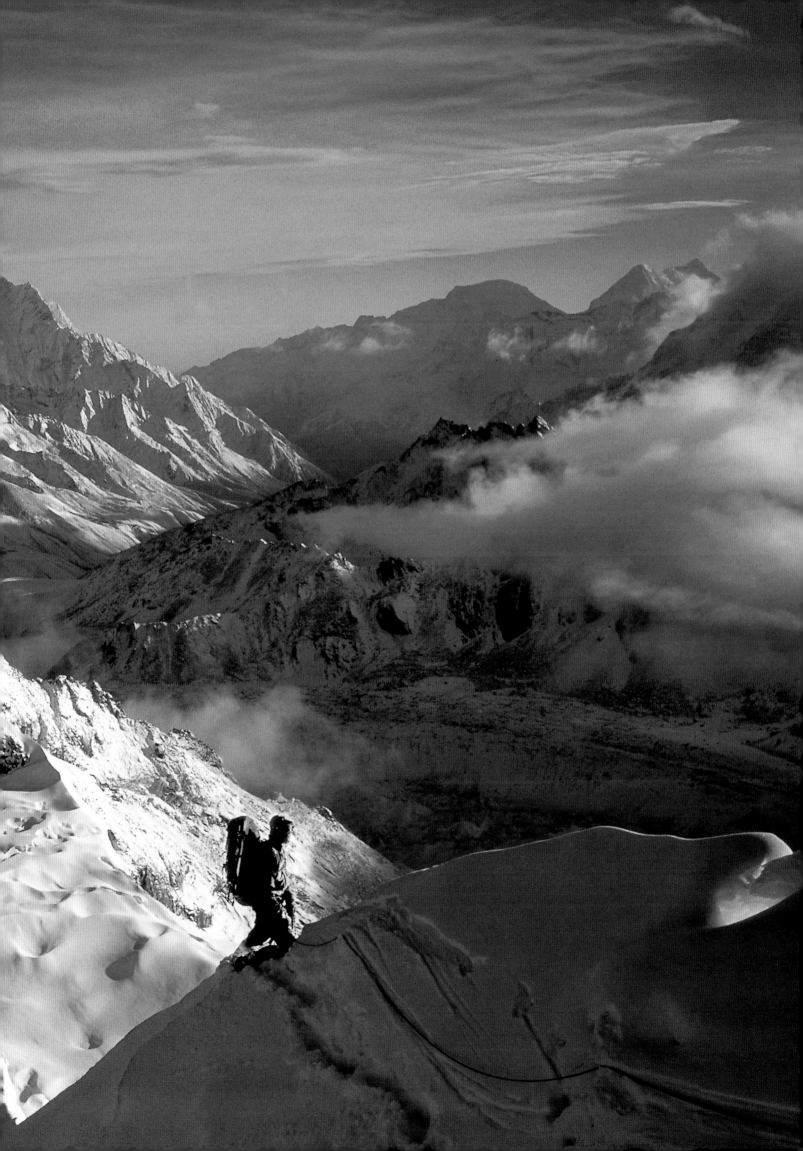

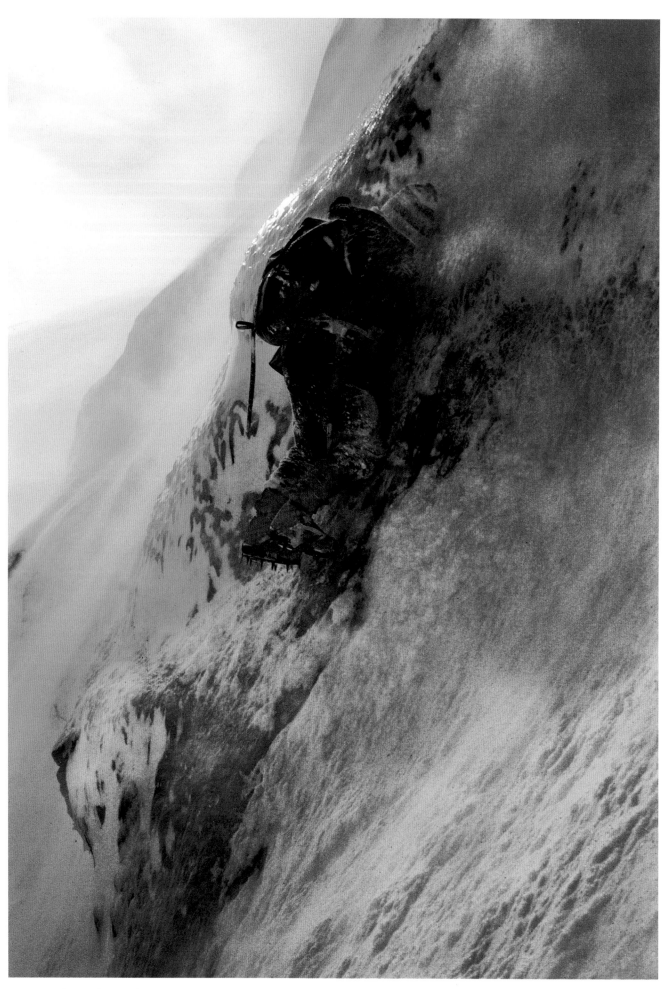

Doug Tompkins endures Hell's Lum Crag, Cairngorms, Scotland. YVON CHOUINARD. *Fall 1988*

Overleaf: Snowfall forces Steve House down the south face of Nuptse by way of the 1961 British route. Left to right is Ama Dablam, Kangtega, and Thamserku. Nepal Himalaya. MARKO PREZELJ. *Winter 2009*

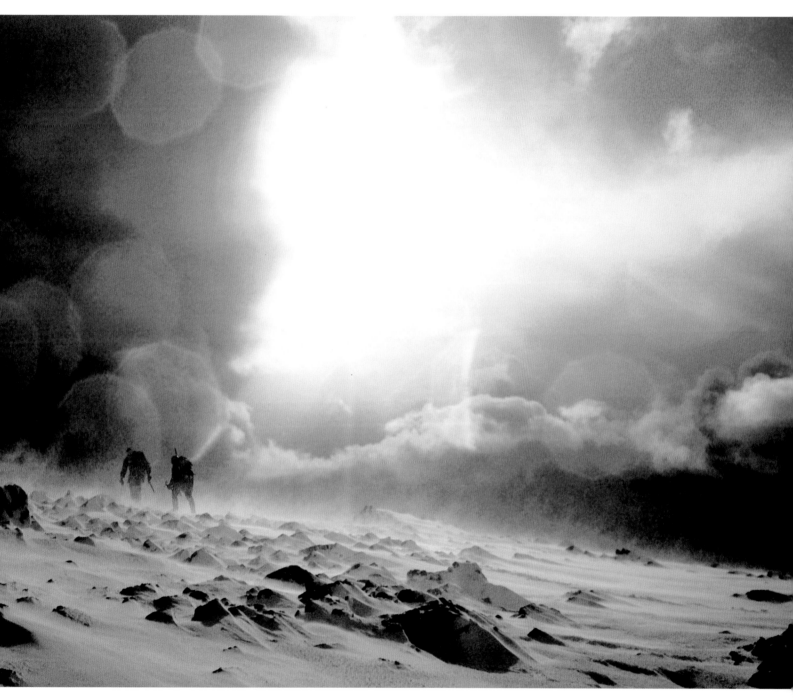

Full frontal exposure: Claude Andrieux and Christophe Bertoux approaching the summit of Ben Nevis, Scotland. RENE ROBERT. *Fall 1991*

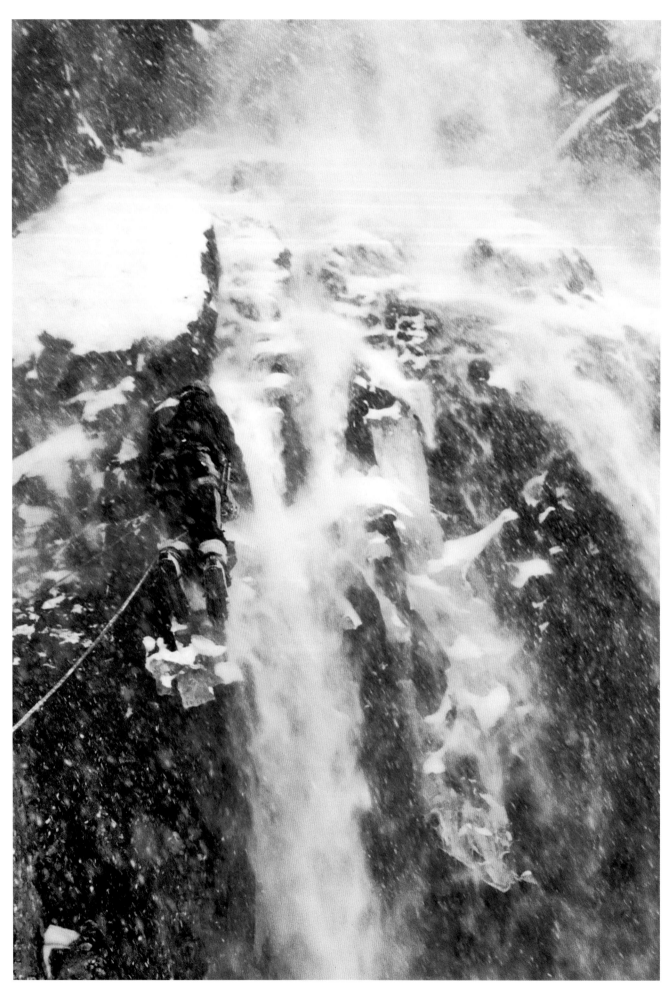

Kevin Cooper denying the cold and clammy on Necrophilia. Rocky Mountain National Park, Colorado.
TOPHER DONAHUE. *Fall 1998*

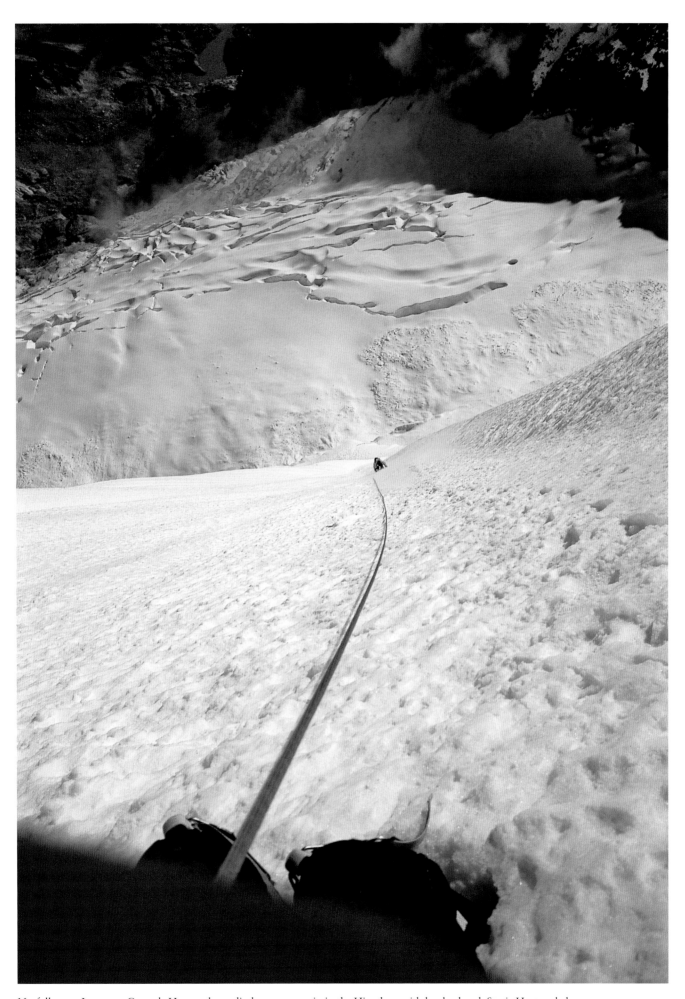

No-fall zone: Laurence Gouault-Haston downclimbs steep terrain in the Himalaya with her husband, Stevie Haston, below.
LAURENCE GOUAULT-HASTON. *Fall 2010*

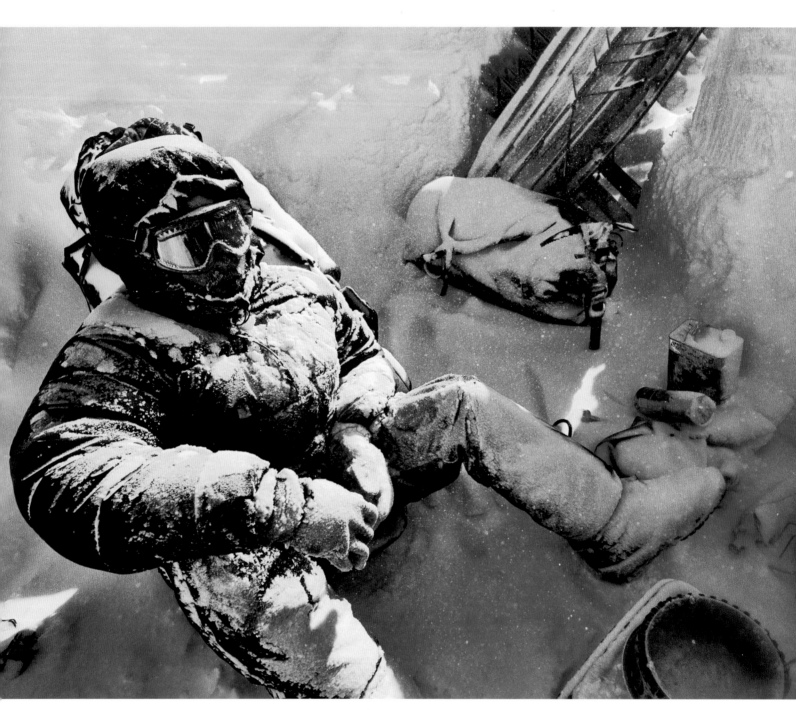

Dave Garrow, high camp on Mount Logan, Yukon Territories, Canada. CORY RICHARDS. *Fall 2004*

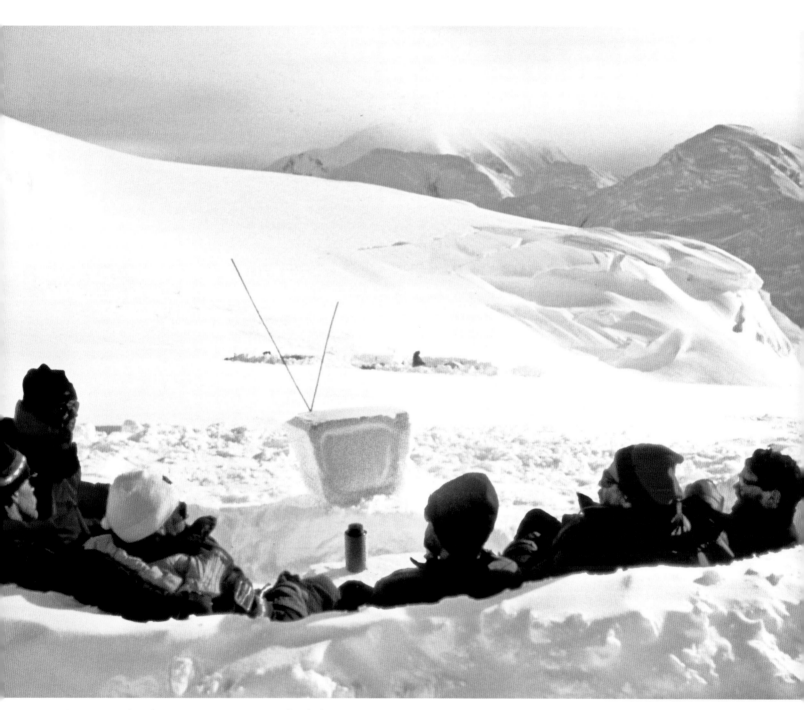

"Can't get anything but snow..." Base camp, Denali, Alaska. BILL STEVENSON. *Winter 1996*

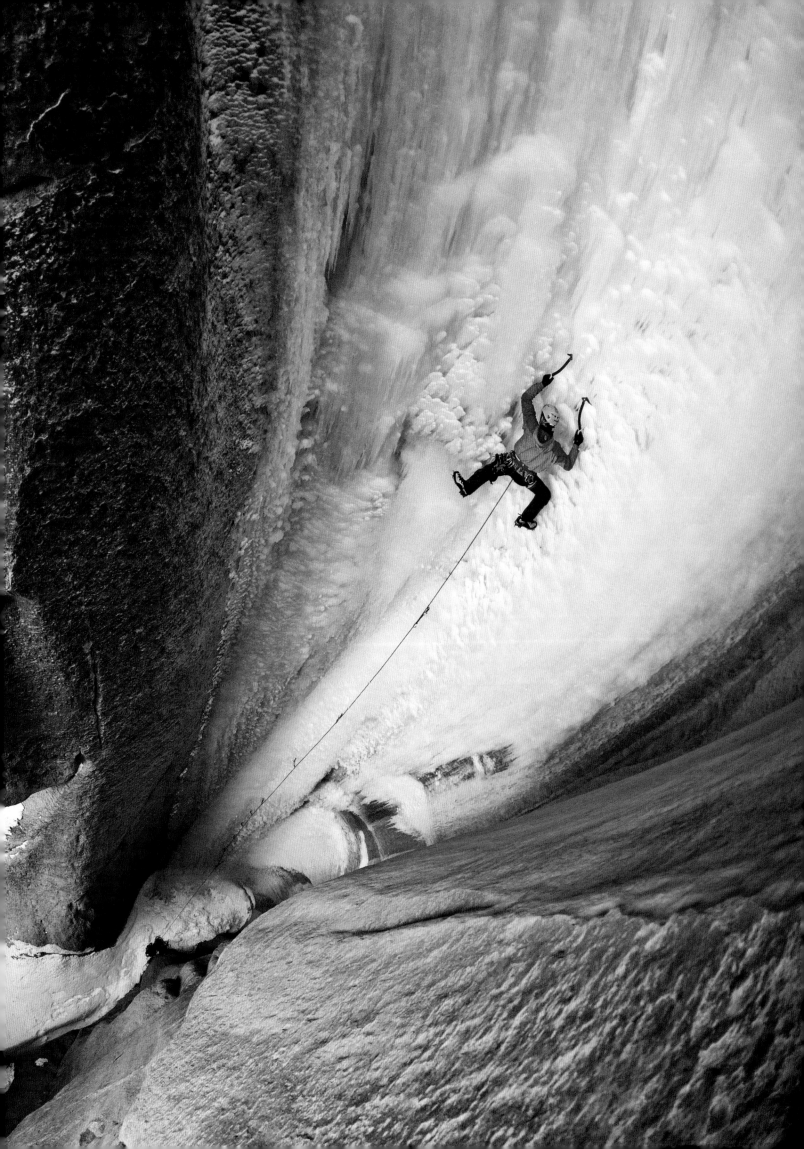

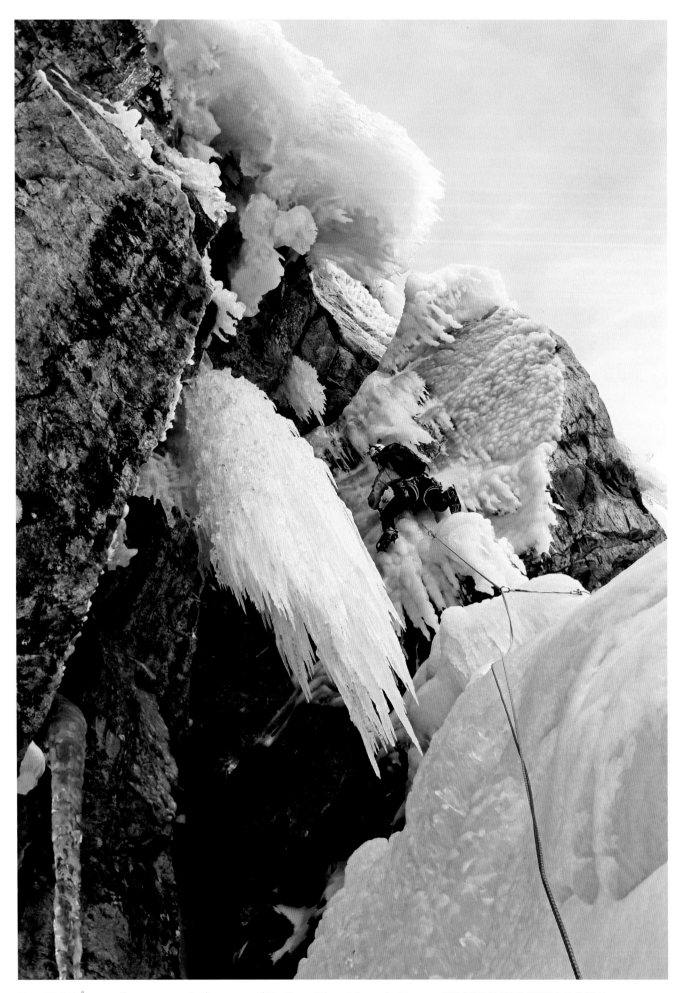

Bjørn-Eivind Årtun strikes a pose on the first ascent of Pin-Up on Kjerag Mountain, Norway. ANNELIN HENRIKSEN. *Fall 2009*

Overleaf: Erik Kelly finding the best of both worlds in the desert. Englestead Canyon, Zion National Park, Utah. ANDREW BURR. *Fall 2009*

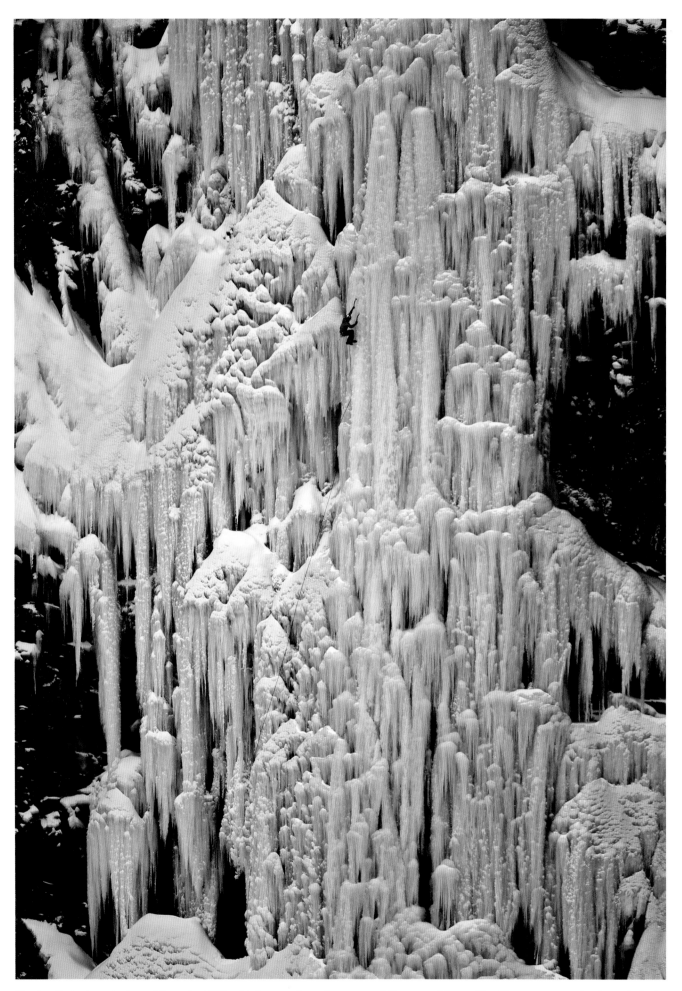

The ice climber's equivalent of Yosemite, Eidfjord is home to huge frozen waterfalls, most of them – like this one – are previously unclimbed. Norway. CHRISTIAN PONDELLA. *Winter 2010*

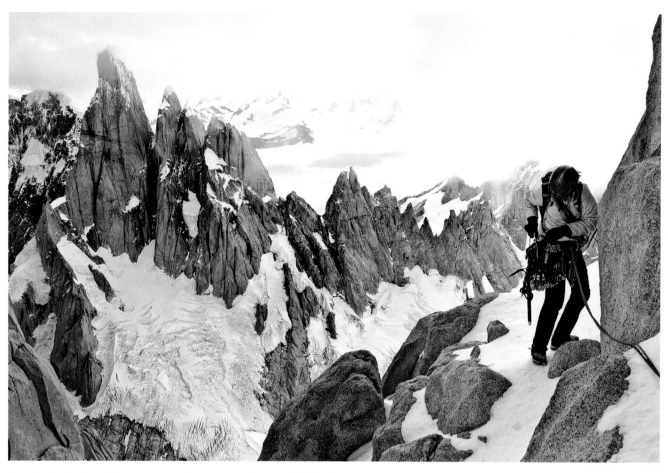

Kate Rutherford – and the rest of us – in a moment of pause. Fitz Roy, Patagonia. MIKEY SCHAEFER. *Fall 2010*

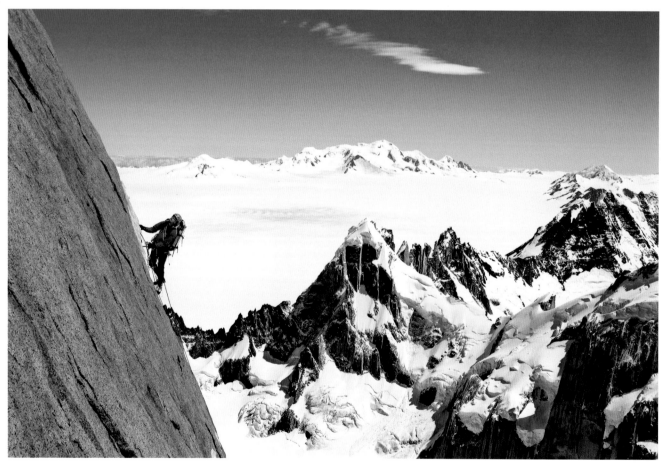

Day two, nearing the summit of the third peak of the four-peak Torre Traverse, Colin Haley follows the second pitch of the Schnarf-Huber route up the north ridge of Torre Egger. ROLANDO GARIBOTTI. *Fall 2008*

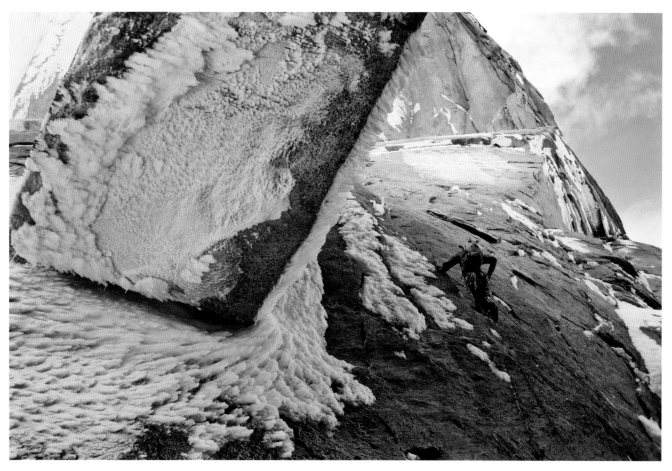

Near the col below Cerro Standhardt, Patagonia, Colin Haley climbs past the bus-sized jammed block on the first pitch of the mixed route Exocet. MAXIME TURGEON. *Fall 2008*

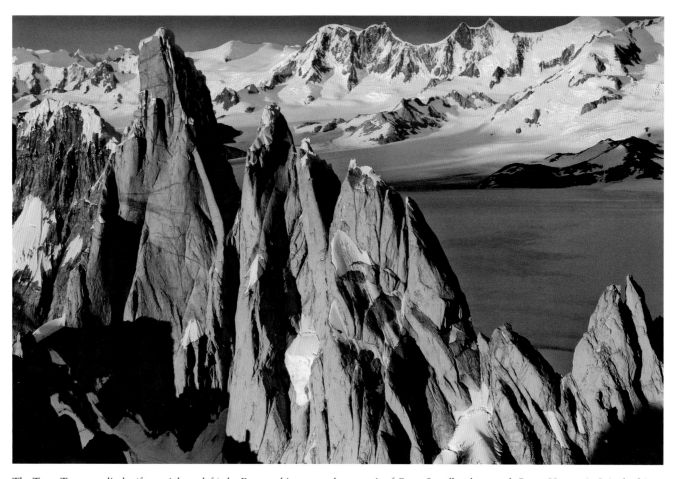

The Torre Traverse climbs (from right to left) the Exocet chimney to the summit of Cerro Standhardt, ascends Punta Heron via Spigolo dei Bimbi on the north ridge, then the Scharf-Huber route on the north ridge to the summit of Torre Egger, and finally, via El Arca de los Vientos to join the upper portion of the West Face route, to the summit or Cerro Torre. Patagonia, Argentina. ROLANDO GARIBOTTI. *Fall 2008*

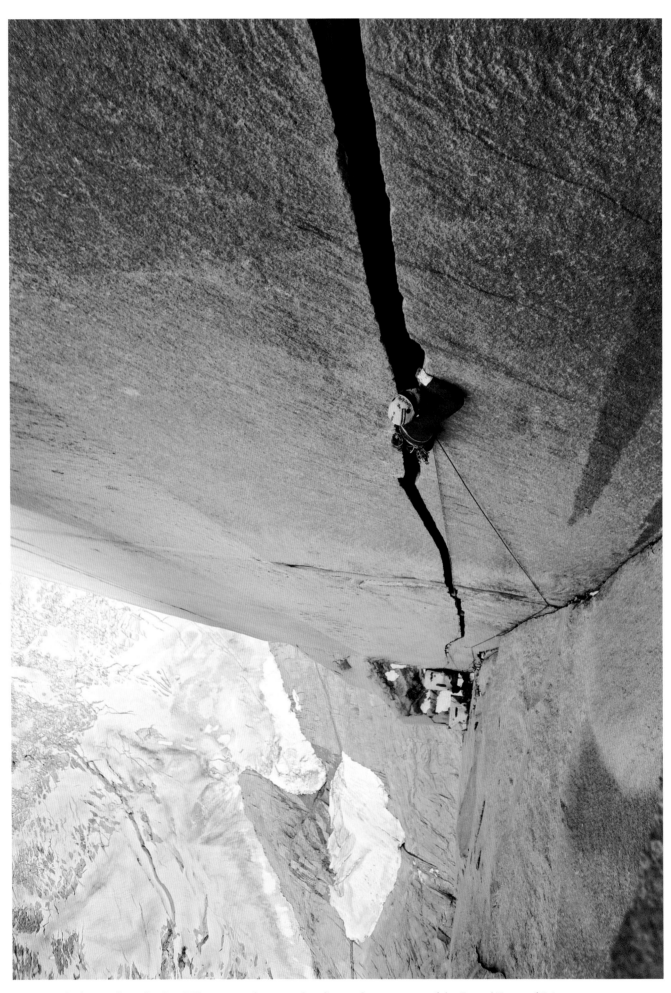

Patagonia climbing ambassador Sean Villanueva works a very clean line on the east corner of the Central Tower of Paine in Chilean Patagonia. BENJAMIN DITTO. *Fall 2009*

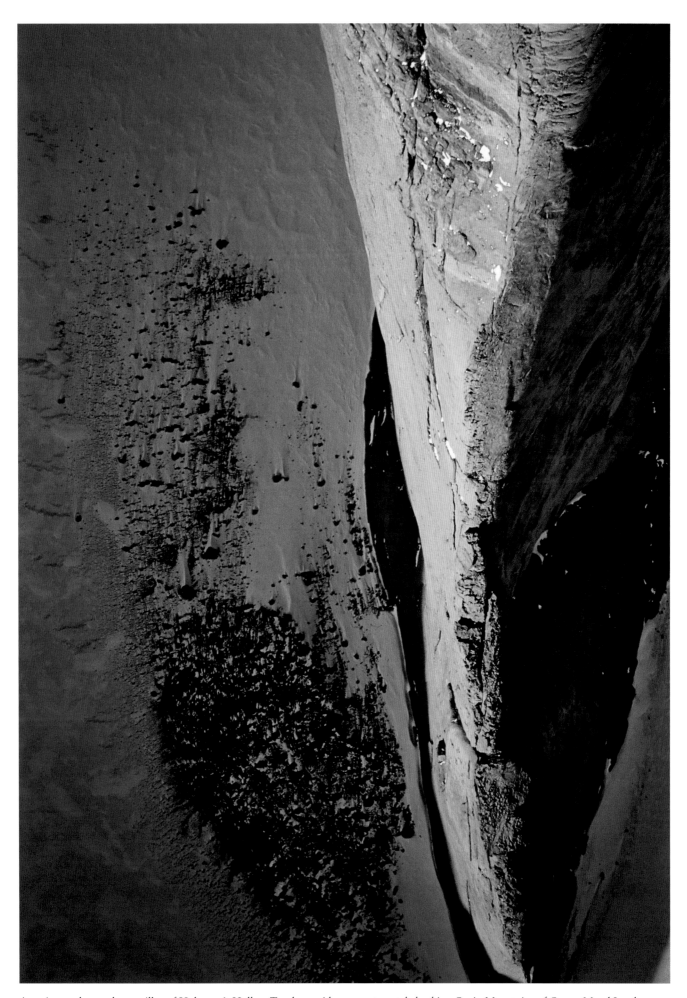

A cavity on the southeast pillar of Holtanna's Hollow Tooth provides a sweet portaledge bivy. Orvin Mountains of Queen Maud Land, Antarctica. RENE ROBERT. *Fall 2002*

Nature's revenge. LAYNE KENNEDY. *Spring 1994*

PERSONAL WORK

Jane Sievert

MY PATH TO PATAGONIA, like Jennifer Ridgeway's, started with a chance meeting. I was a climber who spent her summers in Yosemite. Winters, I'd head to Mammoth to ski. I was working that winter at Altitude 9000, the restaurant at the base of the mountain when Malinda and Yvon Chouinard walked through the door. He was a hero to any climber, and I vied for their table.

They became my regulars for the week they were in town. Although I couldn't believe my good fortune at having a chance to talk climbing with Yvon, in the end it was Malinda's description of their company that captivated me the most. I tucked her Patagonia business card into my apron and decided that once the ski season was over, rather than go back to Yosemite, I'd head to Ventura to check things out.

Several years later – and after I'd worked several jobs at Patagonia – Jennifer Ridgeway glanced through the company roster that included a brief bio of each employee and decided I'd be a good candidate to join her and Karen Bednorz in the photo department. She hired me not for my professional photographic experience – I didn't have any – but because my years as a climbing bum had given me the ability to recognize an authentic photo. As the saying goes, nothing is wasted.

Jennifer's instincts were good – and ahead of her time. She hired Gregory Heisler to photograph Mardy Murie, the grandmother of the conservation movement, published a photo exposé on ivory poaching in Africa, and used the catalog to champion dam removal. In addition to her soft spot for cowboys, she had a sense of humor and an appreciation for the obscure. She patiently mentored me, moving me away from the obvious toward the more complex and subtle.

Because we published photos of friends – and friends of friends – the word spread, and we had no trouble getting great submissions. Many came from dirtbag climbers, paddlers, skiers – those who live on the cheap and follow the season. When it was discovered that Patagonia would pay good money for snapshots of their daily lives, many a photographer was born.

Over the years, we have jump-started scores of careers. I have seen a climber with good photographic instincts move on from getting published by Patagonia to shooting for big commercial clients, only to submit to us again when established enough to have time to do personal work again.

Working with us can be frustrating, too. There is no formula or standard for getting published. Everything comes in on spec – and we are all over the map. We never pick a photo based on who has taken it. We are stubborn too – bucking photo fads and holding true to the celebration of natural light and photojournalism. And unless you're living out of your car eating rice and beans, even the most published Patagonia photographer does not make enough to support a living. I have spent many an hour discussing career paths with struggling photographers. The reality for most is that to make a living, one has to go beyond the outdoor industry.

In the early days, we were opportunistic. If Jennifer was moved by a photo, we bought ad space. If nothing came in, we wouldn't bother to advertise. Same went for catalogs; they were oversized, so we didn't crop photos, and we could add pages if we had something spectacular to share. Karen and I would scour the building for extra products and seconds to send out to friends going on interesting trips or climbs. If Jennifer heard about a deserving conservation project, we would support it.

Today, we run a professional digital studio and accept only photos submitted to our specs. We have a marketing strategy and an advertising plan, but the photo department is still grassroots – and small. Karen still works here as our image buyer. Sus Corez is our photo librarian, and Jenning Steger shares the photo-editing work with me. And although we are notoriously slow at editing submissions, the photos keep coming – over 80,000 per year, each like a present, always a new surprise to unwrap. No team of marketing gurus could dream up what comes through the mail.

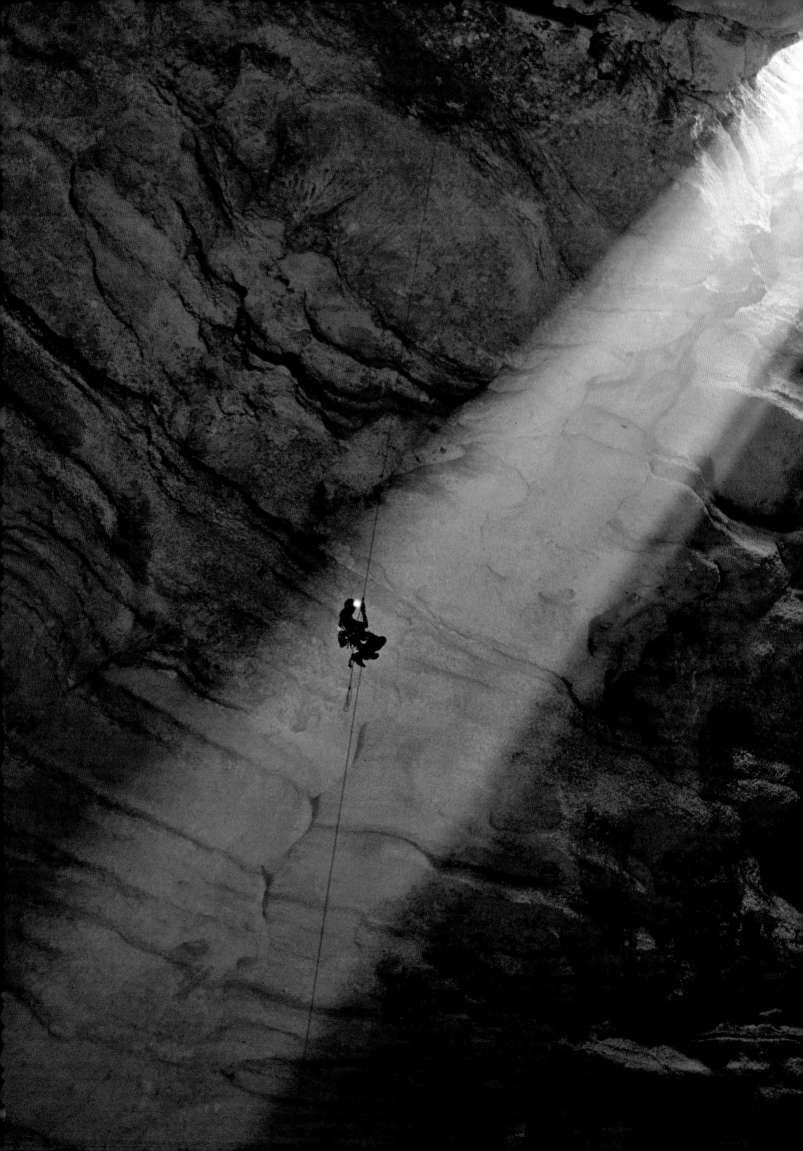

A bird in the hand ... Barney Hallin rides the house thermal over Our Lady of the Rockies. Butte, Montana. PAUL DIX. *Fall 1996*

Overleaf: Ben Cadel climbing the big drop of Majalis al Jinn, Oman. He is going up 600 feet to get out of one of the largest cave rooms in the world. STEPHEN ALVAREZ. *2008*

Lunacy is the mother of invention. François de Pfyffer flying on sailcloth wings in Les Grands Montets, France.
GREG VON DOERSTEN. *Fall 2000*

A tree sitter at home in an undisclosed location in the Cascade Range, 140 feet above the forest floor. The platform rigging protects three old-growth trees. PAUL DIX. *Spring 1990*

Bob Sorenson tightening cable bolts on the San Francisco/Oakland Bay Bridge. California. RICK RIDGEWAY. *Spring 1987*

Puff 'n stuff: Gami yak herders wait out the weather. Gankarling Range, Tibetan plateau. DUGALD BREMNER. *Fall 1997*

Mike Hoover with Mujahideen on a Russian APC, captured in the battle for Urgun, Afghanistan. BEVERLY JOHNSON. *Fall 1984*

"Down in front!" Riding coach, somewhere in Ecuador. TIM BROWN. *Fall 1999*

In the Kichatna Mountains, Denali National Park, Alaska. ROMAN DIAL. *Fall 1990*

Packing up to leave the summit crater. Acatenango Volcano, Guatemala. PAUL DIX. *Spring 1990*

Istvan Horvath with Mihaly Balla and Ferenc Szilagyi, wearing Racka sheep coats. Hortobagy, Hungary. CARY WOLINSKY. *Fall 1988*

The more you know the less you need. Middle of nowhere, Argentina. JOHN WASSON. *Spring 1989*

Overleaf: Reinhard Karl and the Fitz Roy skyline. LUIS FRAGA. *Spring 1984*

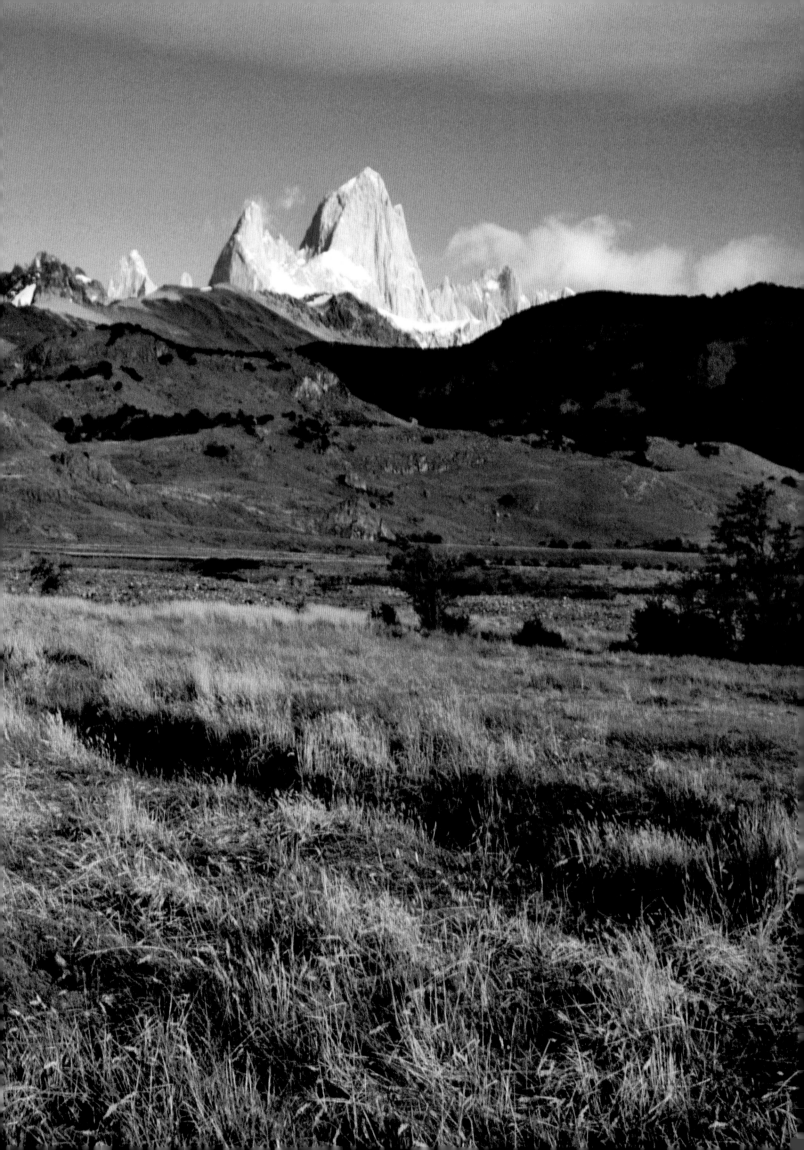